ADVANCED DIGITAL PHOTOGRAPHY

TOM ANG

MITCHELL BEAZLEY

This book is (another) for Wendy

Many thanks to Wendy Gray for the image on page 51

Advanced Digital Photography

First published in 2003 by Mitchell Beazley,
an imprint of Octopus Publishing Group Ltd,
2–4 Heron Quays, London E14 4JP
New edition 2007

Text © Tom Ang 2003, 2007
Design copyright © Octopus Publishing
Group Ltd 2003

All photographs and digital images © Tom Ang
The moral rights of Tom Ang as the author of the
title are hereby asserted in accordance with
the Copyright, Designs and Patents Act 1988

Commissioning editor **Michèle Byam**
Executive art editor **Christie Cooper**
Project designers **Jeremy Williams, Colin Goody**
Project editors **Chris Middleton, Peter Taylor**
Production controllers **Kieran Connelly, Angela Young**
Indexer **Vanessa Bird**

A CIP catalog record for this book is available
from the British Library

To order this book as a gift or incentive contact
Mitchell Beazley on 020 7531 8481

ISBN-13: 9 781 84533 256 3
ISBN-10: 1 84533 256 3

Set in Trade Gothic
Printed and bound in China

AD
DIGITAL
PHOTOGRAPHY

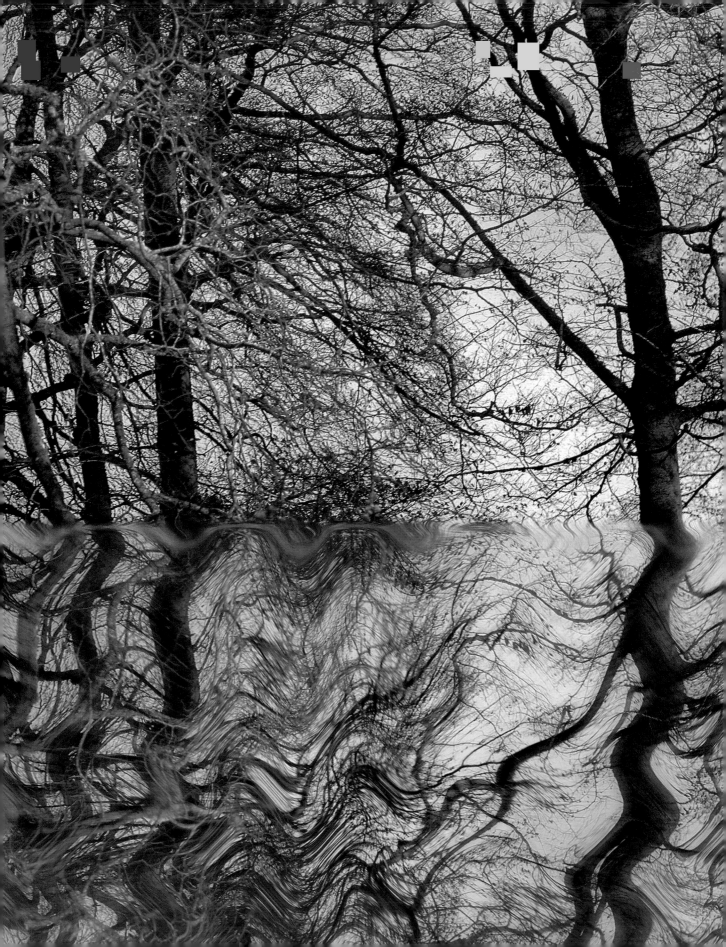

Contents

006 Introduction

PART ONE

007 **DIGITAL IMAGING PRINCIPLES**
008 The imaging chain
016 Software operations
020 Understanding digital colour
024 How scanners work
028 How printers work

033 **MASTERING HARDWARE**
034 Know your digital camera
042 Better scanner techniques

PART TWO

047 **MASTERING IMAGE MANIPULATION**
048 Advanced tone control
052 Digital dodge and burn
054 Advanced retouching
058 Distortion correction and cropping
062 Artefacts and noise
066 Advanced colour control
074 Advanced masking and selection
080 Working with type
084 Advanced compositing
092 Advanced painting
096 Increasing file size
100 Advanced black and white
106 Advanced digital darkroom
112 Advanced digital filters
114 Advanced sharpness control
120 High-pass sharpening

121 **MASTERING YOUR MATERIALS**
122 Organizing your images
126 Output your images
132 Output to Web

137 **REFERENCE**
138 Glossary
142 Further reading; Web resources
143 Index
144 Acknowledgments

Introduction

In the first edition of this book, I wrote that "digital photography has truly come of age". For this, the fully revised second edition, it is safe to say that digital is the predominant form of photography. Major picture agencies now accept contributions only in digital form. Virtually all press and news photography throughout the world is routinely captured digitally, and previously conservative picture users such as book and magazine publishers not only accept digital images as a matter of course, they explicitly commission photography in digital form. While digital techniques have advanced on numerous fronts, it has left knowledge and understanding of digital photography a long way behind. Photographers using digital cameras professionally for the first time, picture and art editors commissioning digital photography for the first time – producers and consumers alike are all having to learn a new language and new ways of working.

This book is written for everyone who has enjoyed using a digital camera and working with images on computer but who now wishes for a more in-depth review. It aims to help confidence in the use of digital technology, to lead to an exploration of the less-frequented aspects of digital images.

Most importantly, digital photography enables a short-cut to be taken past the high costs of 20th-century technologies into a 21st-century era of lower-cost high-quality imaging. As the Internet has opened up the world to anyone with a computer and modem, so now is digital photography releasing the power of visual communication to anyone with a computer. Remember there are far more people around the world who have a computer than ever had access to a darkroom.

One result is that the less-developed world is potentially the greatest beneficiary of this technology – digital photography can make a positive difference not just to your life but that of the world around you. I hope this book will help you to have fun while working effectively – all as contributions to the greater good. This second edition has been thoroughly revised and updated to reflect recent developments and changes in work-flow practices.

Tom Ang, London 2006

PART ONE

DIGITAL IMAGING PRINCIPLES

MASTERING HARDWARE

The imaging chain

Digital photography is a hybrid of old and new technologies. It blends chemical-based recording and processing with electronics-based systems of image acquisition and computation. Mature silver-gelatin processes combine with recent advances in digital imaging and miniaturization to create a complex of branching options and multiple outcomes. This means that the once straightforward chain of photography – from releasing the shutter, through film processing to the final print – is broken. Numerous decisions face us wherever those links need repairing.

General principles

An overview of the basic principles of digital photography will help you draw up a grand plan for understanding the subject. Like points of the compass, these principles will help you keep your bearings as you sail towards the new horizons that these technologies promise.

The first principle is that the information content of a digitally processed image cannot be greater than the information content that was first acquired. In other words, the results of scanning or image capture (the transfer from the analogue to the digital domain) set the maximum quality level of the final result. It follows that image manipulation is not (and cannot be) about increasing the information content of an image. Rather, it is all about quality restoration.

The second principle is that errors or artefacts in an image correspond to, and characterize, a specific phase of the process. The corrections and manipulations that typify digital photography are essentially a system of compensation for, or correction of, those artefacts.

Artefacts can arise at every stage of the process: for example, in the properties of the capture system (e.g. lens aberrations or distortions); in the image acquisition (e.g. interpolation errors), and in the results of post-processing decisions (e.g. over-sharpened contours). Each type of artefact calls for a different regimen of corrections.

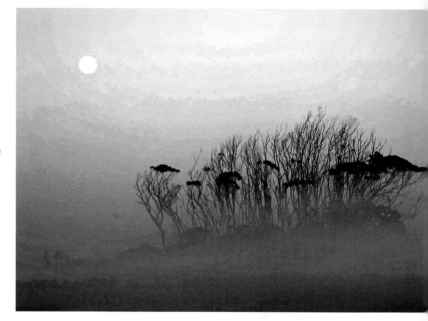

The soft and incredibly subtle shadings of a misty dawn in New Zealand are a stern test of any recording system. Unfortunately, it was too tough a test for the digital camera, which has failed to record the smoothness of tonality in the scene. Banding or posterization is apparent in the sky. With experience, you will learn the strengths and limitations of digital photography. In this instance, you would fare better recording the scene on film.

It follows that errors introduced in one phase of the process are passed down the chain to the next and cannot be wholly eliminated.

A third principle is that the workflow of digital photography is hierarchical. What can be achieved at one stage depends on an earlier state, or on previous actions. For example, a scan to 48-bit space forbids painting; working in RGB space prevents the control of pure luminance data, and so on. You obey this principle when you change from one mode of working to another in order to apply a certain effect.

Fourth, information or data in excess of that required by an output system (e.g. a monitor or printer) is ignored for the purposes of the output. It follows that there is no point giving more data to the output device than is necessary. Excess data reduces efficiency without adding to quality.

Handing down quality

As we have seen, steps further along the chain are dependent on what happened in the earlier stages. The

Photo-electric effect

The basis of all digital photography is the photo-electric effect. When photons or particles of light strike atoms, electrons absorb the energy and may be bumped up into a higher energy state so they are then free to move around. Technically, the formerly "bond" or "valence" electrons become excited onto the conduction band. The number of electrons in the conduction band depends on the amount and wavelength of the light. Therefore, by collecting and measuring the freed electrons, we can extract data about the light. And by changing the voltage and the direction of voltage gradients, electrons can be directed around. On digital cameras, light is captured by millions of tiny receptors. More receptors equal a higher quality image.

An advantage of film over digital cameras is that very long exposures do not lead to significantly raised noise levels, e.g. lighter spots in dark areas. This night shot, with an exposure lasting several minutes, of a monastery in northern Romania, shows deep, smooth blacks on film which would be very difficult to achieve digitally.

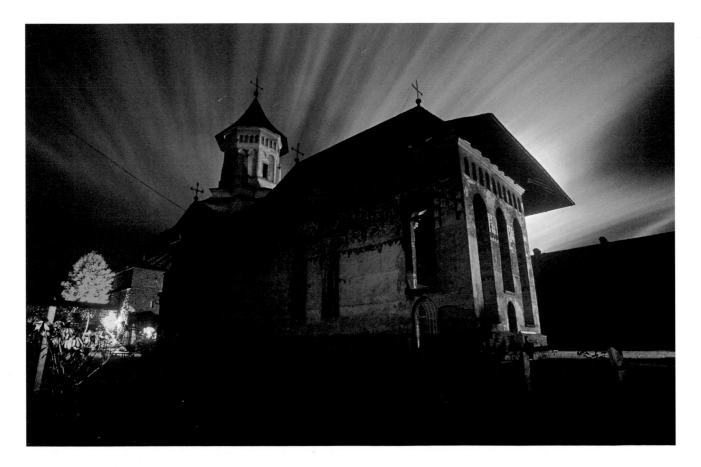

» FOR MORE ON IMAGE QUALITY SEE PAGES 96–99

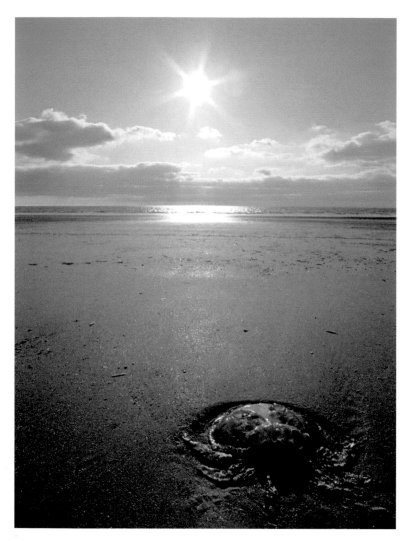

An ultra-wide-angle view such as this shot of a stranded jellyfish, taken with a 17mm lens on 35mm film, is extremely difficult to achieve on the majority of digital cameras. One reason is that photo-sensors carry a raster of micro-lenses on their surface to improve light-gathering.

Light entering photocells near the edge of a sensor at too oblique an angle – as would be the case with a wide-angle view – would not be properly gathered, causing unacceptable darkness towards the sensor edge, as well as colour fringing.

Well overflow or blooming

When a great deal of light arrives at a sensor, more electrons may be released than can be stored. If this happens, they spill over into neighbouring sensors, disturbing their values. The problem produces a characteristic effect. The result is most often seen as an irregular coloured fringe – usually red/blue – next to bright areas bounded by a dark border.

final output quality depends on the original input quality. However, these limits and the transmission of quality loss should not be confused with another feature of the imaging chain. While duplicates and copies made in the analogue or film-based domain are always inferior to the original, duplicates made in the digital domain are identical. But if digital copying transmits data with perfect fidelity, that includes any deficiencies in the image. So, image quality and data quality vary independently. That is why a large file – one containing very many pixels – is no guarantee of output quality.

Note also that the invisible digital code of ones and zeros, ons and offs, must itself retain perfect integrity. Even apparently insignificant imperfections in a file could render it unusable. For example, if the tiny hexadecimal number 2A does not appear in a certain field of a TIFF file, even if you have a hundred million bytes of perfectly good data you may find it impossible to open the file.

Analogue and digital domains

Analogue media record changes in the subject as more-or-less proportionate changes in a measurable medium. For example, variations in brightness record on film as changes in the amount of silver after processing. Film-based photography operates in the space/amplitude domain.

Digital recording takes place in two phases. First, it must separate more or less continuously changing variations into small sections or units. This is a process called sampling. The system then measures the data in each sample to arrive at a value – a process called quantization. So, digital recording may be said to operate in the space/ frequency domain.

Note that the majority of recording processes, whether digital or analogue, compress data. So it is not true that digital recording is superior to analogue in this respect.

File size and resolution

The central currency of digital photography is the pixel. The majority of confusions regarding file size and resolution can be resolved by returning to this fundamental: do you have enough pixels in your image for the output you want?

The size of output multiplied by the output resolution tells you how many pixels you need in your

image. If you have the right number of pixels, you can proceed, if not, you need to make simple resizing or resampling adjustments; that is all there is to it.

A file with many pixels is always larger than a file with fewer pixels (if they are in the same format). But the relationship is not straightforward.

First, remember that images are stored as one or more channels of data. To obtain an idea of the file size, you must multiply the number of pixels by the number of channels. Now, if you have one byte (8 bits) to each pixel per channel, then you will have as many bytes as pixels per channel. For example, if you have a million pixels in a greyscale image, you have 1 million bytes. In an RGB image, you will have 3 million bytes – a million for each separation channel – but in a CMYK file, you have 4 million bytes. Note that digital bytes are counted in powers of ten, so a KB actually contains 1024 bytes, and the binary million or 1MB contains 1048576 bytes.

Now, when you check how much space an image takes up in the computer's filing system, the figure you see seldom equals the actual pixel-per-channel count. First, the file may be compressed so it is smaller. Second, the file may take up only a fraction of a portion or sector of a disk. As far as the computer is concerned, the rest of the sector cannot be occupied by other data, so it shows the file as occupying the whole of the sector, making it appear larger than it is.

Image acquisition

Image capture takes place over three basic stages. First, the opto-electronic components work together to convert light energy into manageable pulses of electricity. Next, the camera's on-board computer processes the signals to turn them into a digital data stream. The resulting signals are then in a form which allows data to be extracted. For practical purposes, they are mined for information, guided by principles of human visual psychology and physiology. That is, the information is extracted to give a pleasing and accurate image.

It follows that there is nothing absolute or inevitable about the image that a digital camera sends to your computer. The different ways in which the data is extracted is, in theory, entirely arbitrary. The signals may be processed for other kinds of information, such as letter shapes – as used in speed-trap cameras for

reading car number plates. In industrial quality control, it is the precise dimensions that are extracted – so that robotic machines can identify and extract faulty components. But digital photography makes the toughest demands: not only for accurate tones and perfect colour, but for sharp outlines as well.

Pros and cons of digital versus conventional photography

CONVENTIONAL (FILM)	DIGITAL
Materials	
PROS	
High quality possible	Very compact storage
B&W extremely robust	No chemical processing
Colour very robust	Easily transmitted
Easily packed	Can print on location
Lower cost start-up	
CONS	
Colour materials not robust	Large investment needed
Limited shelf-life	Susceptible to dust and damp
Needs processing	Needs separate data storage
Susceptible to X-ray damage	Needs electricity
Cameras	
PROS	
Very robust	Can be very compact
Can avoid battery reliance	Easy to use
Widest range of lenses	Instant feed-back
Conservative on battery use	Quiet operation possible
CONS	
No instant feedback	Reliant on delicate cables, etc.
Can be bulky	Battery conservation worries
Can be noisy	Limited wide-angle views

Quality measures

There is no straightforward method of measuring the quality of digital images. With film-based cameras, there is a well-tested if simplistic measure: the MTF (modulation transfer function). The quality of a digital image depends not only on the lens, but the construction of the sensor, as well as the software operations which extract image detail. In the end, however, there's not much wrong with simply examining the image very carefully.

» FOR MORE ON RESOLUTION SEE PAGES 44 AND 96–97

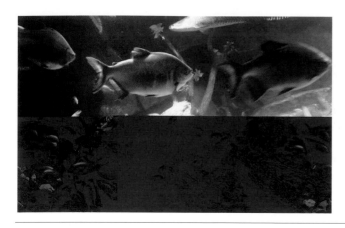

An image as defective as this is very rarely seen. It is from a digital camera and shows a normal image as captured in the top half, but a wildly reversed image in the lower half, taken from another image. This reproduction is taken from a screen-grab of the file, because when it was saved and an attempt made to open it again, the above warning was displayed.

CCD sensors

By a very wide margin, the type of photosensor most widely used in digital photography is the CCD (charge-coupled device). In 1999, nearly 100 million photosensors were produced, of which 90% were CCDs. Although such devices are relatively expensive to make and electrically complicated to run (economies such as the integration of processing functions on the same chip as the CCD are not possible, and CCDs run on a relatively high voltage of 15V), they offer advantages in delivering a clean signal, with low noise. Their popularity has fed their own development. The resolutions available to well-heeled photographers rose by around a million pixels per annum over a period of about five years until the plateau of 6 million pixels – which gives excellent image quality – was reached. The new generation of sensors delivers 22 million pixels and more. However, the vast majority comprise very small chips, so their use with lenses designed for 35mm film still delivers a focal length factor (*see p. 38*) of at least 1.5X.

The sensors can be arranged in a number of ways. The most popular is a rectangular grid, with the sensors arranged in horizontal and vertical rows. The grid can be rotated through 45°, which offers advantages in increasing the area available for collecting light. Another method is to pack two, differently sized, sensors under each cell in the grid – which may improve the dynamic range.

CMOS sensors

CMOS sensors offer numerous advantages over CCD sensors for the manufacturer. A CMOS sensor uses the same production lines as other computer chips, it may run at voltages as low as 2.5V, and the signal processing can be integrated on the same chip. CMOS sensors are used in Webcams, fax machines, digital cameras in mobile phones, etc. Sadly, as this list suggests, its Achilles heel is image quality: a great deal of clever processing at the level of individual sensors is needed to produce a clean, noise-free system.

In fact, each pixel is active (hence the alternative name: active pixel sensor) and equipped with its own transistor to even out variations between sensor behaviour and other problems which limit the effi-

The relative size of pixels and dye clouds

Photosites on CCD or CMOS sensors are larger than typical dye clouds in films. On digital cameras sensors measure from four to twelve microns (millionths of a metre) square. In contrast, the diameter of a typical dye cloud varies between one to three microns.

How CCDs gather light

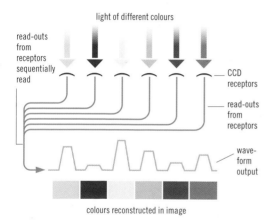

The CCD (charge-coupled device) is the most widely used type of photosensor. Instead of removable film, a fixed sheet of millions of sensors is electrically charged to be sensitive to different colours of light. Data is gathered from each and composed into an image.

Counting pixels

Pixel counts (or resolution) published by camera manufacturers can have one of three different meanings. The *actual* number of pixels means how many there are on a given sensor. The *effective* or useable number refers to the pixels which are actually used – these are always fewer than the actual number. Finally, the effective pixels may produce a file containing more pixels – this is the *interpolated* pixel count.

ciency of CMOS sensors. However, each sensor is individually addressable, unlike each CCD sensor which cannot be reached without first reading off all the CCDs in its row preceding it. This means that the sensor could be used for metering, and even auto-focusing.

At the time of writing, only a few "proper" digital cameras use CMOS chips, and they are notably high-end cameras, such as the Canon EOS 1 series and Nikon D2X. Other types of sensor, such as MOS (Metal Oxide Semiconductor), are also coming into service. Experience has shown, however, that the type of sensor itself is not as important as the way the data is interpreted by the camera's software: image processing can at least partially compensate for the specific inadequacies of any method of image capture, including noise removal.

Colour filter array interpolation

Sensors in themselves respond more or less equally to different wavelengths of light, as a result of which they are not able to distinguish between colours. Suppose you place a coloured filter, say, green, over a sensor. If green light falls on that sensor, much light will pass through and produce a high signal. In contrast, if red light falls on the sensor, little light passes through, producing a low signal. By covering sensors with a grid of coloured filters we can record variations in colour. The majority of current systems use red, green, and blue filters (usually in a Bayer pattern, i.e. one which uses two green filters for every red and blue), but other systems are in use which, for example, substitute one green with a green-blue filter. Note that laying a layer of filters over the sensors has undesirable side-effects: the filters reduce the flux of light reaching all sensors and, additionally, their depth tends to cast a shadow or occlude sensors at the periphery of the chip. The latter effect limits the use of wide-angle lenses (*see p.37*).

The image data from a colour filter array can deliver a recognizable image without any image processing. But both the colours and details will be poor – each pixel carries only the value for its own filter: one under a red filter may have the RGB values 122, 0, 0 while a neighbouring pixel has 0, 0, 34 – it

CCD sensor array

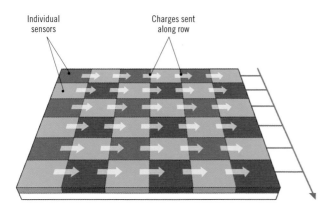

Individual sensors

Charges sent along row

We have already seen in the diagram, opposite, how CCD sensors gather different brightness of light. However, CCDs consist of rows linked in one direction. For any individual sensor to be read, data from earlier in the chain has to be sent down and read off one by one. This slows down processing and can lose data, resulting in noise.

CMOS sensor array

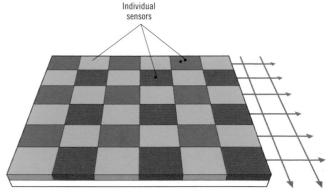

Individual sensors

CMOS (Complementary Metal Oxide Semiconductor) sensors feature individually addressable sensors which can, in theory, be read in any order. This simplifies signal processing, allowing more rapid image capture. But the sensors are inherently noisy so individual transistors are needed for each sensor to regulate stray current.

» FOR MORE ON RESOLUTION SEE PAGE 44

lies under a blue filter. Colour filter array interpolation, also called "demosaicking", is a computation which takes the signal values of groups of sensors to assign each pixel a full set of red, green, and blue values.

In fact, demosaicking is a family of image-processing techniques which vary in their complexity, ability to define edges, and degree of freedom from artefacts. In the simplest technique, nearest neighbour replication, each interpolated pixel value comes from that of the nearest pixel in a standard direction. A red pixel gets its red value, then the blue value comes from the upper right pixel, and the green value from the left. The green pixel gets its own green value, then the blue value comes from the upper right, red from below... and so on. It is very quick to compute, but gives inferior, artefact-prone results.

A much more complicated example – variants of which are used in today's cameras – involves working out how similar the surrounding pixels are to whichever pixel is being examined – in short, calculating gradients of values. These are a good indicator of whether there is an edge, or a smooth transition of tone. To do this, the software looks at a square block of 25 pixels, centred on the one in question, to calculate gradients in each of the eight compass directions: north, north-

G1	R2	G3	R4	G5
B6	G7	B8	G9	B10
G11	R12	G13	R14	G15
B16	G17	B18	G19	B20
G21	R22	G23	R24	G25

Colour filter array
Colour filter array interpolation, or demosaicking, uses grids such as that shown (*above*) for its calculations. For example, to find the red value for sensor G13, we check the nearby red sensors. If they are very similar, it is a safe bet that the value of red at G13 is that same as R12 and R14.

east, east, and so on. Different gradients are calculated according to the colour we want to extract, and according to the colour of the central pixel.

From the gradients, threshold values can be applied. If the gradients are not steep, we average out, i.e. smooth the data more than if the gradients are steep. Conversely, if the gradient is very steep, there is no need to average out the data. The choice of threshold values is more or less subjective: there are no absolutes. The interpolated value for the other two (RGB) channels of a single pixel results from a full analysis of all 24 pixels – which helps create results that are relatively free of artefacts.

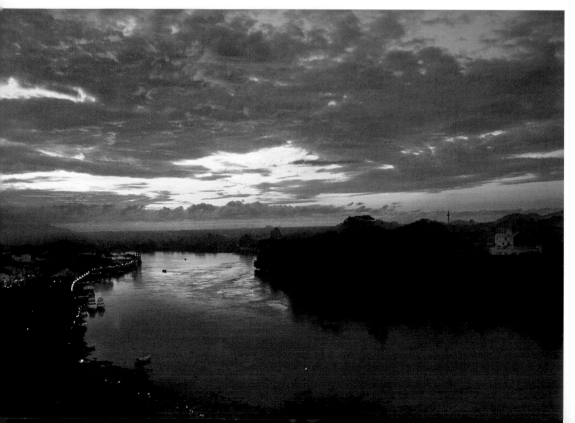

In this view over the Sarawak river, a low ISO equivalent speed was set on a digital camera to obtain the best image quality. As light levels dropped, I needed to capture a river boat with lights. I raised the sensitivity so I could use a short shutter time to prevent blur. Such effortless flexibility is not possible when using film.

If you travel in challenging environments, such as the Negev Desert in Israel, you will want to ensure that every shot taken is of the best possible quality, with maximum reserves. For this, film is unrivalled and will remain so for the foreseeable future. Digital technology's proponents may scoff, but the fact remains that every sharp image on high-quality 35mm film is the equivalent of at least 12 million pixels of data.

Repeating history

Early colour photography used red, green, and blue starch grains arranged like a filter array, but irregularly distributed. Colour film, in contrast, stacks the red, green, and blue-sensitive layers on top of each other. The triple-well CCD is just like colour film, save that the blue-sensitive sensors are in the top layer while the red lies in the bottom for the triple-well CCD.

Clearly, all of these calculations involve an enormous amount of computing. There are six steps for each of the eight gradient calculations alone. Multiply that over, say, 5 million pixels, and you have some idea of the size of the task. Yet modern cameras such as the Canon EOS 1D Mk II N can capture images at rates exceeding 8 frames of 8 megapixels – hundreds of thousands of computations – per second. In fact, the bottleneck may no longer be at the camera, but where data is transferred from camera to memory card. To make the best use of fast image processing, it is essential to use memory cards with the fastest rates of data through-put: modern cards offer rates as high as 133X base (133 x 150 kbits/sec).

Triple-well arrays

One family of sensors does not rely on coloured filters to separate the colours in an image. Rather, this type of sensor aims to capture the red, green, and blue values for each pixel directly, from the source. The technology works because light of different wavelengths penetrates to different depths in silicon (and, indeed, in most other materials). Blue light is adsorbed mostly at the surface, while green penetrates a little deeper – to about half a millionth of a metre. Red light reaches the deepest, to beyond two millionths of a metre.

To exploit this property for colour imaging, the silicon layer is divided into squares, each corresponding to a pixel. Cunning silicon fabrication enables the resulting charges (of the photo-electric effect) to be read at different depths of the silicon layer, each corresponding to the blue, green, and red channels for that pixel. At the same time, the clever design improves the separation of charges in each channel, resulting in a MOS (Metal Oxide Semiconductor) type of device.

In theory, this adds up to a direct read-out of the RGB values of each pixel. As there is no need for demosaicking or colour aliasing, the camera's onboard processors are freed up to capture the image swiftly.

Planning your Exif strategy

Exif is a device-independent standard for the data saved with a digital camera image. It allows information such as shooting conditions (e.g. white balance), camera settings (e.g. exposure time, override, and focal length), as well as the date and time to be stored together with the image file. This is a useful reference for the photographer, but it can also be used by printing software to optimize print quality. Most image management software such as FotoStation and Quantum Mechanic Pro can read Exif data and, indeed, allow the subsequent editing of entries.

» **FOR MORE ON COLOUR SEE PAGES 20–23**

Software operations

The concept of computer software is familiar to anyone who has used applications to add power and efficiency to everyday tasks such as writing, surfing the Internet, working with typography, or manipulating images. However, it is also an invisible presence in every type of digital device. Software is needed to run your digital camera and your scanner. Even for the humble battery charger, software had to be written to regulate charging rates against the measured resistance of the battery, the temperature, and the

These two images (*above and right*) are of identical size – 1440 x 2160 pixels, yet they occupy different amounts of file space. One takes up over 1.5MB more than the other. The reason is the differing amount of detail they carry. The still pond reflection contains large areas of even tone. The red flowers are full of fine details. The latter is harder to compress, because of the detail that needs to be retained. The file size after compression is actually larger than you would expect from its nominal pixel size.

operating voltage (then it lights up the correct indicators to help you).

Types of software

Long before you have mastered your basic image-manipulation software you are likely to have looked at numerous other types of software as well. These may cost you, but choosing the right one for your type of work, and style of working, may save you a great deal of time and effort – as well as increase your enjoyment. Don't forget: it's not just about money. Perhaps the major part of your investment is the time needed to master all the features to an expert degree.

Download software

You don't have to stick with the software that came bundled with your camera. Some of it lacks features and works less efficiently than a specialized package. However, you will need to hang onto the manufacturer's software if features on the camera can be programmed. But if you simply need to extract and catalogue images to be saved on your computer, software such as FotoStation, and Photo Mechanic are far superior to most camera manufacturer's offerings. For users of the Apple Mac, iPhoto is not only highly automated and easy to use, offering many effects and printing options, but best of all it is a very powerful application for distributing photos through the World Wide Web. Furthermore, it is free and integrates with other Mac applications.

Digital image processing

Digital processing does not stop with photographic images. In fact, image manipulation is the culmination of the extremely packed and short history of research led by satellite surveillance and remote sensing commenced during the Cold War, leading to robotics in industry, automation in astronomy, and military targeting systems, plus the increasing need for the electronic archiving of information – the scanning of documents, for example.

Image databases

You need software to help organize your files: to add notes, move them from folder to folder, and to create on-screen contact sheets. Once you've started gathering more than a few dozen images, software like Portfolio, FotoStation, Photo Mechanic or ACDSee become your second most essential application.

DTP

Desktop publishing (DTP) software has been around since the 1980s, and is much easier to use for the creation of books, magazines, and pamphlets than trying to force wordprocessing packages to do the work. Inexpensive packages include Serif Page Plus, Microsoft Publisher (both PC only), and Apple Pages (Mac only).

Other software

The more you work with your images, the more you will need to protect your investments in time and effort from loss and damage. The first essential is to ensure you make regular and multiple back-up copies of your files: your best images should be saved to at least two different locations in addition to your computer's hard-disk, e.g. another hard-disk plus DVDs. If you cannot trust yourself to back up work regularly, invest in software that will duplicate copies of folders without supervision.

For Windows users, the next precaution is against attack by viruses and worms: ensure your operating system is fully up to date by checking regularly for security updates. Install virus prevention software if necessary. All users should exercise the usual precautions with unknown files: do not download, let

alone open, files attached to emails from unknown correspondents. Users of the Apple Mac OS should not be complacent either, although the numbers of viruses are very few and mostly only irritating, an infection can still cause you wasted time.

A third level of prevention is to ensure that your system is free from errors and faults: regularly employ utilities which check the hard-disk, verify file structure and remove redundant files to ensure the integrity of your data and computer system.

File formats

After the confusion of file formats in the early days of digital photography, there are now really only two

Hints for installing software

Ensure your computer set-up (version of operating system, available RAM, type of processor, and monitor) complies with the minimum system requirements of the software. Note that some software is supplied on a DVD, and requires a DVD player. Ensure that your disable (turn off) any virus prevention software. Read the "Read Me" file for the latest instructions; and follow the instructions. A full version of any package, e.g. from version 10.3.9 to 11, usually installs a full load of software. You may have to remove the old software manually: follow the uninstall instructions carefully as a simple deletion of a folder may cause conflicts. A part version, updating, install, e.g. from 8.0 to 8.3, will update relevant old files but leave others intact. Do not delete any files unless instructed to do so. Some installations require a restart: ensure you have no open windows with unsaved work as these could interfere with a restart.

The best advice for learning about your software is to play and experiment. There are often features that did not make it into the manual, or even the "Read Me" file. Also, be radical and try using tools for purposes that they were not designed for. Here, the *Highlight* dropper tool in Photoshop's *Levels* was chosen and deliberately applied to darker areas. The results are bright, dramatic, and usable, yet they needed no more than four key and mouse-click actions. There are other ways to achieve similar results, but all are far more complicated and less immediately responsive.

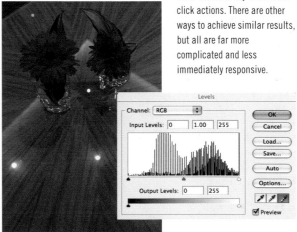

» **FOR MORE ON IMAGE DATABASES SEE PAGES 124–25**

formats that need concern you. If most of your work is for the Web, you are emailing examples of work, or if you are highly productive and need to cram hundreds of pictures into a small space, the format of choice is JPEG. It is universally used by digital cameras, as well as by royalty-free sources. It is an ideal compression system for Web-based photographic images (images seen on-screen).

The other format, prized for its versatility and attendant reliability, is TIFF. It is the cornerstone of the paper-based publishing industry. Use TIFF as the format for any image intended for output on paper, whether through inkjet, laser, or commercial printing.

The second rank of formats includes PNG, PICT, and BMP. These may use simpler coding methods, but offer no other advantages. GIF is vital for Web-based illustrations and animations that have clean lines and solid colours, but its properties are unsuitable for images that have long tonal ranges, wide varieties of colour or subtle tonal transitions – in other words, photographs.

Another format is not normally regarded as an image format, but it is more important than any of the second-rank formats. This is the PDF, or Portable Document Format, which is native to the Adobe Acrobat program. It is important because many publications use PDF files for transfer, so it is a format that is used to output printing plates. In the same family of formats used to transfer images and designs across media is EPS (Encapsulated PostScript).

TIFF

The latest standard for TIFF does not spell out the acronym, perpetuating confusion over whether T stands for "Tag" or "Tagged". Tags are the feature which make TIFF files flexible and versatile. Thanks to them (45 different tags are defined in version 5 of the standard, and private ones can be defined), it can

be adapted by software engineers for a wide variety of uses. Cleverly, if there is a tag which the application does not recognize, it can be safely ignored. TIFF is like a book: the basic structure (pages, chapters) remains the same, while the contents vary.

The format allows an efficient compression method, LZW – Lempel Ziv Welch, which can reduce file sizes by around 50%, given the usual mix of detail and proportions of even tone without any loss of data. This method is said to be "byte-oriented", which is important to know as it means that the data can be efficiently compressed and stored whether it is saved for Mac or PC. However, printing presses usually prefer uncompressed TIFF files.

Raw formats

Raw formats are those produced by a camera with the minimum of image processing applied. Different makes of camera, even different models from the same manufacturer, produce raw files in which the data is ordered in a different way. As a result there are numerous different raw formats. Some cameras comply with Adobe's DNG (Digital NeGative) protocol – the nearest thing to a standard raw format. Raw files have to be converted to formats, such as TIFF, or follow JPEG protocols before the image can be used.

The conversion is quite complicated. As raw files are minimally processed – each pixel is assigned only one channel of colour – that of its own colour filter – we must apply a colour filter interpolation (*see also p.13*) to extract full-colour images. At the same time, the white balance, colour saturation, and contrast must be determined. These steps offer the photographer full control over the final result but the extra time and effort needed for raw processing can be onerous.

Specialist software is needed for raw conversion: all camera manufacturers offer conversion software specific to their own range of raw files but many of these applications are rather poorly written and limited – not only in the range of controls available but also in the lack of professional features such as the abillity to batch-process and save settings for future conversions.

Powerful raw converters to consider include Adobe Camera Raw, Apple Aperture, Adobe Lightroom, Capture One, Bibble, Breezebrower, Sharpraw. One feature shared by all these applications is their high

Save to native

If you expect to open your file in the program that created it and to print it out from the same program, then save to the native format, such as Photoshop or Painter. This opens fastest and it best preserves extras such as layers and paths. Otherwise save to a standard format, such as TIFF.

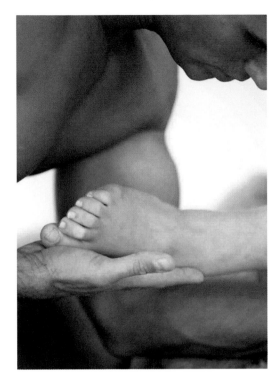

This digital camera image decompresses to 9MB but takes up less than 2MB on disk after JPEG compression. With the smooth tones and lack of fine details, it is tempting to compress the image further. However, you will pay the price in increasingly obvious JPEG artefacts: the image has the appearance of being divided into blocks of similar colours. *Top right*, the artefacts are not obvious, but an increase in contrast, *bottom right*, reveals the JPEG artefacts.

RAM requirement: they need a lot of memory to process the large files characteristic of raw formats.

File compression

In the early days of digital photography it was essential to compress files (reduce the file size) because mass data storage was costly and inefficient. In these days of cheap mass storage, however, the original need for compression is no longer as compelling – at least, until you have decided on your output medium.

This is where the overheads associated with uncompressed work – the time needed to save and open files, plus compatibility issues – come into play. If speed of operation is important, it is worth assessing whether you should routinely compress your image files.

"Lossy" methods of compression discard inessential data, while lossless or "non-lossy" methods do not. Lossy methods are sometimes said to discard redundant data. This is not so: if you can see signs of data loss, the data was not redundant – it was important to image integrity. Lossy compression also goes against the grain of digital copying, where the underlying point is perfect duplication.

The key issue, though, is that lossy compression allows for enormous compression ratios. The ratio

between the original and the compressed file size can reach 50:1, so you would need to accept degraded image quality. If your final output medium is the Web, this may be an acceptable price for rapid downloads.

Remember, of course, that all output processes are essentially lossy: the output is always of lower quality than the information used to create it. All output methods, including print, discard data by clipping beyond a threshold resolution.

JPEG

The JPEG (Joint Photographic Experts Group) standard defines a protocol, a key feature of which is the three-part method of compression. First, data is compressed, and some removed, without loss of quality. Second, data is reordered for quantization. Here variable amounts of the data can be discarded through the choices you make on the quality sliders. Third, coding compresses the results of the last step losslessly. The sum of these effects helps to achieve JPEG's very high compression rates.

In practice, you should check the effect of compression on your image by viewing it at full size, e.g. 100% for images intended for the Internet. Images at any other magnification will be dithered for the screen which distorts accurate assessment.

It is often recommended that you do not save and resave files in JPEG because each save recompresses the JPEG and loses more and more data. If you experiment, you will discover that for mid- to high-quality compression, i.e. middle to low levels of compression, numerous resaves in JPEG make hardly any difference to the image quality. In short, a few resaves in JPEG are not likely to do much visible harm.

JPEG compression levels

For output to print, use quality settings of between seven to nine. You will probably be hard pressed to see any difference between the nine and ten settings, but the difference in file size can be significant. For Web output, quality settings of three to five will be fine; even less if the image has simple outlines and tone gradations.

» FOR FRACTAL COMPRESSION SEE PAGE 99

Understanding digital colour

With a well-known reference or "memory" colour, such as sky, you might think you had to work extremely accurately. But beware that blues are poorly reproduced in the four-colour CMYK printing space. The blue of a Mediterranean sky is also different to that of an equatorial sky (as here, in Sarawak), and so on. In fact, quite a range of blues would be acceptable – provided the neutrals remain achromatic.

Digital colour management works by accepting the differences in the colour output of different devices. It then references the colour output to a standard colour space – in theory, the profile connection space. In practice, we use a working colour space. The best known working colour space is Adobe (1998). A profile for a device defines its colour space according to its difference from the working space.

The fundamental idea at the heart of digital colour is that any colour representation can be simulated by varying the intensity of a small set of colours. In practice, we use three colours for virtual images, such as those seen on a computer monitor, and four or more colours for paper printing. As we have seen, the three-colour system is RGB (red, green, blue), and the four-colour system is CMYK (cyan, magenta, yellow, and black – the "K" stands for "key plate", which carries the black).

This is possible because the entire range of visible colours can be created or simulated by varying the brightness or amount of these carefully chosen sets of colours. In RGB, the colours comprise the additive primaries. CMYK's slightly different range of colours combine to form the entire range of colours printable on paper (with the exception of metallic finishes).

When these standard colours are coded and organized digitally, we call them channels. The data for variations in brightness of red are kept in the red channel, and the same process is applied for data about the blue and green. Together, the composite channels create the full-colour image.

Richness of colour

Universally, the digital world works in 8-bit colour in each of three channels of red, green and blue. Eight bits allows 256 different greyscale steps in each individual channel. If you multiply out all the combinations, the total is about 16.8 million colours. Redundancy is, however, essential for computing purposes. In fact, even 16-odd million colours are often not enough, and we often need to encode to 16 bits per channel – meaning trillions of colours – in order to make up for defects in digitization and to allow enough code to reach into extended dynamic ranges. This is because the need for data bits rises exponentially with the widening in dynamic range.

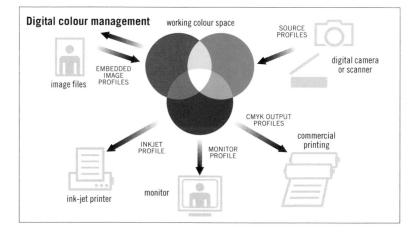

Digital colour management working colour space
SOURCE PROFILES
EMBEDDED IMAGE PROFILES
image files
digital camera or scanner
CMYK OUTPUT PROFILES
commercial printing
INKJET PROFILE
MONITOR PROFILE
ink-jet printer
monitor

If your viewer has no other reference points, colour accuracy can be wildly wrong. Provided, that is, that greys, blacks, and whites – the achromatic colours – are neutral, or properly achromatic. So which of these two images presents the true colours? One was manipulated in Lab space – the b channel was distorted – the other is as captured.

Colour gamut

It is well known that different materials and processes produce different ranges of colours. For example, we see vast differences when we compare the range of colours from crayons with those of oil paints, and then, in turn, with colour transparency film. We say of the limited range of colours possible from coloured crayons that it is a narrow, or restricted, colour gamut. In contrast, the colour gamut from oil paints is extremely large, and so is that of colour transparency film.

But while oil paints can create a tremendously rich palette of dark colours – look closely at any painting by Rembrandt or da Vinci – their range of bright colours is limited: look at how Monet struggles to get sunlight into his work. Conversely, bright colours in colour transparency films are unrivalled by any other colour reproduction system, but they struggle with dark tones. When we consider colour gamuts of two systems, then, we need to consider not only the extent of each, but also where the gamuts do or do not overlap.

In digital photography, the principal problem is that, while colour monitors cover a greater colour gamut than output processes like inkjet, there are colours reproducible by inkjet with cannot be seen on a monitor. And vice versa. The main task of colour management systems, then, is to manage such non-congruences.

Advanced colour calibration

The reason for colour calibration and colour management is that we want to be confident that the colours we see in an original print or slide, the image we capture in a digital camera, and the manipulated masterpieces on the monitor will all print as we see them. And, indeed, that anyone else printing the images will obtain the same end result.

Monitor calibration

Calibration makes the behaviour of something – like your monitor, whether a CRT (cathode ray tube) or LCD (liquid crystal display) type – comply with a standard. You ensure that pure whites on the monitor are indeed white, that a pure red corresponds to a standard red, and so on. There are two phases to calibration. The first is to decide which standards you wish to work to. Then you need to ensure that the monitor meets those standards.

Colour calibration can be achieved using subjective methods that involve comparing colour patches onscreen and making adjustments to match a given target or aim-point. Alternatively, it can be done objectively using instrumentation: this is far more accurate and reliable, but also rather more costly.

Fortunately, for the majority of purposes, precise colour calibration is arguably unnecessary. The reason is that the variables that can upset a colour-

Luminance and chrominance

It is becoming common practice to refer to a channel as carrying either chrominance or luminance data. A chrominance channel carries more image colour than image detail, whereas a luminance channel carries essentially no colour data, but only brightness data – which defines detail. In digital photography, the green channel is effectively the luminance channel, whereas the red and blue channels carry most of the chrominance data stream.

» **FOR SOFT PROOFING SEE PAGE 126**

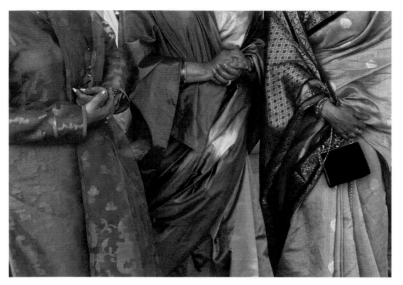

Skin tones are the key test for any colour reproduction system. But even here we need to take care. To make the skin tones in the image above a pale Caucasian pink would be a mistake, as these are Pakistani women. The dresses give a clue, but cannot be relied on in the absence of more information. If you lack necessary clues, the safest course for colour correction is to find a neutral white – e.g. a specular highlight.

managed workflow are usually greater than the errors typical of the semi-subjective calibration methods. These variables include changes in the light-levels in the digital work-room, and variations at the printing-press, over which you will have no control. Even changes in the weather, such as from a cold rainy day to a hot, dry one can visibly affect colour reproduction.

Of the objective methods, there are two approaches. One operates directly on the electron guns of CRT monitors. The other uses a device – usually a colorimeter – which measures the colour content of the monitor's image to adjust the video processor to match the displayed colour to a standard.

Calibration systems that operate at the electron gun level or in a closed loop with the LCD controls, such as those from Barco, are preferable but very costly.

Ideal viewing conditions

It is a good idea to consider the features of ideal viewing conditions, if only to realize how far your own conditions fail to reach them. Walls should be painted white or a mid-tone neutral grey. Curtains should not be coloured, so they block light without filtering it. Ambient light levels in the room should be constant throughout the day, and preferably only bright enough to find your way around the room. The monitor should be hooded against local lights such as desk-lamps. Away from the monitor, prints should be viewed in standard daylight-viewing booths and transparencies viewed on standard light-boxes.

The most popular, and entirely adequate, solution is to use an external colorimeter which controls colour through video software-based adjustments.

How to calibrate and characterize your system

If you have any experience in digital photography, you should already be working on a calibrated monitor in a colour-managed system. Monitor calibration is not the problem it used to be: out of the box, most monitors are now factory-calibrated to be nearly as good as they will ever be. Nonetheless, heavy CRT monitors can be stressed during transport and are affected by local magnetic fields (from loudspeakers, power supply units, etc.), so calibrate them once in place.

Setup

Software-based monitor calibration such as that in Adobe Gamma (installed with Photoshop in Windows XP) and in the Displays panel in System Preferences of Mac OS are capable of adequately accurate results. But because they are based on visual judgements, they do not give the most consistent results. The important preparation for using them is to ensure your monitor is well warmed up (for at least 30 minutes). Also keep unshielded electrical equipment well clear. Conduct the calibration in normal viewing conditions. It is best that all important colour work is done at night, unless you work in a room without windows (which is not recommended for your sanity). Whatever you do, do not carry out vital tonal or colour-correction work at varying ambient light levels.

Adjustment

Follow the onscreen instructions. When asked to choose the gamma, select 1.8 (actually it is about 1.7) to produce a bright image. The other choice is 2.2 – giving a darker image – which looks attractive because colours appear richer. This high gamma is used on Windows computer monitors and domestic TV sets. Choose it only if your images are intended for viewing on the Web. (Remember: most people have Windows PCs.)

Choose the white point (*see box opposite*) depending on the nature of your work. Now an image on your monitor should be roughly in line with the same image viewed on others, irrespective of make, resolution and type – calibrated to the same settings.

Note that the choice of white point for the monitor is different from the white point calibration of a

White point selection

D50 **5000 K warm white: pre-press and graphic arts standard; paper viewed under domestic light. For output to mass-production printing and most inkjet papers.**

D65 **6500 K average white: bright white paper viewed under tungsten light; midday mid-latitude sunlight. For output to bright white inkjet papers. Compromise between warm white and cool white. A good all-round choice.**

D93 **9300 K coolest indoor lighting; cloudless mid-latitude midday; good for office work. For output to domestic TV sets and the majority of Web users.**

Colour preferences dialogue boxes are daunting to behold: see Photoshop, *above*, and PhotoRetouch Pro, *above right*. The key settings are the *RGB Working Space*. Choose *Adobe* RGB (1998) unless you have another. Avoid *sRGB* unless you work exclusively for the Web.

For your CMYK space, select one suitable for your printer (desktop or commercial). Choose *Perceptual* for the rendering intent. Finally, for profile mismatches, tell the software to consult you every time. For most work you can leave the other settings at their default.

camera. Once set, the monitor calibration is fixed. The camera's white point calibration, on the other hand, is adaptive. It attempts to produce a colour balance that is correct for the ambient conditions, aimed at delivering neutral whites and mid-tone greys.

Modern colorimeters for calibrating screens give the best results and are relatively inexpensive if shared between friends (provided the licence allows for multiple installations). You should recalibrate each time you change any settings such as resolution or white point, after moving the monitor, and at least once every month or two if you are producing critical work.

Other types of colour settings go deeply into colour management.

Measuring and characterizing colour

There are two fundamentally differing ways of describing colour. Measuring it, we use the wavelength or frequency of light (they are equivalent). But to capture and actually use colour, we have to characterize it as quantities of closed sets of primary colours.

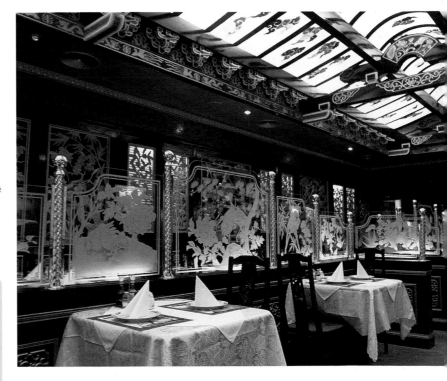

Where light originates from many sources it is not only impossible to correct the white balance for all of them, it is likely to destroy the richness of the visual experience. In this Chinese restaurant in Budapest, Hungary, fluorescent lights show green on the glass partitions, tungsten light shows orange on the tablecloths, and daylight tints the skylights blue.

» FOR MORE ON COLOUR MANAGEMENT SEE PAGE 30

How scanners work

The pallid, weak look of this image is typical of a poor scan. The shadows are full of vague detail, while highlights, such as on the face of the sleeping child, are flat. The high density of the shadow areas conceals a good deal of information, but only scanners with a high D-max rating – of four or better – would be capable of extracting such low-contrast detail. There is little point trying to improve the image as there is not enough data to work with: scan again (with a better scanner if possible), or attempt a multi-pass scan.

As the portal through which the analogue image enters the digital domain, scanning determines the subsequent quality of digital image manipulation and output. Errors made at the scanning stage are guaranteed to be a source of problems later. While scanning is essentially the retrieval of information from an analogue original (such as a print or transparency), followed by a translation into digital code, the detail of the process is not straightforward.

How that information is retrieved depends on the characteristics of the original. Scanners are mechanically set up to work in different modes with reflection originals (prints or printed material) and with transmission originals (photographic film or transparencies). Note that a flat-bed scanner will not be able to scan in transmission mode if it lacks a light-source facing the sensor, in other words, on the other side of a transparency original.

In addition, most scanners need to be told whether the originals are negative or positive. You can, of course, simply invert the scanned result if the setting is incorrect, but image quality may be inferior to using the correct setting. The additional step is also unnecessary extra work.

In addition, the scanner needs to be told whether a colour original is negative or positive. In this case, it is very important to make the correct setting: a normal colour negative is scanned using built-in corrections for the orange/pink mask. You may also need to set for a family of films, e.g. Fujicolor or Vericolor, but some scanners offer corrections for these. One exception to this is if your film has been cross-processed to negative: it is better to scan it as a positive, then invert it.

The quantity and quality of the information depends on the use and destination of the digital file – this is where parameters such as resolution and colour space are decided. The design of some scanner software makes changing settings an inconvenient chore, while in others it is plain sailing. With well-known scanners, it may be possible to replace the manufacturer's software with more sophisticated alternatives, such as Silverfast or VueScan.

Software

Most scanner software will, in addition to offering the usual colour and tone controls, also provide a filter for sharpening the image. This may be superior to that offered in your image manipulation software. But the pre-scan image is of too low a quality and resolution to assess the best setting for the image.

The way the scanned input is coded by the software depends on its intended use. Coding into normal 24-bit colour means smaller files and faster processing. Saving to 48-bit, if your scanner and software allow it, doubles the file size and will mean slower processing, but it will give you superior quality reserves.

One feature to beware of: some scanners save to their own format, so double-clicking on the file opens

Data compression in film

It is well known that film has a smaller tonal range than the scenes it normally records. We can say, therefore, that the data from the scene has been compressed. It is, if you like, lossy compression (*see p. 19*). All film compresses, and none more so than colour negative. If you look at any colour negative film, what is striking is how few hues can be distinguished – yet colour prints show a full colour range, thanks to, effectively, a process of analogue decompression. It is data compression that causes the main difficulties in scanning colour negatives.

» FOR CROSS-PROCESSING SEE PAGES 107–108

Getting closer

Modern sensor designs such as CIS (Contact Image Sensor) or LIDE (LED Indirect Exposure) bring the sensors so close that they are almost touching the scanned object. Both combine high-tech lighting methods with light-emitting diodes. One benefit is that the scanner can be very compact. And as the LEDs are energy-efficient, these scanners can be powered from the data cable – USB or Firewire.

the scanner application rather than something useful like Photoshop. To avoid frustration, ensure that you choose *Photoshop* as the file type when you *Save As*.

Optical features

The crucial elements in a scanner are the optics. In the majority of flat-bed designs, the light-path from the illuminating source to the sensor is highly elaborate, reflected in six or more mirrors before entering a lens assembly. That means a total of ten or more air/glass surfaces. The reason for the design is to minimize losses from veiling flare, but the result is to cause reflective losses. This is why flat-bed scanners usually fail to penetrate dense material, such as the blacks of transparency film.

In contrast, film-scanners use a much more direct light-path – in part explaining their better ability to penetrate high-density material (their superior D-max rating).

Another factor to beware of is that flat-bed scanners may not capture the entire image evenly. A good test is to scan a plain sheet of paper covering the platten area. Many scanners produce a scan with uneven brightness. Furthermore, if the sensor is not the full width of the scan area, the edge details must be scanned at a slight angle to the sensor. This may reduce resolution at the extremes of the scanned area.

Choosing scanners

There is no universally ideal scanner, any more than there is a universal camera. Some monster flat-bed scanners can produce top-quality scans of anything scannable, but they cost monster amounts of money.

However, even budget-friendly flat-beds can produce reproduction-quality scans from average-sized prints. The film-based photographer can now consider purchasing a relatively inexpensive film-scanner, as modern models can deliver very good results. Let us look at the features you should consider.

Film scanners

If you suspect you may use medium-format film in the future, purchase a medium-format scanner now. They cost more than 35mm scanners, but are made to much higher standards and can last your entire career. For medium format, scan resolutions of around 3000 ppi (pixels per inch) are ample, but aim for a D-max of at least 3.8. For 35mm format, scan resolutions should reach 4000 ppi.

Flat-bed scanners

You can use flat-bed scanners to make a quick reference scan of a whole sheet of slides or negatives – just like a contact sheet, only paperless. Photographic prints can be scanned almost without reserve on any modern scanner, even those costing less than ten rolls of colour print film. As the light is

The best way to scan negatives, particularly in colour, may be first to make a print at around A4 in size and then scan it on a flat-bed scanner. With a print in hand, you are assured of the image colour, exposure and contrast. But, better, the print may hold more image detail than even a high-resolution scan. Shadow detail in a well-made print is likely to be superior to that obtainable from a scanner.

quite tightly focused, make sure you clean off dust very carefully or it too will be scanned in unforgiving sharpness and detail. While the depth of field is limited, it is usually sufficient to hide the slight crinkles of prints. Nonetheless, best results come from perfectly flat originals. Take care also that glossy originals do not cause Newton's Rings effects (bands of pale colour).

Note that you may obtain better results by first printing a negative in the darkroom, then scanning it, than by scanning the negative itself. This is particularly true if the negative is very unexposed (thin) or overdeveloped (thick), or if you do not possess an excellent film-scanner.

Scanner features

When deciding on a scanner, you may be confronted with a great many facts and figures. All are important, but none more so than the apparently obscure titbit that later turns out to be crucial to the way you work. Consider the following:

Film length

It is obvious your scanner should accept the film formats you use. What is not so obvious is what you have to do to get the film into the scanner. Some insist that you cut your filmstrips up into very short sections before they will fit. For example, if normally you have three 6x6cm shots on a length of film, you may have to cut the strip to two shots to fit. This is maddening if you will also want to print the same strip in the darkroom, so check this detail carefully before you purchase.

Interpolated resolution

The maximum input resolution of a scanner is obviously a selling point. Formerly, some advertising promised fabulous figures such as 4800 ppi for relatively entry-level machines – but these were interpolated figures, and not the true optical resolution. Thankfully, this practice has receded into the past, but there remains another to beware of. The maximum resolution quoted may be limited to a small area or smaller formats. For example, a scanner promising 3048 ppi will cover only a narrow strip in the centre of its A4 scan area; the maximum resolution for the full area may be just 2000 ppi. This in itself presents no problem as larger formats do not need such high resolutions.

Maximum density and dynamic range

These may be confused – and by manufacturers' data too. Maximum density measures the deepest black through which a scanner can usefully extract information. It is usually in the range of 3.6–4.1 density units.

The dynamic range measures the span from lightness to darkness that a scanner can distinguish. It is equal to the maximum density less the minimum density that can be read – between 0.2–0.6 . If the

A colour transparency with a limited range of tones – ranging from lit areas with details to open shadows with lots of light – is ideal for scanning. There are no extremes of brightness or black and the colours are all muted. Even a flat-bed scanner should be able to extract a good scan from such an original.

Drum scanners

These offer almost mythic qualities of performance in the eyes of digital photographers – perhaps because their purchase price puts them in the category of the unattainable. While a drum scanner can produce irreproachable image quality, they are fickle, delicate, may consume costly materials, and they need great skill to operate. They also do an excellent job of capturing every speck of dust and microfibre. The Imacon Flextight range of scanners are presented as "virtual" drum scanners in that the originals are stretched over a partial drum and scanned by a linear CCD. This configuration gives the best results for any CCD-based scanner but remains inferior to true drum scans.

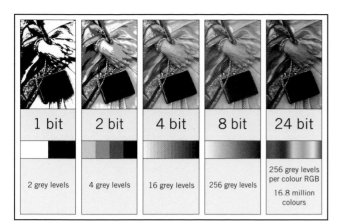

1 bit	2 bit	4 bit	8 bit	24 bit
2 grey levels	4 grey levels	16 grey levels	256 grey levels	256 grey levels per colour RGB 16.8 million colours

Bit-depth and colour resolution

One-bit, or bi-level, coding captures only black and white. It may appear limiting, but it is the perfect coding for scans of line art, which are in any case only black and white. The diagrams above clearly show that you need eight bits, producing 256 grey levels, before a graduated tone of black to white appears as a continuous scale to the eye. So images with a bit-depth lower than eight appear banded or posterized. When eight bits are assigned to each of red, green, and blue channels, each 256 grey channel offers multiple possibilities – a total of over 16 million. Note that although CMYK has four channels, and can therefore code for more colours, it does not necessarily mean that more colours can be reproduced.

Maximum necessary resolution

The highest resolution widely available for 35mm-format film is 4000 ppi. This is more than sufficient for top-quality prints to 16x24", or even larger. While machines are available to scan to 8000 ppi resolution or greater, that is hardly worthwhile for 35mm film. One reason is that the improvement in MTF (modulation transfer function) is under 5% – that is, nearly invisible. Besides, to take advantage of it you must have perfect picture-making conditions, i.e. the highest quality lens perfectly focused at optimum aperture, and the camera on a tripod with no movement in either camera or subject. Very few optics can resolve better than 3500 lines over the 35mm format.

minimum recordable density is 0.3 and the maximum density is 3.8, the dynamic range is 3.8–0.3 equals 3.5. Ideally we look for scanners promising both high maximum density – at least 4 – and large dynamic range – at least 3.7 density units.

48-bit space

A surprising number of modern scanners will scan into 16 bits per channel i.e. 48-bit space (some into 36-bit space or 12 bits per channel). Some scanners claim to work in 48-bit but only produce files in 24-bit. If you have a choice, retain the scan in 48-bit. This is, despite the overheads in terms of much longer scan times and larger files, well worth doing for colour transparency materials.

Multiscanning

Scanners may offer multiple or multi-scan capabilities, also known as signal averaging. This means that the final scan is made by averaging the results of two, four or more scans by superimposing successive scans on one another. The averaging of multiple scans helps to remove noise and smooth out other artefacts such as scanner jitter (uneven scan lines). However, scanning times are greatly increased.

Dust-removal features

A number of scanners are able to remove dust and scratch defects from film. The detection principle is based on differences in the response of dust and image on the film to light.

The most widely used method is based on infrared light, which is scattered by dust, but not by the dye-clouds of film. The dust is detected as part of the scanning process, creating what is effectively a map of all the specks. This "map" shows where surrounding details need to be repeated to fill in the dust specks. In other words, this automatically does what you would do yourself when using the *Clone* or *Healing Brush* tools to remove defects manually.

Bit-depth

Bit-depth is a measure of the way in which different colours can be given a code or name. Increasing bit-depth is like increasing the number of digits in a phone-number: the more you have, the more different phone users you can accommodate. However, as the range of colours rises as a cube of the bit-depth, a small change leads to an enormous increase.

» FOR MORE ON SCANNING SEE PAGES 42–46

How printers work

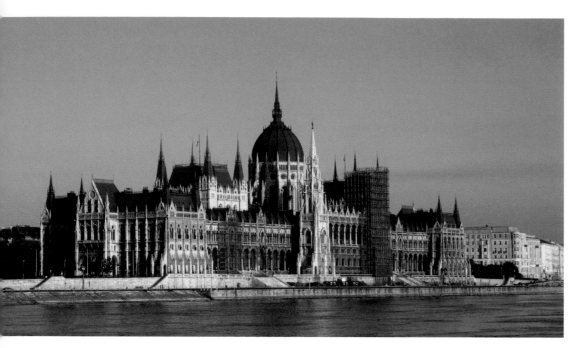

A subject displaying a combination of smooth tonal gradations with fine, sharp detail – such as this view of the Hungarian parliament building on the River Danube – presents a challenge for the inkjet printer. Error diffusion or random dithering helps to smooth the tones out without the need to work at very high resolution, but the dithering lowers sharpness, so the resolution of fine detail is impaired, causing softness where you want sharpness.

The truly revolutionary nature of modern printer technology is seldom appreciated. The process of building up letters using an array or raster of fine dots is utterly counter-intuitive – it is just about the most difficult way to write text. Equally, it is not obvious why one should go through the trouble of splitting an image into millions of tiny dots when we have a perfectly excellent, thoroughly tested method of making prints. But then, that is what they thought of Gutenburg: why carve out and set all those bits of metal when all we have to do is pick up a quill?

Inkjet compared to darkroom prints

For prints of around A3 size, inkjet prints made from a high-resolution scan (3200 to 4800 ppi) of a 35mm original can be sharper than any darkroom print of that original when viewed from a normal distance. However, close examination will show that inkjet prints are made up of tiny dots, so the velvety smoothness of a gelatin-silver print is still not quite matched. Nonetheless, an inkjet print can look significantly sharper, i.e. appear to resolve far more detail, if a little sharpening is first applied to the scan.

Control

Gutenburg's method of working was to make a descriptive representation: the letter-press type he created is, we now say, an analogue model of his subject – the Bible. In contrast, modern technology tries to reduce everything down to its simplest elements. Instead of 80 different bits of metal for each upper and lower case letter, numerals, and other symbols – we replace it with one nozzle spraying ink. Instead of hundreds of pots of differently coloured inks, we work with four pots. Modern printing is, therefore, a triumph of the reductionist project.

Curiously, while the digitally-based raster is the basis for the printing of images, modern technology has had to learn that to deliver subtlety, the most economical method is to imitate the untidiness and slight irregularity of chemical processes. In other words, to behave as if it is an analogue system.

It follows that digital prints are wholly dependent on two things over which the digital photographer has little direct control. First is the way in which the the inks themselves are formulated: we are using only six to eight inks to simulate thousands. You can purchase specialist formulations – such as from Lyson and

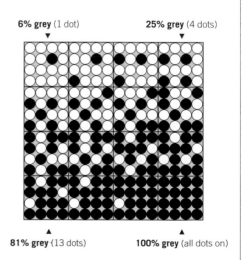

If you attempt to enrich the colours of an image which is deficient in data (*far left*), the result can be banding or posterization as the increase in saturation can be sustained in some pixels but not others (*left*). You can try altering the printer settings (*above*). This causes the printer to reinterpret the data to give more brilliant results — with fewer banding artefacts.

Piezography – which improve on manufacturer's inks (cheap inks can reduce output quality).

Second, there is the software that turns image data into a series of commands telling the printer where and when to squirt ink, and how much. After all this technology, it is disappointing that the accuracy of colour reproduction is still a long way from assured. The system is what engineers call "tight" – it takes very little to go wrong: any one of 72 ink nozzles could be blocked, one ink might be too dark, and the entire operation would be compromised.

In short, there are precious few parts of the process that we can control – and nearly all of these are indirect, because we have to make a setting then print it out before we can make any judgements.

Half-tone cells

The fundamental principle underlying digital printing is the half-tone cell. This is a grouping of points in space that a printer can address. Each point can be filled with ink or not, and in a variety of ways to simulate a greyscale ramp from white to black.

We start with the assumption that at any printer-addressable point (a place where ink can be placed), the choice is limited to either placing a dot of ink, or not. From this comes the notion of the half-tone. If we apply no ink, we have a white assemblage. Each extra point filled with ink is another greyscale

step towards black. If we fill every point with ink, we obtain a black assemblage.

The number of greyscale steps equals the number of points in the half-tone cell, plus one for white. From a normal distance, these small dots merge to appear as a shade of grey. For smooth-looking transitions, we need in excess of 100 steps, therefore each half-tone cell must measure around 10x10 dpi. Better is a half-tone cell of 14x14, giving nearly 200 greyscale steps. Note that the cell is filled in a

Half-tones explained

Suppose we have a half-tone cell of 4x4 dots. We have 16 dots to work with: this gives us 17 grey levels. One dot is 6% grey, two is 12% and so on. Note that adjacent cells with the same number of dots, i.e. of the same grey level should fill in different parts of the half-tone cell in a random pattern. If not, a large area of the same density will develop a pattern which is very destructive of image detail. The process of controlling the random placement of dots is part of the technique of dithering, which also enables a wide range of colours to be reproduced by a few hues.

6% grey (1 dot) 25% grey (4 dots)

81% grey (13 dots) 100% grey (all dots on)

» FOR MORE ON COLOUR GAMUTS SEE PAGE 31

process known as dithering. Differing proportions of three or four colours are mixed so that, from a distance, the basic colours blend and appear to be another colour. The technique was known to Roman artisans, who used dithering in that ancient precursor of the digital image, the mosaic.

Dithering, like the filling pattern in half-tone cells, has to be irregular or else unsightly patterns will result. This is a difficult technology, with many features hidden behind proprietary engineering. Curiously, what must be simulated is the random way in which silver-based film reproduces tones and colours – without that randomness, extremely high device resolutions are needed for satisfactory output quality. For photographic purposes, choose dithering patterns called "error diffusion", or "random", and avoid regular dithering patterns.

Colour gamut

The extent or range of colours that can be reproduced by any device or system is known as the colour gamut. The widest range belongs to top-grade colour transparency film: yellows in particular have a depth and brilliance that nothing else can touch. Next comes the gamut of colour monitors, and, perhaps surprisingly, a long way behind is paper-based printing.

If different gamuts differed only in extent, we would have few problems. But gamuts also differ in shape. This is because monitor colours are synthesized by three colours, whereas four colours are used in mass printing. Specifically, some violets and blues and greens are reproducible in a colour monitor, but cannot be produced by printers. Conversely, certain cyans, greens, and dark reds are printable, but not reproducible on-screen.

This lack of congruence makes it necessary to decide how to map colours which fall outside a gamut into the output space.

Colour gamut can only be increased by using more inks: printers with seven inks show a greatly improved gamut over printers struggling with four inks. Similarly, mass-printing processes using six inks – HiFi Color or Hexachrome – produce brilliant results.

RGB working space

This establishes the colour space that the image manipulation software operates in. It is defined

If the colour transparency of this scene in the Aegean lacks the brilliance and richness of the visual experience, the printed reproduction leaves the original colour vibrancy even further behind. We can partially compensate for the losses by using glossy paper, increasing the mid-tone gamma or contrast, as well as saturation. Even improved sharpness helps.

random manner: if not, cells with equal populations of dots will form up in patterns.

A printer, then, with a device resolution of 2400 dpi must devote most of its resources to creating half-tone cells. With 10x10 dpi cells, the output resolution drops to the equivalent about 240 lpi (lines per inch); with 14x14 dpi cells the resolution drops to a mere 170 lpi.

The crucial result, which has the force of mathematical law, is that the more "greyscale steps" you reproduce from a given device, the lower the output resolution can be. Conversely, if you want high-detail resolution, you must sacrifice greyscale definition.

As greyscale variation is simulated or represented by differing numbers or populations of dots, we call this a frequency modulation (FM) method of greyscale reproduction.

In contrast, mass-printing processes rely on varying the size of dots in fixed arrays: so greyscale reproduction in this case is amplitude (strength) modulation (AM). In fact, modern inkjet printers employ a mix of FM and AM.

Dithering

Greyscale simulation with half-tone cells is only half the story. We have to use a handful of colours to simulate the appearance of thousands: this requires a

Gamuts compared

The larger, rounded triangles (*left*) enclose all colours visible to most human eyes. This is the CIE Lab colour space. Right at the centre is white. The diagram on the right shows the extent of the RGB gamut: it ranges deep into violets but is limited in greens and dark reds. Overall, its area is greater than that of the CMYK gamut (*far right*). However, CMYK can reproduce some greens, yellow-oranges, and blues that RGB cannot. Thus, although RGB covers a larger gamut, it does not fully enclose CMYK colours. This creates the problem of how to print colours which fall outside one space or another. This is solved by deciding on the appropriate rendering intent. In photography, we usually choose *Perceptual*.

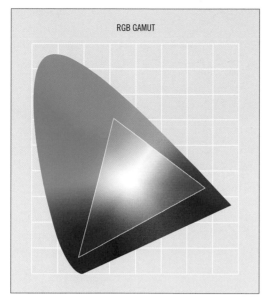

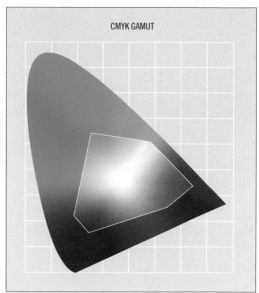

without reference to any particular device, and so may be thought of as a device-independent space.

Set the largest available space to work in so that your operations are not hampered. On the principle that information in excess of device requirements is largely ignored, output processes will limit colour gamut anyway. A good choice is Adobe RGB (1998): this is wide enough to enclose almost all of the CMYK space. An even larger space is Kodak ProPhoto RGB, which is designed to take in the colours of wide-gamut colour transparency film. ProPhoto RGB is best reserved for top-class work at high bit-depth for output to film writers or six-colour (Hexachrome) presses.

Monitor RGB

The profiles that you create for your monitor during calibration can be set as the working space. But this severely limits gamut. Use this as the working space only if you are working entirely for the Web.

CMYK working space

In contrast to the RGB working space, CMYK makes sense only with reference to the specific output or processes that you have in mind, that is, whether you are supplying to an offset lithography press or to your desktop printer. In the first instance, consult the printer you are supplying to for their recommended CMYK profile. Failing a specific recommendation, use a generic profile for your region, e.g. Europe ISO Coated FOGRAF27, or US Web Coated (SWOP) v2, or Offset Print – Toyo Catalog. Given the unpredictable variations caused by printing stock and tracking (the contamination or cross-talk of colours from one part of the printing plate to another) these profiles are adequate for most tasks.

Having set a CMYK space, it is important to make use of it to "soft-proof" your images, to check that the image will reproduce with the important colours intact. With the image open, choose *View* > *Proof Colors* (in Photoshop): this converts the monitor image using the output profile to simulate the appearance of the printed image.

Rendering intent

The business of matching a printable colour to a colour in the image which cannot be printed is controlled by the rendering intent. In photography, we usually choose *Perceptual*, in which visual

Working colour space

Modern printers use as many as seven different inks, and the coloured ones are variants of the subtractive primaries – cyan, magenta, or yellow. But that does not mean that the printer drivers work in CMYK – some do and some do not. Unless you have been specifically instructed, it is best to send RGB files to a printer – any printer. Sending CMYK files may unnecessarily limit the colour gamut available to the printer and produce dull prints.

» **FOR MORE ON OUTPUTTING YOUR IMAGES SEE PAGES 126–31**

The image on the right is of a scan of a transparency film version of a standard colour target. The gamut warning is turned on so that out-of-gamut colours are shown white. The image looks like a disaster. But a printed image may, in fact, appear nearly identical to your scan: the majority of out-of-gamut colours are close neighbours of in-gamut colours.

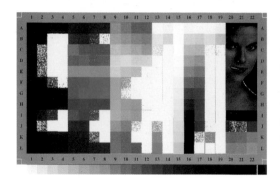

relationships between colours are preserved as far as possible. This is possible as exact colour matches are seldom essential in photography. *Relative Colorimetric* is also suitable for photography, but is best used where both destination and source gamuts are already well matched. *Absolute Colorimetric* is not recommended unless you have specific colour matching needs, while *Saturation* may create more intense colours with less attention paid to colour matching.

Black point compensation

Varying the black point from one device to another (as a result of changing profiles) affects the tonal range that can be output. Technically, when turned on, this feature alters the colour space to ensure that when the pure black of one is mapped to that of another space, the tonal range is not reduced. Generally, then, it is best to keep black point compensation turned on.

Colour-managed work

Ensure your digital camera is set to use Adobe RGB (1998) in preference to sRGB. If you receive images from different sources, decide on a consistent policy regarding profiles which do not match your own preferred set. The easiest method is to convert

automatically all mismatched profiles to your profiles (the preferences set in the Color Settings). However, for critical work it is best to set the system to ask you for permission to convert in order to warn you of potential colour problems. While working on images, check that increases in saturation do not exceed the gamut: do this by invoking the gamut warning display or by soft-proofing.

Professional software such as Photoshop, Photo-Paint and PhotoRetouch Pro have made colour management easier than ever before. You make settings at a centralized *Preferences* panel. However, there is more to colour management than simply attaching colour profiles to images and calibrating everything in your system.

Given the wide range of factors that influence the accuracy of colour reproduction, it is optimistic to think that all problems will be solved just by making the right settings in the colour settings of your software. The following is a checklist of points to consider when working on output problems. (*See also pp. 126–31.*)

Mass or desktop printing?

The method of printing may affect the white point you choose: D50 for mass printing, and either D50 or D65 for desktop printing. D65 may be best with bright white glossy papers. Action: try different white points to check for best results.

Complexity of image

Highly complex images with vector graphics from graphics software may strain the capacity of the raster image processing, leading to errors. Give the system more RAM or simplify the image, by turning it into a bitmapped image with no vector graphics, flattening images which are in layers, or simplifying components such as paths.

Changes in ink or paper

Different paper types from even the same manufacturer cannot be relied on to reproduce colour in the same way. Changes of paper as well as changes in ink supplies affect colour accuracy. Even changes in weather can affect colour as paper dries out, or humidity soaks in.

Digital camera colour profile

As a source of digital files your camera should also provide its own colour profile. Check your instruction book to see.

Don't fear JPEG

Even at their best, glossiest and whitest, ink-jet paper cannot hold more than about 200 lpi of detail. And that assumes desktop printers can construct 200 half-tone cells per inch – which few can. In short, you may set very high levels of JPEG compression with impunity when outputting to inkjet because the artefacts are likely to be lost. If your priorities are small file sizes, ensure that you have the requisite number of pixels for the output, then compress it as much as you can.

MASTERING HARDWARE

Know your digital camera

The focal length multiplier in digital SLRs is an advantage for many subjects, including natural history. In close-ups the multiplier has the effect of opening up your working distance so it is easier to approach nervy subjects like butterflies.

The similarity between a digital camera and film-based cameras is deceptive. Under their skins beat different hearts, driving different muscles. On the one hand, you no longer have to think about whether film is correctly loaded, but you do have to ensure that any of a dozen digital settings are correctly made. You might not have to worry about having sufficient film, but your nerves will be tested over whether there's sufficient battery power.

Digital camera technique

As they look very similar and have similar basic functions, the techniques for using digital cameras appear largely the same as for film-based cameras. But the differences, while small, can be important to the advanced digital photographer. Failure to be aware of them can really impede success.

Image character

One of the most interesting differences between film and digital is that the rate at which a digital camera can capture and process images depends on the characteristics of the image. This is because the overhead in processing and compressing varies with the complexity of each image. If it is full of even tones and large blocks of identical colour, and shot at low ISO equivalent ratings it has low noise, and so it is easy to process and compress. The file will zip through the camera quickly. By contrast, subjects

with a great deal of detail and images which are very noisy, such as those taken at high equivalent ISO speeds, can take much longer to process. Heavily compressed images need longer to process as well.

Response times

Early digital cameras were slow, slow, slow: slow at being woken up, slow at taking the picture on pressing the shutter, and slow at writing the image data to storage. Modern digital cameras have improved on all aspects of speed: many of those with higher specifications and prices will start up nearly instantly, capture the image with imperceptible delay on the shutter press, and capture several images per second. Speed of operation may be slowed down by setting high ISO sensitivities, by recording the largest files, e.g. raw format, and if components, such as the memory card, are slow in operation. Nonetheless, at the time of writing the best digital cameras still lag behind the ten frames per second of top-end film-using SLR cameras.

Of these, the most significant is the "burst" capacity: the number of shots that can be taken in succession. On film-based cameras, burst capacity is limited only by the number of shots on a roll. On digital cameras it is severely limited – typically to four to seven images at best – except on the costliest professional models.

Related to burst rate is the recovery (or cycle) time: the time you have to wait after taking a burst before you can take more. Some cameras offer good burst capacities, but at the cost of causing a long wait – thirty seconds or longer – before you can shoot again.

Improving battery life

Battery life in many digital cameras is measured in hours, or dozens of images. Keeping an eye on battery life is a fact of life for the digital photographer. Worse, battery life drops dramatically when flash is used and if the LCD monitor is left on all the time. Turn off the LCD preview after each shot is taken unless you need to check the image. Some models, such as those from Sony, display the time remaining but even this is little better than a weather forecast – an educated guess.

It is well known that Li-ion (Lithium-ion) and NiMH (Nickel Metal Hydride) batteries do not suffer from the

progressive drop in capacity that afflicts NiCd cells. Less well known is that fact that Li-ion and NiMH batteries perform best if they are conditioned from new with two or three cycles of full charge and full exhaustion before you use them normally. So, when you first use a Li-ion or NiMH, charge it fully (follow the timings given by the instructions, e.g. two hours), then remove the battery for a few seconds and reinsert it for another two hours to be sure. Then use it – and do not recharge it – until it is completely flat. Repeat another once or twice. Each time, the working capacity should improve noticeably.

Raw format

Where a digital camera has to do minimum processing on the image – i.e. to produce raw format (*see p. 18*), you might expect it to work more rapidly. However, because the file is much larger than the same image in JPEG, cameras set to raw may in fact work more slowly as the size of the data pipe limits the speed of operation.

Nonetheless, capturing images in raw format is popular amongst advanced digital photographers as the resulting files offer the greatest scope for image adjustment with the least image degradation. Raw conversion allows you to set white balance, colour saturation, gamma (contrast), and sharpness, and exposure can be also varied: the results of the raw conversion resaved in TIFF or JPEG, while the original raw file remains untouched. At the same time, if raw files are compressed, they are compressed losslessly, so there are no artefacts such as those caused by JPEG compression.

An important advantage of digital cameras is that they can operate almost silently. They suit quiet, candid work. Here, despite being inches from them, the cuddling couple were completely unaware of the many shots taken while awaiting a train in Hungary.

Digital cameras are revolutionizing photography, even in traditional areas where analogue photography is problematic. One such is the theatre. With wide-ranging adjustment of white balance and sensitivity (to compensate for coloured lights and low levels of lighting), plus near-silent operation, digital cameras seem almost designed for the theatre.

However, by working in raw format, you are substituting work later on for the image processing not done in-camera, immediately after capture, and just prior to the image being written to storage. This can add considerably to the workload at the end of each shooting day: not only do files have to be backed-up, they also have to be processed. With cameras producing files in the order of 48MB, raw processing a day's shoot can take many hours and requires the use of a powerful computer.

Some cameras can save a small JPEG file within the raw file: this is handy for sorting images and software which cannot extract a thumbnail image from the main file, although it does add to the total size of the file.

Download utilities

The download and image-handling utilities provided by the camera manufacturer may not be the best. Indeed, some are not worth the disk space they occupy, while others, such as Kodak's, are swift and powerful, with useful batch-editing capabilities. Other users may wish to consider Photo Mechanic Pro, which works quickly and simply. Alternatively, there is FotoStation which offers a richer set of features.

It is a nuisance when the image files are set to open a useless camera utility. FotoStation can change the file originator so that when double-clicked the file opens Photoshop, for example, rather than the download utility. Image-management utilities can also do useful things like changing all the file names, organizing caption data easily.

Digital camera colour profile

A colour profile for an input device such as a digital camera defines the differences between the colour space within which images are produced by the

» FOR MORE ON SOFTWARE SEE PAGES 16–19

ICC

The International Colour Consortium is a group of industry leaders – including software as well as hardware developers – which defines international standards aimed at improving the quality and reliability of colour reproduction.

camera and the nominal, larger, profile connection space – which in practice equates to the colours visible to the human eye. In theory, for advanced work, it smooths out your work flow if images from a camera embed the camera's profile: it should remove all necessity to make colour and tonal corrections to the image.

The process is to capture a standard target such as the Macbeth Color Checker or IT8.7 series under standard lighting conditions. This target is then analysed by software such as PictoColor inCamera, Binuscan Photoretouch-Pro, or Monaco EZColor which compares the colours in the captured image with the standard colours to create a profile. This profile will note, in effect, that the captured image was a little too red in the yellow patch of the target, accurate in the blue, but too blue in the green patch … and so on. The resulting profile can then be attached to any image produced by the camera, minimizing post-production colour adjustments.

Even the slightest view of the sun past the arch of a citadel in Hungary causes lens flare and internal reflections. The effects have been aggravated by using a wide-angle lens attachment, as that offers several more air/glass interfaces for reflections.

A fly in the ointment, however, is in the stipulation that the standard target be photographed under standard lighting conditions. If you shoot under different lighting conditions, then the profile you need will be different. At worse, you will have to work with a profile for each lighting condition, but even if you did produce profiles for, say, a sunny day, partially cloudy days, and so on, you then have the problem of selecting which profile to use on, say, a day with very high cloud cover. In short, the use of camera input colour profiles is limited to those who work in highly controlled circumstances such as studios using near-identical lighting set-ups for catalogue photography.

White point calibration

A great, revolutionary strength of digital cameras is their ability to change colour balance on the run. You can step from a scene lit by an Aegean blue sky into a dark church lit by candles, then move into a gallery lit by fluorescent lights – every picture you take on the way will be correctly colour-balanced. No longer do you have to worry about whites being too blue in the open, too red under household lamps, or too green under fluorescent tubes. Modern cameras carry out the adaptation so fluently, it is like viewing the world through your own eyes – it is amazing.

Digital cameras achieve white point balance by analyzing the chrominance channels, i.e. the red and green in highlight pixels. If there is an imbalance of red and green, that suggests a shift from white. The camera's software corrects that shift for the entire image, changing the colour balance overall.

Some cameras allow you to set the white point manually, to match, for example, daylight or tungsten, and so on. Alternatively, you can aim the camera at a grey or white area and ask the software to set the white point according to the target.

Therefore, you can deliberately set the "wrong" white point, e.g. tungsten, while shooting out of doors. In short, this is nearly equivalent to using a coloured filter over the lens (with a small proviso that some image data is compromised).

Setting up

First, set up Photoshop's *Edit > Preferences > Colour Settings* so that it always asks about profile mismatches or missing profiles. If your digital camera can be set to produce untagged files, so much the

The top of a car just after a light drizzle reflects the re-emerging sun. Although there is a great deal of distortion caused by the wide-angle attachment, the picture does not suffer from it. The bulging lines of the landscape and horizon mirror the actual curve of the car roof, and even add to the visual experience.

better. Take a picture under controlled conditions of a subject with a good range of colours – preferably a standard colour chart that you can assess – under identical lighting – while at the monitor.

Open target untagged
Open the file in Photoshop and, when asked about missing profiles, select *Don't Colour Manage*.

Select a basic working space
Open the colour settings dialogue again, and ensure that *Preview* is checked. Next systematically apply one *Working Spaces: RGB* after another. If you see no differences, colour management is on. If so, close this dialogue and open *Image > Mode > Assign Profile* and choose *Don't colour manage this document*. (Now return to the *Color Settings* dialogue.) You are looking for the RGB space that gives the most accurate-looking image. If necessary, make smaller adjustments through the *Custom* menu: you can alter gamma or brightness, and white point or colour balance, as well as primaries – the basic separation channels, in other words.

Create profile
When satisfied with the image, write a new name in the box, and click *OK*: this creates a working space, but does not yet create a profile. To do so, select *Save RGB…* near the top of the RGB dropdown menu, give the profile a name. Add the suffix ".icc" (even if you are a Mac user) and save it into the ColorSync profiles folder.

Exit without change
Click on *Cancel* or hit *Escape* to ensure you do not adopt the camera settings as your working space.

Tag files
You can tag a file as you open it, if asked about *Missing Profiles*. Or you can add it afterwards, from the menu *Image > Mode > Assign Profile*.

Lenses for digital photography
As the portal through which the world outside enters the camera to be caught by sensor or film, every last quality and feature of the camera lens impinges on the characteristics of the captured image. As digital cameras have evolved, manufacturers have learnt that they cannot simply press-gang lenses originally optimized for film into the service of the digital. Lenses that are superb with film are not necessarily top performers when delivering an image to a sensor. At the same time, the impact of undercorrected aberrations such as distortion and light fall-off can now be at least partially reduced by image manipulation techniques. As a result, advanced photographers – especially those with experience with film cameras – need to approach lens specifications and characteristics in a new way, starting with the most basic measure: focal length.

Equivalent focal length
There are numerous different sensor sizes in use – there exists nothing like the standardization of film formats. If we are told the focal length of a lens is 12mm, we need to know the format that it covers before we can tell whether the lens is an extreme wide-angle or a medium telephoto. We now specify the actual focal length of a lens as the focal length for the 35mm format that would cover the equivalent field of view. In short, the equivalent focal length (efl). For example, a camera lens may offer a zoom range of 5.8mm to 34.8mm: this carries little meaning without knowledge of the sensor size. But 5.8mm – 34.8mm

Sensor formats
Sensor formats for smaller, point & shoot, cameras are derived from vidicon types for early TV cameras in which the actual pick-up size was rather smaller than the nominal size. Thus a 1/2.7" type sensor actually measures 6.6mm on the diagonal, 5.27 x 3.96mm overall. Other common types are 1/1.8" (8.9mm on 7.2 x 5.3mm), 2/3" (11mm on 8.8 x 6.6mm). For dSLRs, the APS-C format is most popular, measuring 30.1mm on 25.1mm x 16.7mm, while the 4/3 format measures 22.5mm on 16 x 13.5mm.

» FOR MORE ON LENS TESTING SEE PAGE 40

Defects in an image (*above right*) may be electronic or optical in origin. Towards the edge of the image (*above*) are magenta fringes on the inside of dark boundaries and cyan fringes on the outside. This shows overcorrected lateral chromatic aberration. Electronic overexposure is visible (*top*) as a white patch devoid of detail. Parts of the tree which should be black are light, due both to spillage of electrons in the CCD array as well as flare in the optics.

translates to 35–210mm equivalent focal length, and tells us it runs from a moderate wide-angle to telephoto. And we do not need to know the size of the sensor (in fact it measures 1/2.5" or 10.17mm).

Focal length factor

Equivalent focal length (efl) is most useful when applied to digital cameras with fixed lenses. With digital SLRs (dSLRs) the same lens may be used first for 35mm film, then on a dSLR. If the sensor of the dSLR is smaller than 35mm format (nominally 36 x 24mm) then the effective focal length of the lens is increased (*see also p. 40*) as the smaller sensor ignores and thus crops off the outer portion of the image. Note, incidentally, that by cutting off the periphery of the image, smaller sensors enable you to benefit from using the best – central – portion of the image. You thereby reduce the effects of light fall-off, distortion, coma and astigmatism.

When the same lens is used with different sized sensors, it is convenient to refer to the focal length multiplier or factor by which the focal length of a lens is increased. Typically the factor is in the range 1.3X to 1.6X, depending on the camera. For example, a 100mm focal length lens used on 35mm film or full-format sensor gives a field of view of a 100mm lens (focal length multiplier of 1). On a smaller sensor, e.g. measuring 22 x 15mm, the effective focal length is multiplied by 1.6, giving 160mm: the field of view is that of a 160mm lens.

Field of view

The field of view (FoV) of a lens is a measure of the extent a scene is captured by the lens. It is the angle subtended by the lens, at the focal plane across the diagonal of the format, with the lens focused at infinity (hence the alternative terms "angle of view" or "field angle"). Note that as the field of view varies with the diagonal of the format, it can be the same whether the format is square, rectangular, or even circular. However, the visual experience will be different: a 90° (very wide) field of view on a square format does not appear as wide as the same field of view seen over a rectangular image. This point is relevant because of the variation in digital formats with different proportions in use today. The squarest format is 3:4 and is very widely used, while the traditional 2:3 of the 35mm format is less popular, and the wide-screen format of 16:9 is gaining favour.

Lens specification

With the majority of digital cameras, the lens is fixed, i.e. non-interchangeable, and with almost all cameras, that lens is a zoom. A zoom range of about 35–105mm efl covers the majority of shooting situations and is considered the minimum specification, but modern cameras are offering zoom ranges far greater than this. While the wide-angle setting extends to 24mm efl at widest – with the majority around 35mm efl – the long end can reach 400mm efl or more.

The maximum aperture of fixed-lens cameras is usually modest, with the exceptional opening up to f/2.8 at the wide end. In the majority of lenses, the maximum aperture reduces as focal length increases and may drop to as small as f/5.6. In short, these lenses are not suitable for working in very low light conditions. Another limitation in the aperture settings of non-interchangeable zoom lenses is their minimum aperture: these may stop down to only f/8. This may restrict special effects such as using long shutter times in bright conditions. These limitations encourage professional users to use dSLRs with

Super close-ups

Digital cameras which focus to within 5cm of the lens sound impressive, but are often less than useful. Such a close focusing disturbs any subject other than inanimate things or plants. Focusing is very tricky: the camera needs to rest on a tripod. But even worse, it is almost impossible to light the subject properly.

their larger maximum apertures and more versatile aperture ranges.

Another feature of modern zoom lenses is their ability to focus to very close up, with some focusing almost to the front of the front element. For best results, ensure that close focusing or macro mode is available at long focal lengths, and is not restricted to the wide-angle setting. This is because working at the wide-angle end gives a poor perspective as it forces you to approach very close to a subject in order to obtain a high magnification image.

Optical characteristics

Two lenses with identical descriptive specifications can give results of very different quality; their optical characteristics, such as correction for aberrations and their susceptibility to veiling flare, may differ. High-quality lenses produce images with good contrast, showing lots of fine detail, and with little distortion – straight lines are not curved. When a bright light-source is in the field of view, these lenses do not flare – project a glaring spread of light – and internal reflections are well suppressed. In addition, the best quality lenses will also deliver very high-quality images at a distance as well as from close-up.

Another characteristic is the variation of image quality with aperture. Most lenses are at their best somewhere between the largest and the smallest aperture, with significant falls in quality at the maximum and minimum aperture. It is a worthwhile exercise to discover the optimum aperture for your lens by photographing a test target, e.g. brick wall, at different apertures.

The widespread acceptance of zoom lenses is due, in part, to the acceptance of their defects, chief of which is geometrical distortion. They are arguably less sharp than single-focal length or prime lenses but the sharpening of images which is now an accepted part of image processing helps disguise the softness of a lens's image. Geometrical distortion too can be corrected in software. The most sophisticated solution is to create specific correction algorithms for each lens design: this is the strategy of DxO Optics Pro whose Optics Engine analyses the lens settings against a database of the lens used to carry out a complex algorithm which corrects the distortion.

Thanks to the drive to create smaller and smaller lenses, vignetting and light fall-off is also a common

For subjects like nature and sports, the focal length multiplier is an advantage. A 400mm for 135 format becomes an extremely useful 640mm on a digital SLR with 1.6X focal length mutliplier. This helps bring us almost face-to-face with a deer that was some 9m distant. But pay attention to avoiding camera-shake: image stabilization lenses are ideal for this work.

defect of modern digital camera lenses. Lateral chromatic aberration, in which the size of the image varies – albeit minutely – with wavelength, was a minor technicality with film cameras but is now a common problem because sensors are now so small, they can reveal the aberration. Fortunately, these defects are also easily corrected in software such as DxO Optics, as well as Adobe Photoshop, and others.

Telecentric lenses

Early in the development of digital cameras, it was realized that rays falling obliquely onto a colour filter array are occluded, or shaded (*see also p.13*) because the sensors lie at a distance between the filter layer. The result is that less light reaches the sensors at the edge of the sensor compared to sensors at the centre. With lenses of very short focal length this problem is severe as the rays reach the filter array at a very steep angle. One approach to this problem is to design lenses that project their rays as perpendicular to the sensor as possible. Telecentric lenses are optics in which the chief rays of light either enter the lens parallel or leave in parallel – they do not diverge or converge as in other optical designs. True telecentric designs are not appropriate for photography, but designs that are near telecentric in image space (i.e. light is projected without strong divergence) are being used, particularly in the Four Thirds format created by Olympus and Kodak, and adopted by Panasonic, amongst others.

Field of view and formats

To find the approximate field of view given a focal length and format, divide the length of the diagonal of the format by the focal length (using the same units, e.g. mm). Note: normal focal length lenses give a field of view of 52–56°.

Format diagonal/focal length	Field of view °
0.5	28
0.75	41
0	54
1.5	73
0.75	83
2	90

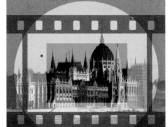

35mm film area projected image

sensor area

A lens for 35mm format throws an image circle enclosing the format. The smaller photosensor takes in only the central portion, resulting in reduced field of view and an equivalent increase in focal length.

» FOR MORE ON RESOLUTION SEE PAGES 44–45

Our increasing familiarity with digital manipulation changes the way we view images. In the above view – taken from a bridge in Costa Chica, Mexico – the projection distortion caused by pointing the lens downwards is not obvious (the image scale in the lower part of the picture is higher than in the upper part). But the image is visibly improved by the simple correction of slightly stretching its upper part.

Operational features

Features which do not impact directly on image quality may still be important for the digital photographer. Many zoom lenses are controlled by rocker switches which drive a motor, but these are clumsy compared to being able to turn a zoom control directly by hand. And while most lenses focus automatically, at times it is a great advantage to be able to focus by hand. You may also consider whether the lens has its own self-closing cover (handy but liable to jam) or whether you put the lens cap on yourself (reliable, but you have a cap to lose). Another key feature is the availability of a lenshood. This not only shades the lens from stray light, it also offers protection.

Finally, consider whether digital cameras with fixed lenses can accept supplementary lenses to increase wide-angle, telephoto, or close-up performance. Some cameras need clumsy adaptor rings and the attached lens may block the viewfinder. Others simply do not accept anything.

Out of focus

Given the usual preoccupation with the sharpness of images, there would seem to be little point attending to the unsharp image. Yet a little thought shows that unsharpness is characteristic of the greater part of most images. The quality of the unsharp image, therefore, must contribute significantly to the overall image quality.

A Japanese word, *bokeh*, is used to refer to unsharp quality. In a perfect optic, an unsharp dot of light is evenly lit, but in practice the dot is usually brighter in the centre than at the edges. (With catadioptric or mirror lenses, the out-of-focus highlight is annular – dark in the centre with a bright ring.) The smoothness of the transition dictates bokeh quality: for portraiture and technical photography, we want high bokeh – smooth, out-of-focus images.

Bokeh quality is best with lenses that are well-corrected for spherical aberration, and where the aperture diaphragm uses more than seven blades (or, better, is circular).

In digital photography, subtlety in bokeh tends to be lost due to contouring effects (posterization) and colour interpolation. A sharpening regime also increases edge contrast, and this disables smooth bokeh. It follows that for good bokeh in digital photography you need the highest possible resolutions. Consider simply shooting on fine-grain film, then scanning.

Image quality and aperture

Like any other complex system, lenses perform optimally at certain settings. Chief among these are the focusing distance and the working lens aperture. For advanced work, it is essential to know the settings that deliver the best quality.

Lens flare and internal reflections

One advantage of the very small lenses used in most digital cameras is that they are less prone to flare. Nonetheless, you should take care to avoid flare: prefer digital cameras whose lenses can carry a lenshood.

Digital image problems

The nature of digital image capture dictates that the problems it suffers from will have a nature quite different from that of film. In fact, because the system

is so intolerant of fault or any laxity, technical problems are very few. If you have any, the image is simply dead on arrival – you cannot open it at all.

Parsing or corruption faults

For a digital file to be decoded and displayed, data must be read off in a specific order and errors checked as they occur. The smallest failure could return a message that says, in effect, your software does not know what to do with the data. You may well have all the data you need, but just a little detail is lost which means the whole stream is undecipherable. The error shown on page 12 is extremely rare.

Exposure problems

Many photographers look upon digital photography as a panacea that will cure all exposure problems forever. Sadly, that is not so. Accurate exposure is as desirable a way to give birth to an image as ever. Indeed, the smaller sensors of point and shoot cameras offer exposure latitudes similar to those of transparency film, i.e. very limited. However, the ability to adjust the overall brightness level and mid-tone contrast of image can help disguise exposure errors. Note that one parameter that is set when images are captured in raw format is exposure; but even so, the raw format allows for a wider range of brightness adjustment than JPEG capture.

Exposure accuracy is most important where the subject offers a high luminance range (high dynamic range) that exceeds the capacity of the sensor. With static scenes there is a solution: two exposures are made – one to capture shadow information, the other allows shadows to fill in but holds highlight detail. The images are then superimposed and blended so that shadow and highlight details show through.

Moiré

Moiré is the appearance of a new pattern when two regular patterns are superimposed on each other. The new pattern appears to lie over the true patterns. It is caused by the interaction of regular details which are out of phase. The appearance of moiré also depends on the resolving power of the system. This can happen when the true patterns appear in an image, such as two different types of sheer fabric. But while it was formerly an obscure optical curiosity, moiré presents a particularly intractable problem in digital photography.

As digital cameras rely on a regular array of sensors to detect an image, any fine regular pattern near the

limit of the sensor resolution has the potential to cause a moiré pattern.

There are software solutions such as the Camera Bits Moiré Eraser, or Image Doctor. Optical methods involve blurring or low-pass filters, which cut the higher frequency detail that would cause a moiré, but many photographers distrust them.

Kodak's approach (also used in other dSLR cameras) is an ingenious application of a phenomenon called bi-refringence, in which certain crystals can split a beam of light into two parts. Kodak's low-pass filter does not blur the detail but transmits an incoming beam as three, the spacing of which corresponds to the spacing of the photosites. Detail which could cause the moiré is therefore spread over several sensors, which defeats the creation of secondary patterns.

The art direction for illustrations to a book called for a light, cool, modern tone. In order to achieve this with film you would need to work either with filters on the lens or over the lights. Either way, you cannot be sure about results before processing. With a digital camera, the exact tone and nuance can be set and reviewed right in the studio. The first image (*above left*) shows the colours as might have been using normal settings, the other image the result of overexposing deliberately by 1.5 stops with the white point set from a warm skin tone.

Exposure latitude

Any recording device – film or photo sensor – registers changes accurately only over a limited range of brightness (luminance): the straight or linear portion of response. This can be short or – nearly the same thing – it can be steep, as is the case with slide film. Exposure latitude is greater where the straight-line portion is not steep, and is more limited where the slope is steep.

» FOR MONITOR WHITE POINT SEE PAGE 23

Better scanner techniques

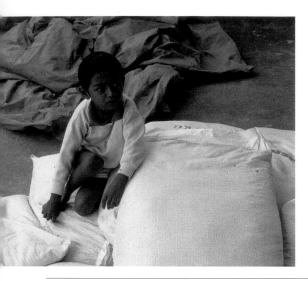

A scan retaining highlight detail (*left*) loses shadow detail, while one retaining dark detail (*below left*) loses the highlights. The two scans can be blended using the *Layer Options* control (*below*) to create a well-balanced image (*far left*).

Of the fundamentally different methods of scanning, making a scan from a reflection original – such as a print – is far easier than scanning a transmissive original, such as a transparency or negative.

For scanning reflection originals the dynamic range that has to be encompassed by the scanner is modest: less than six stops (i.e. the difference between darkest and lightest is six stops). For transmissive originals, however, the dynamic range can be very wide indeed, running to 11 stops or greater.

This is important for two reasons. First, it is extremely difficult to arrange lighting and optics that can penetrate the highest densities seen in modern films. Second, the long dynamic range makes heavy demands on the computer coding required. As a result, very inexpensive flat-bed scanners can make superb reflection scans, whereas to obtain really good transmission scans you need relatively costly hardware.

Scanning for best quality

Squeezing the utmost quality out of your film/scanner combination is simple to effect, but it costs in increased scanning time. If you are fortunate enough to be throwing away an old computer, see if it can still run the scanner (and printer too). Keep it, and forget about tying up your main computer. It is here that Apple Macs come into their own: one inexpensive

cable is all you need to network two Macs together.

Modern scanners produce surprisingly good results. But a number of strategies can help you obtain the best quality from whatever equipment you use.

Scanning in 48-bit

A number of modern scanners will scan into 16 bits per channel, i.e. 48-bit space (some into 36-bit space or 12 bits per channel). This is necessary in order to code for high maximum density readings. Some will produce 48-bit files, while others only output files in 24-bit. If you have a choice, retain the scan in 48-bit. This, despite the overheads in terms of longer scan

Speedy scanning

When you have a number of small, similar originals to scan to the same size, lay them close together so that as many as possible fit onto your scanner's working area. Now scan them all as one image. This creates a large file with all the images together. You now simply need to select, copy and paste each image into a new file. Choose the *Rectangular Marquee* tool, select an image (cropping any excess out at the same time), copy, make a new file, paste in the image and save (flattening it first if necessary). Amazingly, once you've made the selection you simply hold the *Command* (*Control*) key down and press *C, N, Return, V* (and *E* if you want to flatten it), *S*, then add a file name and hit *Return*. This is so much neater than making separate scans.

times and larger files, is well worth doing for colour transparency materials. Ensure you carry out colour and tonal corrections while still in 48-bit. Unfortunately even superior software such as DeBabelizer does not work in 48-bit, but most of the basic corrections are available in Photoshop and Photo-Paint 10. PhotoRetouch works fully in 48-bit. Once the basic corrections are done, you can, and indeed should, turn the image into 24-bit.

Multipass scanning

For dense negatives or high-contrast, high-density transparencies such as Fuji Velvia, choose multiple scanning if available. If your scanner driver does not offer multiple scanning, all is not lost. See if Silverfast or VueScan drivers support your scanner by checking their websites. The process takes longer, but the results are worth the wait.

Dealing with moiré

If you have problems when scanning printed material, the most effective remedy is usually to scan at a much higher resolution than you need, then downsize later. Another trick is to try placing the original at an angle for scanning and correct the rotation afterwards. Start with an angle of about 15° or 30°. This goes against the advice to avoid rotation (*see p. 45*), but here both the angle and the losses due to interpolation contribute to suppressing moiré.

Software or scanner sharpening?

One of the choices presented by scanners is either to allow it to perform sharpening, or to do the work yourself in Photoshop. Sharpening (preferably unsharp masking) in the device that is acquiring the image for you may take longer, but it may give better results than Photoshop can. Beware that the scanner's interpolated preview image is not a reliable indicator of the effects of unsharp masking.

The best approach is to see if you can see any difference. Try scanning an image without sharpening, then with different levels of sharpening performed by the scanner. But remember that scanner-sharpened images will show up dust and dirt equally clearly.

Dust problems

Taking precautions to avoid problems with dust saves a great deal of time and trouble further down the line. So, if you process your film, work with clean filtered

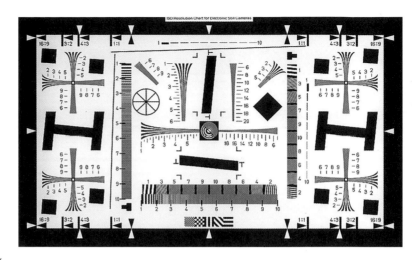

water especially during the final wash stages. And of course when drying the film, make every effort to dry it in dust-free, filtered air. Keep your negative files perfectly clean and dust-free before and after filling them with film. Avoid stacking negatives flat on top of each other: their combined weight will squeeze dust particles on the film into the emulsion or backing to create permanent damage.

Maintaining a dust-free zone

Clean your film and handle it with utmost care when scanning. The scanner itself should be kept meticulously clean: keep it covered with a plastic

Standard targets such as this can be used to check the performance of your scanner. They can be bought, but tend to be expensive. However, you can create your own target: create lines of varying thickness and orientation, and patterns of greyscale ramps (missing from this pattern, which is an international standard target for still cameras).

Rotating crooked scans

You can straighten up a poorly aligned scan in some scanner drivers and software by using the Crop tool and rotating it so it lines up, accepting the crop. Another, more accurate method, available in Photoshop, is to use the *Measure* tool. Call this up and drag along one edge of the image. Then rotate the image under *Image > Rotate > Arbitrary*. You will find a figure for rotation already entered in the box. Ensure the rotation is in the right direction (clockwise or counter-clockwise) and hit *OK*. Your rectified image is delivered. Note the image canvas increases to encompass the whole image: you will then need to crop off the excess.

» FOR MORE ON MOIRÉ SEE PAGE 41

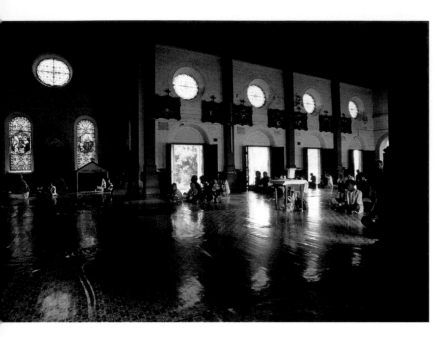

Broadly speaking, given images of average proportions, images smaller than about 150 pixels long cannot show anything but the broadest structure of a picture. For Web use your images generally need not be longer than 720 pixels – which is also adequate for smaller prints, i.e. half the size of an average postcard. For fair-quality prints and output to A4 size, you will work in the 2000–2500 pixel range. For good-quality work, the numbers rise to image lengths of 3000–4500 pixels.

Output scaling

Another source of confusion is the variety of approaches that manufacturers take in designing scanner driver software. Some require that you set a scaling or enlargement factor, others ask for the output size – and some allow you to set both. Worse, as you change one figure, others mysteriously change or else you are forbidden to enter certain numbers – usually for reasons that are never explained.

Part of the reason is that scanner drivers are helpfully written to prevent users from creating impossibly large files and to discourage odd resolution settings which involve a great deal of interpolation. You learn as you go.

It helps to understand the relation between the scaling factor or output size that you set. Suppose you scan a one-inch-square section of a transparency. If the scaling factor is, say, 4x or 400%, the output size will be 4 inches square. A factor of 6.73 produces a square of 6.73 inches. Alternatively, if you set an

sheet when it is not being used. The glass platten of a flatbed scanner should be blown free of dust and kept clean of smudges and dampness. Use microfibre cloths designed for cleaning lenses to keep the glass platten spotless.

Automatic dust-removal

A number of film scanners use infrared light to detect dust specks prior to a mask-based removal of them. But silver grains scatter infrared very well, so dust-removal based on infrared cannot work with black and white film, apart from those developed in a C41 process, such as Ilford XP2 or Kodak T400 CN. Some systems will not work with Kodak Kodachrome film.

Input resolution

Poor numeracy skills combined with a confusing subject make resolution a topic that will baffle digital photographers for many years to come. One reason for this is that the term "resolution" is now used in at least five distinct senses (*see side-bar on the right of the page*).

The other is that we are not used to the virtual unit. That unit is the pixel, and it has no size until it is output. The central notion, therefore, is that you think pixels and count in pixels. As you get used to working with digital images, you will get a feel for whether the number of pixels you have in the image is sufficient.

Transparency film, with its high maximum density and resulting wide dynamic range presents the greatest challenge to scanners. To extract maximum information from the dark but detailed shadows of a church in Fiji, you need either a drum scanner or to make multiple passes at the scan. The image from combining eight scans was visibly better than a straight, single scan.

The faces of resolution

• **Input resolution in points per inch (ppi) measures the fineness of details scanned – the frequency or density of data sampling.**
• **Output resolution in pixels per inch (ppi) measures the size of pixels in the output – the spacing of output pixels.**
• **Device resolution in dots per inch (dpi) measures the fineness of output from a device such as a printer, or the density of device-addressable points.**
• **Sensor resolution in pixels (or megapixels – decimal millions) measures the total effective number of pixels available on a photosensor.**
• **Lens resolution in line pairs per millimetre (lpm) measures the fineness of detail that can be distinguished to a given contrast.**

output size of 4 inches square, the scaling factor will be 4x or 400%. Personally, I find it unhelpful to set scaling factors and find it is easiest to set output size.

Note another complication, however. These are the chain-link symbols, which indicate that a pair of settings are locked to change in step, i.e. to keep their proportions. If you have already set a crop on the pre-scanned image and have locked the crop, the scanner software will only accept settings that maintain the crop proportions.

Now, if you set an output resolution of, say, 200 ppi then the input resolution must change as you vary the scaling factor or output size. The input resolution increases to provide you with enough pixels to meet the output resolution you seek. And when that resolution hits a limit it cannot increase to match, you will find you can't enter the scaling factor – it is forbidden. Say, for example, you want a four-inch-square image output to 200 ppi, then you need 800 pixels. The original one-inch image must be scanned at 800 ppi.

Scanning silver-gelatin negatives

The scanning of normal black and white negatives – silver-gelatin images – presents special problems. If you have scanned black and white negatives at high resolution – say at least 2700 ppi – you probably noticed the results were grainier than you expected, or at any rate much grainier than a scan from comparable colour material. And if you tried to scan at even higher resolution the problem became worse.

Fundamentally, the difference is that the silver particles which make up the image scatter light, whereas the dye-clouds of colour images attenuate (absorb) and filter light. At the same time, the lighting in a film-scanner is highly directional; it is hard lighting. The net result (technically a high Callier coefficient) is similar to printing with a condenser

enlarger: darkroom workers know that printed results display sharper-edged grain and higher contrast than those from a diffused light-source enlarger. Now, add this to the high-resolution raster of a scan and you create interference or aliasing between the film grain and the regular array of pixels. The resulting scan is artefacted.

Imagine a sharply defined grain: if it lies wholly within a pixel, it is accurately recorded. But if the grain only half covers one pixel and half of another, it will register on both pixels, filling both: thus it appears to twice its actual size. The result of grain/raster interference is that many silver grains appear larger than they really are. It is clear that similar problems can be, and are, encountered with colour film, but they are, in my experience, not as marked as with black and white film.

You can try to reduce grain/raster interference through simple slight defocusing: the classic botch for low-pass filtering. Set the scanner driver to manual focus if possible, or fool it by raising the film with a clear piece of film. This stops very fine detail from getting through. This seems to run counter to common sense, but it may reduce graininess without harming broad image features.

Another way to reduce the problem is to use chromogenic black and white films, such as Ilford XP2 (one of the best films), or Kodak CN400. These films create the image using dye clouds rather than particulate silver.

» FOR MORE ON GRAIN SEE PAGES 65 AND 97

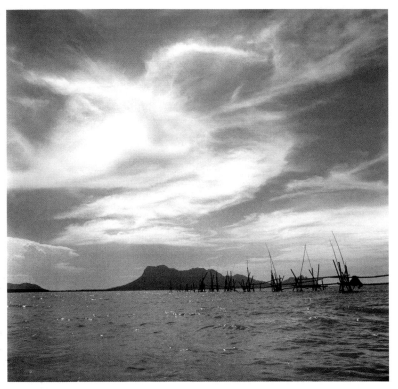

A scan into RGB space of a silver-gelatin negative of fishing lines in Sarawak (*above*). The first close-up (*top right*) is the red channel, followed by the green and blue channels. By a small margin the blue channel (*bottom*) appears slightly grainier than the others. But the red channel (*top*) is clearly the softest. (Differences in the image may be masked by this book's printing process.)

Variation of grain with colour channel

There is more. Suppose we scan our black and white negative in RGB mode. We obtain what appears to be a greyscale image. Now, inspect each of the red, green, and blue channels.

We observe that there are slight differences in the appearance of the grain. This is due in part to a phenomenon called Rayleigh scattering. Some of the light incoming to a film is re-emitted by the silver particles – this is scattering – but the amount of scattering varies with the wavelength of light. It increases as wavelength decreases, i.e. as the light becomes more blue. This is what gives us blue skies (scattering from small air molecules) and gives sunsets their glow. Long wavelengths are scattered less than short ones by dust particles, so the reds and yellows penetrate the atmosphere, whereas greens and blues cannot. Now, the differences visible in the channels of our black and white scans are consistent with this theory. In general you will find that grain in the red channel is less than in the blue and green channels.

But it means you can take your pick. If you wish for the finest grain, select the red channel and simply delete the others. In theory, if you need even finer grain, you could try scanning through a red filter (but the quality fanatic should be aware that CCDs are usually filtered against infrared). To obtain coarser grain, of course, the blue or green channels will deliver.

In Photoshop, you can invoke the *Split Channels* command in the *Channels* palette to create three separate files, each one containing a separation. Just save the one you want to keep and discard the others. But of course ensure you do this to a duplicate file.

Blue channel noise and grain

Do not confuse the greater graininess in the blue channel with noise in the same channel of digital camera images. The differences in cause – one is due to scattering, the other to the low blue-sensitivity of CCDs – are more important than the superficial similarities.

PART TWO

MASTERING IMAGE MANIPULATION

MASTERING YOUR MATERIALS

Advanced tone control

A simple precaution to take before starting any image manipulation is to check that the richness of data in your image is sufficient for the changes you wish to make. If you expect to make only minor changes to brightness or colour, your image can be thin in data; but if not, you should rescan or obtain a superior image.

Large expanses of even tone in this image, from New Zealand, can be expected to give a few high peaks in the *Levels* display, with troughs in between. The image was over-exposed by around half a stop to keep tones high-key without reducing colour saturation.

The *Levels* histogram display shows no gaps in the histogram, with good distribution throughout the dynamic range. But the peak at the far right shows the image is overexposed.

The *Levels* histogram is piled high to the far right, with very few pixels in the mid-tones and none in the shadows. Very little can be done to improve this image.

The best way to check on data richness is to call up the Levels control. Software such as Photoshop and DeBabelizer offer a Histogram display, which provides detailed statistical information.

Greater bit depth

The central element of advanced tone control is to work at a greater or higher bit depth than normal 24-bit colour. High bit depths offer a huge redundancy of data points. This means that there are millions more pieces of code than there are colours to be encoded. This can be usefully exploited to maintain the smoothness of tonal transitions, particularly in mid-tones. And more importantly, the redundancy ensures accuracy of the extreme tones during image manipulation.

The argument is simple. When you reduce the bit-depth of an image from 24-bit colour – which codes about 16.8 million different colours – the image suffers. Richness, depth and range of colours are reduced, and smooth hue or tonal transitions are roughened. But the converse must also be true: if you increase the bit depth, image quality must improve. 48-bit colours number well into the billions, but file sizes double. Just as importantly, not all image-manipulation software can currently handle higher bit depths. Photoshop and Photo-Paint support 48-bit colour, but limit you to a few commands and tools. Key among these are tonal controls, such as *Levels* and *Curves*.

Adjustment layers

An important strategy for maintaining data integrity in Photoshop is to make use of adjustment layers. These allow you to monitor the effect of changes to your image without touching any of the image data until you render the effect. This takes place when you flatten the image layers. Ensure, however, that you work with an image of good quality; if not, the appearance of the image under an adjustment layer may not match that of the final result.

Adjustment layers in Photoshop are available for key adjustments such as *Levels*, *Curves*, *Hue/Saturation*, and simple effects such as *Solid*

Color, Gradient, Threshold, and Posterize – altogether 15 adjustments. In later versions of Photoshop, all adjustment layers for 24-bit colour are also available to images in 48-bit colour (16 Bits/Channel mode).

Levels

The Levels control or equivalent – which may be called "Intensity" and "Contrast" – can be found in all image-manipulation, scanner-, or camera-driver software. The basic features are common to most implementations. Sliders set the black and white points (effectively controlling contrast), while the central slider is best regarded as setting the exposure, i.e. the overall brightness. This is often referred to as the gamma slider, suggesting it alters contrast. Indeed it can, but the precise effect depends on the implementation chosen by your software. Some simply shift the curve, but others change the shape of the curve.

Slider controls

One way of approaching the Levels control is to regard it as an abbreviated form of the Curves control. When you set the white or black points, clipping (reducing) or fixing (maintaining) their values, you are in fact altering contrast, or the slope of the curve. And when you set the brightness (exposure, or intensity) of the image with the central slider, you are changing the area under the curve, which affects the overall brightness or exposures.

Dropper tools

Less well known than the sliders are the dropper tools. Droppers differ in function according to the tools or commands associated with them. You can use them to sample a colour from an image or colour palette, then apply it to a brush. The dropper tool can be set to sample from three different sized areas: a single pixel or point, averaging over a 9-pixel area (3 x 3 pixels) or from a 25-pixel area (5 x 5 pixels). For the majority of situations, the most suitable is 3 x 3 pixel sample. But in Levels they set or apply a tone, and force all other tones to remap or swing around to new values.

Shadow dropper

This sets the sampled area as the black point and all pixels of the same brightness or darker are turned black, with all else shifting in proportion. This is often very effective as it is usually easy to select a spot that should be black.

The patchiness of pixel data is clearly visible as gaps in the histogram display. Manipulation will further reduce the data.

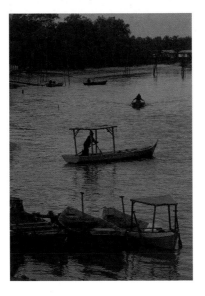

All the pixels are piled up to the left, with none lighter than the mid-point. However, the quantity of data suggests that the data is simply compressed, and this image could easily be improved.

Mid-tone dropper

Clicking with this dropper maps all pixels around the chosen point as the mid-tone. It is a very quick way of adjusting exposure – provided you know what you want to be rendered mid-tone grey. Also, beware: it often causes shifts in colour.

Highlight dropper

This maps all pixels around a highlight. A small error in aim can dramatically alter your image. Fortunately,

Clipping data

The Brightness/Contrast control is often dismissed out of hand because it clips or loses data. But the Levels or Curves controls can also clip data. To avoid destroying image data with heavy manipulation, the advanced worker will prefer to use Adjustment layers in Photoshop.

FOR APPLYING COLOUR PROFILES SEE PAGES 69–70

The compressed tonal range caused by photographing through an aircraft window (*above*) is evident, as confirmed in the *Levels*

display (*above*). This kind of peak in a barren range is characteristic of tonal compression.

Auto Levels produces this overly contrasty result (*above*), with poor tonal gradation. The *Levels* display of the result (*above right*) confirms that data has been spread over the entire dynamic range, leaving large gaps. These could create problems with subsequent manipulation – a good argument for using *Adjustment Layers* whenever possible.

This kind of "comb" pattern in a histogram is typical of a patchy, degraded image.

Using the black and white sliders to increase contrast by moving them closer to each other, and adjusting exposure with the middle slider, results in a more natural-looking image. Sharpening was then applied and the top part of the image slightly darkened.

the change is not permanent, and it is easily reversed. Do not cancel; reset instead. Some software offers a "reset" button. In Photoshop, hold down the *Option* (*Alt*) key, and click *Cancel*.

Curves

The *Curves* control enables you to adjust the entire tonal range of an image by defining new values from a range of input values; hence it is also known as a transfer function, or curve. It is implemented in different ways, depending on the software. For example, you can draw the curve yourself, or anchor certain points while moving others. The curve can also behave in different ways: keeping to straight lines, or allowing only a certain amount of curvature. Remember: a steep curve always indicates a rapid change in contrast, and a shallow or oblique one indicates low contrast.

For the highest quality work, you will want to avoid drawing steep curves. You draw such a curve in order to increase contrast, but a steep curve places high demands on your data. Increasing the contrast requires that data which was sufficient for normal contrast be stretched out over a larger range of output values. Any deficiencies in data, therefore, are revealed as bands of sudden changes in colour or tone with large areas of even tone and colour.

In Photoshop, you can set up to 15 separate "control" points, or nodes, on the curve. It is useful to remember that when you click on the image, its value on the curve will appear as a circle which displays as long as mouse-down. This helps you work out which

Working with Curves

In Photoshop, to move several control points on the curve at the same time, hold down the *Shift* key as you click on each point. You can drag them together if you click + drag on a selected point or you can translate them in any direction by pressing the appropriate arrow key. If you click on a non-selected point or somewhere else on the curve, of course, you lose the selection. *Command* (*Control*) + *D* also deselects the points.

part of the curve to move. Hold down the *Command/Control* key to set a point on the curve.

For most images, you will find that you need to set at least half a dozen control points to enable you to manipulate the line effectively. One method of manipulating the curve with fine control is to use your keyboard's arrow keys to move the selected point up or down, left or right. This allows finer adjustment than using the mouse.

The best results can often be achieved by having the image in Lab colour mode and working the L-channel curve; this minimizes colour changes.

Shadow/Highlight control

While the *Curves* control alters the brightness of pixels irrespective of where they fall in the picture, the *Shadow/Highlight* command is sensitive to the local neighbourhood of pixels. It lightens or darkens pixels to an extent that is based on the surrounding pixels in the shadows or highlights. What is more, the degree to which the neighbouring pixels are taken into account can be controlled. The control was originally designed to lighten the shadow side of silhouettes or improve flash pictures in which the nearby subject is overexposed. But its true value is much wider: as it works by bringing out shadow or highlight detail where they would normally be lost, in fact the *Shadow/Highlight* control is a powerful tool for compressing high luminance range images.

The control is divided into three main parts. The first adjusts the shadows: Amount sets the strength of the effect; the *Tonal Width* adjusts the spread of brightness over which the setting works, while the *Radius* adjusts the physical distance over which the settings work. The second part adjusts the highlights, with similar controls to the first. The third part controls *Color Correction*: this provides a subtle adjustment of saturation. *Midtone Contrast* can have a marked effect over the whole image: it interacts with the Tonal Width settings so you may need to readjust the Tonal Width if you change Midtone Contrast. White and Black Clip set the upper and lower limits over which this control has no effect.

In practice, this tool may be used more than the Curves control. Presets can be saved, and one set can become the default. One can be overenthusiastic with this control: the result then looks as if it were painted, with an unreal lack of contrast in luminance.

The original image, of Sydney, Australia, shows it was a sunny with extreme contrasts between the white parasols and the deep shadows under the palm trees. Overall, the exposure is a little low but acceptable.

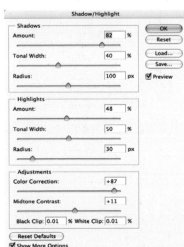

Application of heavy correction in *Shadow/Highlight* – for the purpose of demonstration – brings out a surprising amount of information from the shadows, revealing colours and details that could only otherwise be guessed at and simultaneously showing subtle tonalities in the parasols. A generous setting of *Color Correction* also helps to bring out colours.

This is a screenshot of the very high settings used to change the original shot to the altered image. The default settings for *Shadows Amount* is 7%, for *Highlights Amount* 5%, *Color Correction* +20.

» FOR RICHNESS OF COLOUR SEE PAGE 20, AND CURVES SEE PAGE 70

Digital dodge and burn

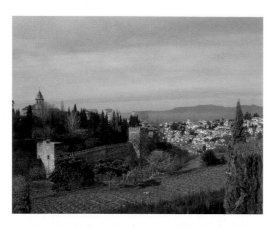

The original, of the Alhambra, Granada in Spain, is pleasant enough, brightly but flatly lit. A little subtle work – none of which changes the actual substance of the image – is likely to improve it.

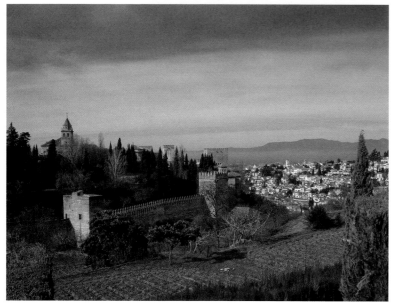

It is well known that the darkroom techniques of dodging – to reduce printed density – and burning-in – to increase printed density – when working with negative materials are easily imitated on computer. Almost equally well known is the fact that digital dodge and burn-in are tricky techniques, requiring a combination of mouse dexterity and skill. The basic rule for successful dodge and burn-in is to work steadily, not too quickly, and allow the eye time to assess the result – again, not judging too quickly. For many workers the essential tool for burn and dodge operations is the graphics tablet. The application of effects by using a pen-like tool on a flat surface gives you precise control over the placement of effects without straining the wrist. But perhaps, more importantly, you can vary the strength of the effect you apply simply by changing the pressure that you use to press down the "pen". Thus you might set a relatively strong pressure in the tool options although if you want a light effect you simply dab very lightly with the pen: there is no need to return to the tool controls to change the setting.

Dodge and burn-in settings

The basic dodge and burn-in tools are only really useful for elementary corrections that are not extensive, i.e. which cover only a small area or involve no colour correction. However, we will see that other tools, such as gradients and layer modes, can be just as valuable, if not more so.

Selecting the tone-bands

The reason for this strategy is to avoid the smudging effect that is a sign of inexperienced burning-in and dodging which is caused by losing the noise or texture of the image. Suppose you wish to bring down a highlight: if you select "Highlights" the bright pixels (which carry no detail) are immediately darkened, making them appear a detail-less smudge. But by choosing *Midtones* or *Shadows*, you make those pixels already with some density, i.e. those carrying some detail, into darker pixels – that alone may suffice to make the area look darker without touching a hair of the highlight pixels. A similar argument applies to dodging shadows.

The first task is to give some shape to the sky, by darkening the upper parts. After some trials, I settled on applying a light blue gradient on a *Color Burn* layer, with a relatively strong but not full opacity of 76%. *Color Burn* not only darkens but intensifies colour, which is useful for the clouds as the otherwise dark grey clouds would not look right.

TONE TO CORRECT	SETTINGS TO USE	
	Burn-in	**Dodge**
Shadows	Highlights or mid-tones	Highlights or mid-tones
Midtones	Shadows	Highlights
Highlights	Shadows or mid-tones	Shadows or mid-tones

Using brush or layer modes

Less familiar as the burn-in and dodge tools are the brush and paint modes, which have similar, if not more versatile, effects. This is thanks to the versatility afforded by working in colour, compared to the achromatic working of burn-in and dodge. The modes are the *Color Burn* and *Color Dodge*.

The best way to use these tools – indeed almost any tool – is to work on a new layer. The beauty of the *Color Burn* and *Dodge* tools is that you can control the strength of effects in no fewer than four different ways: the opacity or pressure of the brush, the darkness of grey or strength of colour, plus the opacity and mode of the layer itself. In Photoshop version 7, you may experiment with even more – layer modes such as *Linear Dodge*, *Linear Burn*, or *Linear Light* all offer slightly different effects.

An important difference between these brushes and the usual burn-in or dodge tools is that the effect is not cumulative – once you have painted an area a full colour it cannot change – unless that is you change the colour.

Using gradients

While brushes are ideal for touching up small areas, they are poor at covering large areas evenly and smoothly. Gradients are large swathes of colour applied so that they transit smoothly from a high density to a low density to transparency. These are particularly effective when used to shade down bright skies, but can also be used to brighten dark foregrounds.

The basic technique is very straightforward – but you can make it more elaborate using multiple layers with different modes. First you create a new layer and set it to a suitable mode, e.g. *Color Burn* to darken skies. Select a suitable gradient – say a very pale grey graduating to transparency. Draw the gradient over the layer and assess the result. You can redraw the gradient or add to it, alter opacity and, of course, change the layer mode too.

For further elaboration you can apply colour to the gradient. This can have a dramatic effect on the image, such as creating a sunset feel if you choose an orange colour. With multiple layers you can apply different modes to each layer appropriate to the colour and purpose of the gradient. For example, to the same image you can apply *Color Dodge* to a gradient from the bottom, and *Darken* to a gradient from the top.

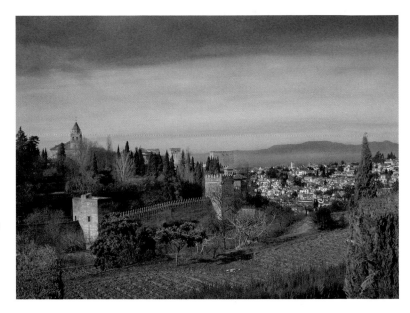

When tonal changes are made in one part of the image, you often find the need to adjust others to maintain a balance. Thus the distant town needed to have contrast increased, the very distant hill to be darkened and the foreground to be slightly darkened. The town and distant hills were given a once-over with the *Burn* tool set to *Shadows*. For the foreground, I created a new layer set to *Color Burn* and applied a very light warm grey to the bottom third of the image to lighten and lift the contrast a tiny bit. The finished image is vibrant.

The *Layers* palette showing a second layer set to *Color Burn* mode and slightly reduced transparency. You can create as many layers as you like to control with utmost finesse the tonal quality of your images.

What is dodge and burn-in?

One way to understand these techniques is that they give you a local adjustment in contrast. You are not simply lightening or darkening an area, rather you are trying to increase the contrast where it is normally weak, i.e. shadows and near the highlights. (Technically, you are making linear a non-linear response, trying to straighten out a flat-S-shape curve.) It follows that if you find yourself working on mid-tones, the overall exposure is probably incorrect.

» FOR ADVANCED PAINTING SEE PAGES 92–95

Advanced retouching

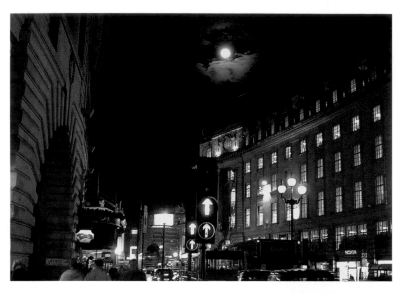

The most significant contribution of digital image manipulation technology to photography is the potential for the perfect, seamless retouch. With sufficient care and skill, it is possible to remove every last defect and leave no trace of the removal process. Of course, the interesting debate is in defining what we mean by "defect". There is no controversy in regarding a speck of dust as a defect, and perhaps a stray hair can be retouched without demur. But is a disgraced politician spoiling the line-up of a nation's great and good a "defect"? And is the penguin walking the "wrong" way in an otherwise resolute mass waddle to the sea a "defect" spoiling a potentially perfect composition? The temptation to retouch such images can be irresistible – but you are opening yourself to criticism.

One night the moon's orbit is closest to Earth, so it appears particularly bright. The *Patch* tool blends the texture of the destination with the cloned texture. This has made it easy to increase the amount of cloud in the sky, as well as fill in some of the blank areas in the rest of the image. Look at the bright display in the building at lower centre, and the dark building to the left of that. Although it is easier to use than the *Clone* tool, the screenshot below shows that many applications of the tool were needed.

Cloning

Another way to reduce the smudging or smoothing effect of cloning is to set the clone to "Aligned": this keeps the source of clone at the same distance from the clone at all times. The basic retouching method is cloning: copying parts of one image (the source) onto another part of the image, or onto a different image (the target or destination area). The relationship of

source to target can be straightforward. Equally, it can be extremely elaborate, having received the attention of clever programmers.

The commonest error made during cloning is work too quickly with too large a brush – from the (understandable) desire to get the job over with as soon as possible. It is far better to use a soft brush that is only slightly bigger than the detail you are working on. Change the size of the brush as you go: avoid using too large a brush on a small speck. To make sure you mop everything up, work at high magnification – one that is sufficient to make individual pixels just visible.

Another common mistake is allowing details to blur over. This is caused by the brush being set to apply the clone only at intervals as the brush is run over the image. This is controlled by the *Spacing* option setting – a control usually found in the brush controls. Set *Spacing* to zero for the least blurring, but be aware this will slow down the brush.

Healing and patching

While cloning replaces one set of pixels with another, the concept can be elaborated to one of preservation of the underlying texture or colour while pixels are replaced.

Healing

The *Healing Brush* tool (from Photoshop 7) works like the *Clone* (or *Clone Stamp*) tool: you define a source, then paint into the destination. It mixes source pixels with pixels on the outside edge of the tool. For this reason, it is best to choose a hard-edged brush, in contrast to a soft brush for cloning.

Some users see little point in it, but most others have welcomed it. For certain types of image detail – particularly specks of dust, or fine fibres – healing saves a great deal more time than straight cloning. It works rather like the Wacom Penduster (*see box*), but is less controllable. For much of my photographic retouching, it has replaced the plain vanilla *Clone Stamp* tool.

Patching

Patching in Photoshop works over larger areas than cloning. You must first select an area then define it as either the source, or the destination. At first, this feels awkward, but you soon get used to it. Next you drag the selection over to another part of the image. According to what you defined, the new area is either

Safety first in cloning

In Photoshop, it is good practice always to retouch on a layer when using the *Clone* (or *Clone Stamp*) tool. But ensure that *Use all layers* is ticked in *Options* bar. By doing this, not only will you be able to remove errors, but you can also alter the mode and opacity of the cloned material. These options are not available when you clone directly into the layer. The usually recommended work flow is to leave unsharp-masking for improving sharpness to the last. However, this can show up untidy cloning. Another useful safety measure is therefore to check the image at 100% or greater magnification to ensure that applying sharpening has not shown up evidence of cloning.

Now that retouching is so effortless and it takes so little time to remove blemishes, we may be too quick to repair an image, and fail to notice that there is nothing really wrong with it. Here a seam in the wallpaper may appear to be an obvious defect to remove. But to do so would unbalance the lines of the composition, and create a visually blank area that would not sit well with the rest of the image.

» FOR MORE ON DUST PROBLEMS SEE PAGES 43–44

The shadows and monochromatic tones of passers-by and pigeons on a square in Paris (*right*) are attractive, but one big shadow is not so welcome. The combination of changing textures and grid-like lines makes the removal of the shadow very tricky indeed. A few applications of the *Smart Fill* filter of Alien Skin's Image Doctor removed most of the signs of the shadow. A few more minutes' work with the patching and cloning tools produced the result seen below. It is not perfect, but it could be with slower, more careful work.

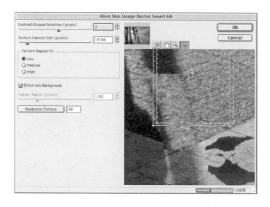

combined with the first or the first is combined with the second, with seamless boundaries between.

Dust removal – Smart Fill

In Photoshop's wake are increasingly sophisticated tools for the advanced worker. One of the most promising is the Image Doctor set of plug-in filters from Alien Skin, which offers tools for retouching or removal of blemishes.

The important feature of these new tools is that they are controllable: unlike the *Patch* or *Healing* tools, you can adjust settings to suit the subject. The most interesting Image Doctor component is *Smart Fill*, which replaces a selection with textures taken from a defined area somewhere else on the image (*see left*). This tool works very well when you want to remove an object which lies against a variegated background, such as leaves. Like many tools, the quality of the result may depend on how much you select to correct. With very detailed subjects and larger file sizes, it may be best to select individual small areas at a time. With smaller files, you can select larger areas in one go.

Using Blur Filters

Filters that work by reducing detail, such as *Dust & Scratches*, are usually derided precisely because they destroy the information on which the image depends. But the advanced worker will always suspect there is a trick that enables one to make use even of such data-destructive filters. The principle is to blur the image defects just enough to make them disappear, return to the original image in the *History Palette*, then paint back the blurred (now invisible) defects into the image, using the *History Brush*.

The complete process is as follows. First, apply the *Dust & Scratches* filter, adjusting the settings until your defects just disappear. Next, return to the original and set the *History Brush* to paint from the image you have just blurred. Then paint back the small areas that you have cleared of defects. Try setting the mode to *Darken* for light-coloured blemishes, and to *Lighten* for dark-coloured ones.

In fact, the *Dust & Scratches* filter is useful where blemishes are sharply defined against the image. You see this typically in scans made from glossy-surfaced prints: dust-specks are sharp and obvious. A skimming application of *Dust & Scratches* – you can try two or

Cloning on a path has been used to thin down the bottom poppy's stem. By first setting the path (*below*), you can experiment with different source points for the best results without having to redraw the path each time. The foreground blur and out-of-focus highlight were removed.

more applications of a very light setting – can eliminate those defects without touching a hair of the print detail.

Cloning on a path

A little-known feature of paths in Photoshop is that the stroke need not be the usual colour or graphic line. It can also be a clone, based on and starting from a source point that you define. Cloning on a path is a highly controllable way of removing telegraph wires, for example, and for erasing clean, straight scratches.

To clone on a path, you need to create a new path, giving it a name. Using the *Pen* tool, click down the centre of the line to be removed, turning corners as needed. You can use all the tools for manipulating paths, such as adding and removing control points to change the shape of the path.

Next choose the *Clone* tool and *Alt/Option*-click on, say, the sky close to the line to be removed. Then choose *Stroke* from the *Paths* palette, and select *Clone* as the type.

The greatest weakness of digital SLR cameras is their tendency to attract dust onto their sensors. These dust specks show up as blurred shadows of spots or micro-fibres. Some cameras such as those from Olympus or Sony use vibration to shake dust off the sensor. But with the majority, you need to clean the sensors directly. Even with the most meticulous attention, it is difficult to remove every speck. Fortunately it is easy to remove them using tools such as Photoshop's Healing or Spot Healing brush.

Work systematically from the corner of the image to the other. Usually dust spots are visible only against skies or if the background is unusually plain, e.g. the walls of a modern interior. If you have to use the cloning tool set the brush to *Lighten* instead of *Normal*.

If you need to repair a colour negative, e.g. for weddings, you need to output the repair as a colour negative. It is impossible to work well with the "native" image (*above left*) but you do not want to change image data more than necessary, so work with adjustment layers (*see box right*). You need adjustment layers to remove the orange mask, to invert the colours, to increase contrast, and, finally, to increase colour saturation.

Use Adjustment Layers

To work on a colour negative image that needs to be output as colour negative, you first need to apply adjustment layers to the image. This will make the otherwise low-contrast and reversed image easy to view. Then work on the background layer to effect repairs.

» FOR MORE ON PATHS SEE PAGE 83

Distortion correction and cropping

This was a hastily snatched shot (*above left*) of the marvellous centre of photography in Budapest. It shows obvious projection distortion, as well as slight barrel distortion from the wide-angle. The *Free Transform* tool has partially straightened the image. Then the canvas has been enlarged (*above*), using the *Crop* tool.

Finally, the *Spherize* filter (*above*) has been applied to correct the barrel distortion.

An image is said to be distorted when its magnification varies across the format. The variation might be very small – less than 5% – but that is enough for straight lines within the image to appear slightly curved, creating evident distortion. Nearly all built-in zooms for digital cameras suffer from noticeable distortion – usually "pin-cushion" (positive) at the long focal length end, and "barrel" (negative) at the wide-angle end.

You might think that in the middle, the two should cancel each other out and there will be no distortion. Certainly, zoom optics display the lowest distortion around the mid-point of the zoom range. But lines often show a slight waviness, indicative of a complicated distortion. Lens attachments, particularly wide-angle or negative power lenses which increase the field of view, all greatly increase distortion.

Projection distortion

A type of image distortion is not caused by defects in, or characteristics of, the lens but through the geometry of the subject and its relation to the sensor. Suppose the subject is flat and presents a square surface. For it to appear square on the image, it must be positioned square on to the camera. Then, and only then, are the distances from the corresponding points on the sensor to the subject the same. If the camera is not square on, then one side will be nearer to the subject than another, so it will appear larger. The difference might seem tiny, but it is sufficient to have an impact on the appearance of the image. In conventional photography, such projection distortion is best corrected using lens and camera back movements. But in digital photography, correction of projection distortion is elementary and easy to effect.

Increasing the canvas size

You may need to increase the canvas size to allow for distortion corrections without losing edges of the image. In Photoshop, the *Canvas Size* command is clumsy and inflexible. The best, if counter-intuitive, way in the latest versions of Photoshop is to use the *Crop* tool.

First ensure the image has plenty of room around it within the window by increasing the window size. Ensure the foreground colour is the one you want.

Select the *Crop* tool, set dimensions in the options bar if required, then drag/draw a rectangle of any size. Now you have a box with drag-handles: drag on these to the proportions you desire, until the box is larger than your image. Hit *Return* and the canvas is enlarged, with your image exactly where you want it.

Adjusting projection distortion

This is commonly referred to as "perspective correction", but it is nothing of the sort. Perspective results from the camera's position – nothing can change that after the event, even with the most powerful image manipulation. But projection distortion is caused by the camera's orientation relative to the subject, and we can certainly play around with that.

One key point to keep in mind is that the adjustments take place only within the confines of the image canvas. If you pull a part of the image off it, you lose it. If you wish to keep a stretched portion, you should first increase the canvas size. Make it a generous increase to give you flexibility as you crop off any excess.

The *Crop* and *Distortion* commands in image-manipulation applications are powerful tools for image rectification. By stretching more along one axis than another you can correct projection distortion. Unfortunately, the consequence of such corrections is that you can lose great chunks from the edge of the image, but the reward is an improved image.

At the same time, you can seize the advantage of your tools to improve your image composition. By pulling on the lower margin of the image, you not only crop off the bottom part of the image, you stretch the sky so it takes up more of the image.

Some software, such as Photoshop, offers tools for so-called perspective correction. These can be tricky to use, but they can also create some wild results that

If you saw this image first, you would not believe it was taken on a simple digital camera from one side, and pointing down slightly. Technically, this is an extremely demanding subject to photograph, yet only a little manipulation work creates a passable imitation of a technical camera at work.

» FOR MORE ON DISTORTION SEE PAGES 40–41

Cropping to the edge
When you are cropping to tidy a scan, the crop margin can approach very close to the edge. You may find it suddenly jumps or snaps to the edge. Your software may have a "Snap to" feature enabled (in Photoshop it is found under the unlikely View menu – where you can turn it off). Or you can try holding down a key while you manipulate the crop: in Photoshop use the *Control* key. Better, use software that automatically recognizes and deletes such edges, e.g. in some scanner drivers.

Transformation tools can be used to create distortions. One of the most efficient methods is offered by the *SuperCrop* tool in PhotoRetouch Pro (*left*). The corners of the distortion can be freely moved within the image, and the distortion can be set either to fill the canvas area, or to conform to the margins of the distortion. Similar effects are possible in Photoshop. For the best results you may need to effect the distortion on a number of steps as this reduces interpolation losses. On the other hand, it is then much harder to control the effect.

offer you a chance to make deliberate "errors" for the purpose of special effects.

Distortion correction

Photoshop can be used to attempt a correction of such defects in the image, but the most obvious tool – the *Spherize* filter – is limited in scope. The trick to using this filter is creating the correct amount of extra space around the image before applying the filter. You may need to change the proportions of the sides to match the filter to the distortion. This is effective if inelegant. If working on a very large file, work on a low-resolution version to speed things up and avoid harming the original data. It will help considerably to display a grid, so you can line up straight lines. As with many filters, you may obtain better results applying the filter a few times with small settings than once with a large setting.

The best solution for lens distortion is offered by the DXO Optics application. This is a sophisticated suite of lens correction applications which are able to correct chromatic aberration, light fall-off, noise, and image softness, as well as distortion. A key feature of its operation is that the specific corrections applied to an image reference is not the image – which you might expect – but the lens and camera combination which produced the image. This approach, of course, does not rely on visual judgements from the photographer and makes complete sense, given that modern lens/camera combinations produce images whose optical qualities are very similar.

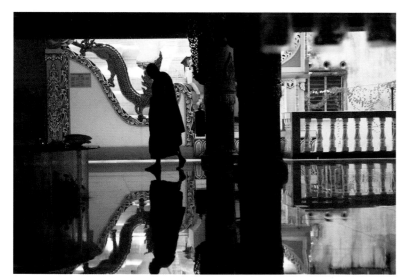

To obtain this picture I had to stand on tip-toes and poke the lens through a gap in some pillars – all while working rapidly. The inevitable result is that it is untidily composed and not well timed. Firm cropping can rescue the image (*see opposite page*).

In contrast to the commercially available DXO, PanoTools is a free suite of software originally written by the mathematician Helmut Dersch. PanoTools uses a powerful image-processing engine known for creating panoramas that also offers powerful tools for the correction of lens distortion based on databases of lens performance. Other tools include morphing, noise reduction, and correction of chromatic aberration.

Cropping

Cropping is an integral part of photography. To frame an image within a wider scene is to crop the scene for the purpose of creating a photograph. Subsequent cropping is a refinement of that process. You may insist on "cropping in the camera", but the fact is that few viewfinders show the image with any great precision. Compounded with that are cropping and misalignment errors introduced by negative carriers, or film carriers in scanners. In short, cropping should be seen as an essential element in the preparation of an image for use. With modern software you can go significantly further in correcting projection distortions while you crop.

While cropping, you can take the opportunity to level the horizon if need be. Notice the crop is aligned to the image, not the frame. A long crop emphasizes the repeating elements and calm atmosphere.

A squarer crop, rotated a fraction to correct the horizontals, makes more of the reflections and the resulting symmetry. Along with the squarish shape, this suggests solidity.

Scan margins

When setting the crop area of your scan, you will normally crop tightly to minimize file-size – very small differences in the position of the margin can make a big difference to file size, especially at high resolutions. But if you have to correct distortion or straighten horizons, leave some free space around the image to allow room for manoeuvre.

» FOR ROTATING SCANS SEE PAGE 43

Artefacts and noise

The deleterious effects of JPEG compression are often most obvious in lighter mid-tone areas (*right*). When applying a filter (*below*), try different settings for the best result.

For the best results, you may need to work adaptively. That is, you make small selections, then apply the filters to each area, adapting the setting each time to fit the features of the image. You can then avoid smoothing areas with detail.

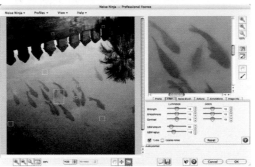

Artefacts are the usually unwanted visible side-effects of the acquisition and processing of digital images. Artefacts are therefore distinct from faults in image quality due to deficiencies in lens performance. A satisfactory way to classify artefacts has yet to be developed, but we can say that image noise forms a major part of the problem, with other artefacts a close second.

Image noise

Noise in an image is similar to auditory noise: it is unwanted because it interferes with clarity. It does not add information, and is usually difficult to remove. Unlike most auditory noise, however, visual noise can contribute positively to the image by giving it a texture where it would otherwise be too smooth.

Image noise is a term that covers a number of different artefacts. In film-based photography, image noise is the result of the way that silver grains vary randomly in size and are distributed in an irregular way. When film is scanned, the grain does not go away. Rather, the noise is augmented by that arising from the scanner.

Scanner noise

All scanners analyse very small variations in an electrical signal in order to obtain information about the object being scanned. These signals become very small indeed when scanning the dark parts of a colour transparency. At the same time, the electrical circuit in the scanner produces its own spurious signals and will also pick up noise from the power supply or electrical activity in the atmosphere. These random effects combine to add noise to a scanner image. The best way to remove these is to make multiple scans.

Camera noise

Noise in the digital camera image arises in similar ways as it does in a scanner: random electrical signals disturb the purity of the information being read off the photo-sensor array. Such stray signals can be detected even when no light falls on the sensor, hence certain noise is called "dark current".

Dark current and other noise present no great problems in most picture-making situations, as the

noise is masked by other artefacts. However, extensive areas of black, as in night-shots or in images where the sensor is set to high sensitivity, may display more noise. This is where isolated pixels are much brighter than, or have unrelated colours to, their immediate neighbours.

JPEG artefacts

The blocky or kernelized texture seen in digital camera images at high magnification is caused by artefacts of JPEG compression. It is more intrusive when compression levels are high – that is, when the input signal (the original image) is low. It may therefore be regarded as a type of image noise.

Removing JPEG artefacts presents similar problems to removing other noise: namely, how to avoid destroying image detail in the process. The main problem is that JPEG noise tends to be equal in every channel, so it is tricky to isolate.

Specialist filters designed to reduce the effect of JPEG artefacts include Camera Bits Quantum Mechanics Pro, and Alien Skin Image Doctor. Both are simple to use, but rendering a large file with high corrections can take several minutes. Neither entirely eliminates JPEG artefacts nor reconstructs lost detail, but both significantly smooth out the more kernelized or blocky tones.

The best results come from working adaptively. Apply the filter to selections, leaving alone detail which you wish to preserve.

Colour aliasing

The demosaicking process (or colour filter array inter-polation) that extracts the full colour data from an image can itself create artefacts. These are most

Noise is not always a bad thing. This shot into a pitch-black corridor has a spooky atmosphere that is greatly enhanced by the graininess of the image. It was captured handheld, using infrared light from a digital camera (the Sony F717) able to record infrared by swinging away the usual infrared absorbing filter. The image is captured in black and white.

Dark noise

Noise is always greater when the signal is weak. In digital photography, this occurs at low-light levels. To combat this, some cameras take what are effectively two shots during long exposures. For half the time, one is a normal exposure; the other half is with the shutter closed. The latter exposure produces a black image with a pattern of noise. When that noise is subtracted from the proper image, a relatively noise-free, cleaner image results. You can imitate this manually.

» FOR MULTIPASS SCANNING SEE PAGE 43

noticeable as bands of pixels of the wrong colour –
hence the name – seen most frequently at edges of
high contrast or sudden colour transition. It is possible
to create a filter that reduces these artefacts, but they
are perhaps best removed by hand as the aliasing
varies with camera and image.

Once you know the defects your camera is prone
to, it is easy to search at contrasted edges and reduce
their visibility. Use a *Sponge* tool to desaturate the
colours or, better, use a brush loaded with a light
colour with its mode set to *Saturation*. This reduces
the saturation to that of the brush colour, so it does
not matter which hue you choose.

Stair-stepping

Another form of aliasing is seen in the stair-stepping or
jagged artefacts (hence the name "jaggies") on edges
orientated at an angle to the vertical or horizontal.
What happens is that a sloping line represents high-
frequency data: to describe it accurately, you need
many and rapid changes in the flow of data. If the
sampling rate of the image is too low to resolve the
changes, the changes appear jerky or jagged.

This artefact is less of a problem than it used to
be, thanks to improvements in two areas. One is the
increase in resolution of capture devices. Digital
cameras with four- or more megapixel sensors are,
for most practical purposes, free of edge aliasing
artefacts; as are scanners with resolutions exceeding

At normal magnifications, image defects from high-quality digital cameras are not easily visible. But increasing saturation or sharpness can accentuate them. In this scene, the high-acutance borders between leaves and sunlight give rise to coloured fringes due to demosaicking errors.

The effects of aliasing (or stair-stepping, or jaggies) artefacts vary with the orientation of image detail. Orthogonal lines will appear extremely sharp – see the vertical and horizontal lines in the image (*right*). But diagonal lines appear heavily aliased. High-contrast lines appear the most jagged, while low-contrast ones (e.g. in the shadows) hide the aliasing.

Do not assume that all jaggies are bad for the image. If you are planning to apply graphic or artists' material effects to an image, the jagged outlines can add to the effect. Here the image has been given the *Photocopy* filter, then the filter was faded in *Linear Light* mode.

Film grain as noise

The film-based analogue equivalent of digital noise is, of course, film grain. Unlike digital noise, graininess is more apparent in the tones between the highest and just above the mid-tones. Grain is less visible in either shadows or highlights because of the eye's non-linear response – shades are not so easy to distinguish at both high and low levels of light. This is important when making corrections to scans: grain compensation should be attempted only after you are satisfied that you have corrected tonal levels.

Defocused spots of light which, on film, would appear evenly lit, are rendered by digital processing as concentric circles. To remove these is a simple matter of blurring each spot of light – but it would be better to avoid having to make any corrections at all.

3000 ppi for 35mm format. The other development is the growing skill with which anti-aliasing techniques – the software algorithms that disguise aliasing artefacts – are being deployed.

The need to disguise edge aliasing is one of the few reasons for using *Blur* filters. You can also try using softening or blurring brushes applied at light pressure just to the most obviously jagged edges.

Adding noise

Noise is not necessarily a bad thing. In moderate amounts it helps create the sense of a "genuine" image – which we could define as one that has not been created in a 3D or other graphics application. Unnatural smoothness of texture and colour is always a giveaway of the artificially created image.

It follows that you do not need to eliminate noise entirely. On the contrary, if your retouching work, such as cloning, leaves a smooth patch, you will need to add noise artificially. This will disguise the retouched areas, to ensure that they match the roughness of other parts of the image.

We might not mind if a scanner cannot penetrate dark areas of a transparency, but a scanner that makes wild guesses at image detail is not welcome. Here the pattern of dark and darker spots in the woman's coat are not due to low resolution, but to scanner noise. Notice also the short, horizontally running lines in the road, which indicate uneven movement of the sensor.

» **FOR CLONING SEE PAGES 54–55**

Advanced colour control

A marine display in Singapore provides the digital camera with a nightmare scenario for colour correction. It is taken through green glass, with mixed lighting from sky and lamps, while the water itself soaks up longer wavelengths.

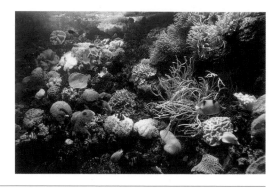

With the *Highlight* dropper selected, we aim at the white coral in the upper-right-hand quadrant. Instantly, the coral is turned white, improving the contrast and mapping the colours to a warmer tone. However, the blacks remain too light.

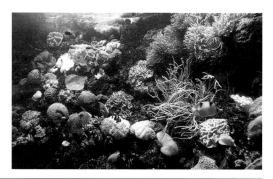

With the *Midtone* dropper selected, we aim at the coral in the middle of the image that should, perhaps, be grey. The result turns the whole image rusty red, showing that the coral was actually slightly blue-green. The contrast is, however, quite acceptable.

Elementary colour control concentrates on correcting colours in the image in hand. But advanced digital photographers know that the exercise is futile if colour is unreliable elsewhere in the operation. Digital colour control is, therefore, not essentially different from working with film.

What is exciting and extraordinary about digital working is the depth and precision with which it is possible to control colour. Elsewhere in this book, we consider colour management – the control of colour coding and reproduction throughout the production chain – but first let's consider some rapid methods of adjusting colour.

Dropper tools

The dropper tools in *Levels and Curves* can be used for colour correction as well as for tonal controls. In fact, you can – with images suffering from a uniform colour cast – correct tone and colour balance with just one touch of the right dropper on the right target.

Shadow dropper

If you choose this dropper and click on the image, the sampled area is set as the black point and all pixels of the same brightness or darker are turned black, and everything else shifts in proportion. If the sampled area is coloured, the shift to black also causes a corresponding shift in colours, thus forcing a colour correction.

Midtone dropper

Clicking with this dropper on your image maps all pixels around the chosen point as the mid-tone, both in brightness and neutral colour. This provides a very quick way of adjusting exposure and colour balance – but only provided you have a reliable mid-tone grey to work with.

Highlight dropper

Having the opposite effect and function of the shadow dropper, this maps all pixels around a highlight. But take care to ensure that you choose a true highlight, or the overall exposure will change. This dropper is particularly effective for balancing colour using an objective, number-based method.

Sample size

Use of a small sample size for the dropper will make the process prone to error unless you work at high magnifications. In Photoshop, set the sample size in the dropper's options panel. Choose the 3x3 average for most work.

Corrections by calculation

You can make colour corrections simply by pulling the sliders about or using the droppers until the image looks right. But what if you are working on an unfamiliar monitor, such as in an Internet café? A more reliable method is to work with objective guidance from numbers, using the *Info* palette. In theory, and if you are brave, you could even colour-correct on a black and white monitor.

The first step is to select an area of highlight with some density that should be neutral after colour correction. What we want is for the highlight to retain its luminance value while turning it neutral, in the process mapping any colour imbalances out of the image. Use a 3x3 pixel sample to find your highlight, keeping an eye on the *Info* panel. You can base your correction on two different options, depending on what is available in your software: either the L channel, or the greyscale level. Make a note of the figure.

Now call up either the *Curves* or *Levels* command and double-click on the highlight dropper. This presents you with the *Color Picker*. Now enter the figure obtained from your reading in the appropriate box and hit *Return*. Next is the tricky step: you must click on exactly the same area that you sampled. Your image is instantly colour-corrected. If you don't quite get it right – the colour is not balanced or the exposure changes too much – you can simply try again.

It is apparent from this that you can apply the same technique using other droppers, making appropriate adaptations. In practice, however, it is easier to locate a clean highlight with some tone than to locate a mid-tone or a shadow.

Finally, we choose the *Shadow* dropper and apply it to a dark area in the foreground. This instantly remaps tonal values greatly to improve contrast. At the same time, the overall colour reproduction appears to be highly satisfactory: the intense blues and subtle russets in the coral in the upper right quadrant suggest that we have obtained a sound balance.

Notice the balance is increasingly blue towards the background. A shadow sample taken from the background would ruin the impression of distance through the waters.

Losses with colour conversion

Some colour manipulations are easier to do in different colour spaces. Colour corrections in *Channels* is often easier in CMYK than in RGB. But beware that conversions between colour spaces entail slight losses of data – colours which fall out of gamut in the translation from one space to another are not restored on the way back to the original space. It is best to avoid converting from one colour space back into another too often.

» FOR UNDERSTANDING DIGITAL COLOUR SEE PAGES 20–23

Replace colour

You can manipulate bands of colours in a number of different ways: in the *Hue/Saturation* control, by selecting like colours using the *Magic Wand*, and through commands such as *Replace Color* and its equivalents in other software.

These methods share a common danger: too great a change causes an unsightly frontier region. If you need to make a substantial change in colour, you should do it in several, smaller steps to ensure softly graduated transitions. Colour adjustment tools found in PhotoRetouch Pro and in Corel Photo-Paint are capable of greater finesse.

Colour through Channel Mixing

Another method of adjusting the overall balance of colour images is to manipulate the relative strengths of the channels using the *Channel Mixer* command. You can reduce or increase the strength of each channel independently. Note that if you wish to keep the overall exposure level the same, the sum of the different channels should add up to 100%.

The *Channel Mixer* (in Photoshop, under the *Image > Adjustments* menu) does a very good digital imitation of the coloured lens filter in film-based photography. As a result, the changes given by this command can range from savage to delicate, but it can create surprisingly pleasant results when applied to strongly monochromatic images. Like camera filters, *Channel Mixing* is effective at changing the overall mood of an image.

A colourful clothes shop in Kuching, Sarawak, is lit mainly from domestic tungsten lamps, giving a warm cast. The notice in the lower right corner should be white, so it was taken as the sample point.

The value of the *Lightness* channel in the sample is 92 (*above*). When we double-click on a dropper, the *Color Picker* dialogue appears (*below*). We type "92" in the box for the L channel, or drag the colour picker in the colour well until the figure shows in the box. After dismissing the dialogue, we resample the very same point in the image. This remaps the colours. You can see (*below*) that the notice is now white and the colour cast is largely removed. However, it is not wholly removed, but some light in the scene came from outdoors, so greater levels of correction are needed as we reach deeper into the shop.

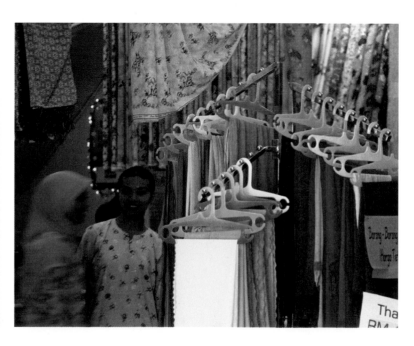

Applying colour profiles

While the majority of experienced workers know to use adjustment layers, few know that the same trick can be applied with a colour profile. A profile does not touch the image data: its job is to tell the software (for the monitor or printer) how to interpret the colour information it is presented with. It follows that you can use colour profiles to change the appearance of an image without touching one iota of the data.

In Photoshop, you have to turn *Color Management* off (an apparent contradiction) before changes made to profiles will be visible. This is because with *Management* turned on, every new profile you assign will simply make the image look the same – exactly the job it is meant to do.

You may apply profiles one after another until you obtain the correction you need. The changes often seem to adapt to variations within the image, so they are very subtle and delicate.

Better still, you can construct your own profiles. These are not "real" profiles as they do not relate a colour space to the profile connection space; but they enable you to shift white balance as well as colour values and gamma (brightness/contrast).

The procedure is as follows: in the *Color Settings* control of Photoshop or similar software, you will be asked to select different RGB working spaces. It is useful to start off with a ready-made space the effects

The importance of adjustment layers

It is worth repeating the many advantages to working with adjustment layers (*see pp. 48–49*). The most often cited is that you can make as many changes as you like via the adjustment layer, but you will not touch the data. One result is to preserve the integrity of data through extensive manipulations. Another, practical, advantage is that you can make different settings on different layers and quickly switch between them to assess which you prefer. Beware, however, that if the image has gaps in its colour data, using adjustment layers is not reliable.

The *Channel Mixer* control is well known as a way of separating colours prior to creating a greyscale image. First check the *Monochrome* button in the bottom left corner (*above*). By the same token, it is a powerful way of controlling overall colour, acting just like a camera filter. You adjust the source channels of red, green, and blue contributing to each of the colour channels of red, green, or blue, thereby controlling the strength of each channel. In theory, the three channels should add up to 100% to keep the exposure the same – which offers another control to work with. *Constant* changes brightness.

» FOR MORE ON REPLACE COLOR SEE PAGE 77

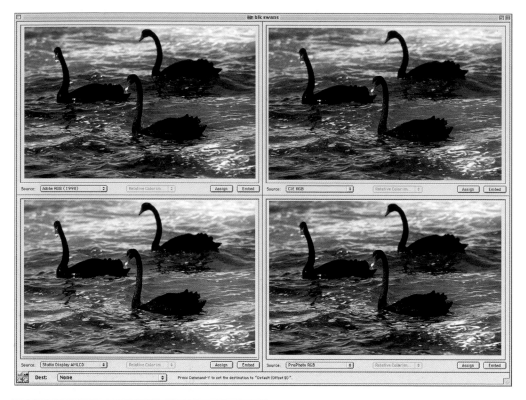

The growing awareness of the importance of colour profiles is shown by the increasing numbers of software utilities. The What Profile? application allows you to display four different profiles applied to the same image, with differing rendering intents for a given destination colour space, or none. As most profile changes are very subtle, this is an excellent way of assessing the relative merits of embedding different profiles into an image. Without this utility, you have to assign profiles one by one, using the *Menu* command.

The *Custom RGB* dialogue box of Photoshop, and its equivalent in other software, will share the same features: settings for gamma, white point, and primary colours. This offers a very powerful yet neglected tool in image manipulation.

of which you like. Now choose *Custom* from the menu. You will be presented with a dialogue that allows you to change a number of parameters, depending on the software. You can change the red, green, and blue values – the basic colours of a monitor – the white balance and the gamma.

Ensure that the *Preview* box is ticked and make your changes. It may help to look away from the screen when you make a change as your eye may adapt to small changes, encouraging you to set dramatic rather than subtle effects. When satisfied, give the profile a descriptive name and close.

Once you have created a set of profiles, you can assign them to your images under the *Image* menu. An ideal software for this is the Typemaker What Profile? application (*above left*). This can be accessed through Photoshop, and shows four-up versions of your image. When you are satisfied with its appearance, you simply embed the profile within the image. Using profiles, you can force even quite dramatic changes without damaging your image's integrity.

Photoshop is the most accessible way to manipulate ICC profiles directly, but it is rather clumsy. If you wish to work more extensively with colour profiles, you need

Mastering control points on curves

If you click on the image with the *Curves* dialogue box open, the point on the curve corresponding to the input value is temporarily displayed. But if you *Command* (*Control*) + *click*, the point is added to the curve – and only that curve if you have one channel showing. If you want to add the control to all channels, then press *Shift* as well i.e. *Shift + Command + click*.

IS RGB or CMYK better?

There is much debate between professionals over this question. One camp says you should work with as much data as possible: converting to CMYK can lose a good deal of data, so it is best to work in RGB. The other camp says that by spreading out your data over four channels, you can make more accurate colour corrections, and points out that your output will be in CMYK space anyway. The right answer is that it depends. For most purposes, working in RGB is simple and intuitive, best for Web work – and probably for today's wide-gamut ink-jet printers. For pre-press work, CMYK space is best. However, Lab is better than either when strong colour changes are required.

professional-quality software (at professional prices), such as that available from Monaco or Qimage.

Working in CMYK or Lab space

In some ways, RGB space is the trickiest for colour correction. While it is intuitive, the distribution of data easily leads to overcorrection. Working in CMYK space spreads the data out over four different channels; as a result, changes in any one channel do not have as large an effect as a similar change in RGB. This makes it easier to make subtle corrections. In addition, if the image is destined to be printed, you will be working with the printer colours from the outset – so helping to minimize output errors.

In contrast to CMYK, Lab space is useful when you need dramatic changes to rescue an image with very poor colour. The channels define variations in hue – from green to magenta, and from blue to yellow. Altering the curves offers colour correction where the colour cast varies across tone-bands. In short, Lab space is ideal for dealing with strong colour casts. Further, manipulating the a or b curves provides an effective way to improve the strength of colours.

Different colour problems with images that are easily solved in one colour space may be tricky in another, so the art is in choosing the right space.

A monochrome image may appear not to need careful colour control, but the opposite is the case. The most subtle changes can significantly improve an image. Special small-gamut inks are available to improve colour control when printing in mono.

A copy of artwork may appear, when seen in isolation, to lack saturation and contrast. But that is the accurate rendering of the subject – not all images have to be strongly coloured or well contrasted.

» FOR DIGITAL COLOUR SEE PAGES 20–23

CONTROLLING SATURATION

Let's explore one of the most subtle and most problematic forms of colour control and reproduction.

Saturation – colour purity or richness – is the greatest weakness of most colour reproduction systems trying to please the human eye. This is very much the case when printing with the four subtractive primary colours. And operationally there are many recurring problems.

Colour monitors can easily project highly saturated colours. The process of soft-proofing an image – checking its appearance in CMYK on-screen, without having to print it out – often juxtaposes an insipid image with your vibrant one. The tendency then is to compensate for the soft-proof by increasing saturation until it nears that of the screen image. Unfortunately, when printed out, these images often look unnaturally saturated – which would be obvious from the screen image if the image was looked at separately and dispassionately instead of in comparison with a projected, additively synthesized image.

Hue/Saturation control

This control, under the *Image > Adjustments* menu, is the obvious control to reach for. In general, if you find yourself racking saturation up by more than 20% or so, you should worry about whether you are doing the right thing. If anything, you want to be reducing saturation. Like all commands, however, the best results often arise from selective usage. In the *Hue/Saturation* control of Photoshop, you can try selecting bands of colour (*Command (Control) + 1, 2, 3,* etc. for reds, yellows, and so on). These bands of colour can be altered after you have selected a band by clicking on the image or by dragging the sliders.

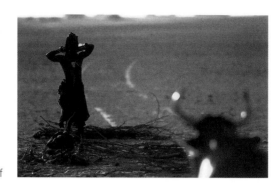

1 DUPLICATE LAYER

The first step in any layer manipulation – indeed, in any manipulation – is to duplicate the background layer. As we are not using masks, there is no need to turn it into a floating layer. In Photoshop, select the layer. The short-cut key for duplicate layer is *Command (Control) + J.*

2 CHANGE LAYER MODE

We are working in Saturation mode, so run down the menu in the *Layers* palette or else, in Photoshop, hit *Alt (Option) + Shift + T.* Keep the opacity at 100% for the present.

3 REVERSE TONES

As the top layer has exactly the same saturation as the lower, changing the layer mode to *Saturation* makes no difference at all to the image. Now what we want is to tone down the lighter regions, so try reversing the light tones to dark ones. To do this without reversing the colours we need a colour space in which luminance is separated from chrominance. Changing to work in CMYK mode fulfils this requirement.

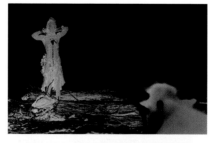

4 ADJUST TONES

First select the *K* channel in the *Layers* palette, then invert it (use *Curves* or, in Photoshop, use *Command + I*). The result is too violent, so turn to *Levels* to calm the contrast down.

WORKSHOP: 1

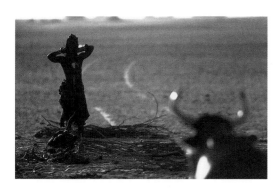

5 ASSESS RESULTS

If we compare this manipulation – of the manipulated K layer – with a straight reduction of saturation, it is clear that the selective desaturation is preferable. However, it is still not convincing.

Saturation layer mode

This is a little-used layer interaction mode that manipulates colour saturation. It takes the saturation of the source layer and adds that to the colour values (hue and brightness) of the destination or underlying layer. The trick, then, is to be clever about the manipulation of the top layer.

In this image, at dawn in the Namibian desert, the scanned file was overworked and the saturation overall is rather too heavy. In particular, the colours of the cow's ears are intrusive.

The remedy then should be obvious: we want to reduce saturation in the lighter tones, while maintaining saturation in the darker areas – such as the woman yawning and stretching.

6 ANTI-MATTER FILTER

For reversal of tones without changing colour balance you may use a pre-set such as the *Anti-matter* filter from Alien Skin. Failing that you can turn the image to *Lab* mode, then use the *Curves* control to reverse the tones. The aim is to reverse tones without making the former shadow areas too weak.

7 APPLYING ANTI-MATTER

The first try was not quite right, so a few others were attempted: the key was to invert brightness only partially, and slide in only a very light desaturation. The result is just by a fine margin better than using the inverted K layer after slight reduction in opacity. There is more colour in the darker parts of the cow and in the figure, yet the image lacks the weakness of overall desaturation.

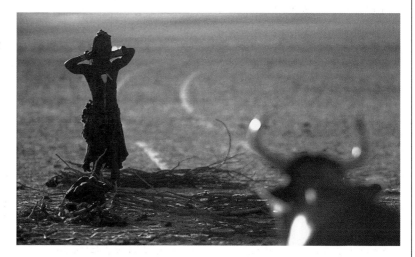

Advanced masking and selection

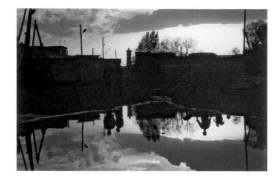

In the attempt to capture an extremely wide luminance range, I decided to expose the sky correctly, rendering the shadows nearly black. I select the shadows to limit tone corrections.

If you set too large a feather zone (*above*) for the selection, a well-defined area (*right*) becomes too broad (*far right*).

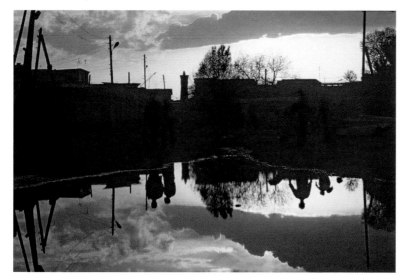

After selecting the darker areas of the image, one can apply *Levels and Curves* corrections to attempt an extraction of detail from the image. The scan was made with 16X oversampling or multiple scanning, which extracted far more information from the shadow region than a single pass would have (unless we had access to a drum-scanner). Despite streaks and unevenness in the scans, the result is an improvement on the original.

Masks and selections (also answering to the more intuitively informative term "editable areas") are two manifestations of the same thing. On-screen, selections are shown as the area bounded by a line of "marching ants" (a moving, dotted line), which encloses the editable area. In fact, the marching ants usually define the mid-point between pixels that are wholly selected and those which are ignored – others lie on a transitional zone, the so-called feather region. As a result, it is difficult to know exactly where the editable area starts or stops.

Working with masks

The mask comes to the rescue. It shows, by gradations of black through white, the strength and extent of a selection. Black, by convention, indicates unselected, white fully selected, and greys corresponding degrees of selection. Now, when a mask is laid over an image, the practice is to display it as a red "rubylith" – as if red paint has been applied so that what is not covered is the editable area; and everything lying under the red "paint" is protected from the editing process. The crucial point is that a mask is a greyscale representation of a selection.

Drawing a selection is easiest on subjects with clean, contrasty outlines, e.g. well-lit man-made objects. But masks are easier to apply over softer shapes such as faces and landscapes. Masks can also be applied by using an appropriate brush. Another difference is that a selection applies to any active layer, including any channels. Masks tend to have their effect limited to the layer on which they are created.

Masks and selections

One method of making selection easier when your subject and its background are not greatly different is temporarily to exaggerate their relative differences. You can then draw the outline you need before returning to the original image. In Photoshop, the easiest way is to add an adjustment layer to increase the contrast so that image boundaries can be found more easily. After making the selection, you can discard the adjustment layer.

If your software does not have adjustment layers, you need to save the selection, then reload it. That is,

first increase your image's contrast, then make the selection and save it. Return the image to normal contrast, then load the selection.

Defringing the selection

However carefully you make your selections you are likely to leave a few pixels on the edge which do not belong either to the selected object or the background. This often happens because of unsharpness in the image, or a bleeding of colour from background into the object. Try the *Defringe* command (*Layer* > *Matting* > *Defringe*). This averages the edge pixel values with that of the background to reduce the suddenness of transition. Try the one-pixel defringe before trying two or three pixels.

Often a selection is fringed in white or black pixels. Most image manipulation applications offer tools such as *Remove Black Matte* or *Remove White Matte* which help to crop excess pixels.

Visual judgement of feathering

This uses the *Quick Mask* mode in reverse. Suppose you make a selection, but are unsure exactly how much feathering you should be using. To change the feathering setting through the menu command is pure guesswork. Instead, turn to *Quick Mask* (in Photoshop, press *Q*) and your selection will be shown as a rubylith.

Now you can blur it using any filter, such as *Gaussian Blur*, which enables you to monitor the

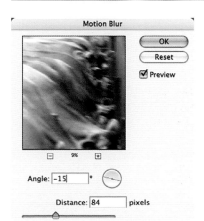

What is feathering?

Feathering is the creation of a zone of transition between one area and another. A feathering radius of 10 pixels means that starting from a pixel that is fully selected, 10 pixels across the selection line pixels are 50% selected, and another 10 pixels from that mid-point, pixels are 0% selected, with an even gradient in between. We have yet to see a software offering that can control the feathering gradient. Feathering should not be confused with anti-aliasing, in which pixels at a boundary take on intermediate values in order to disguise stair-stepping artefacts.

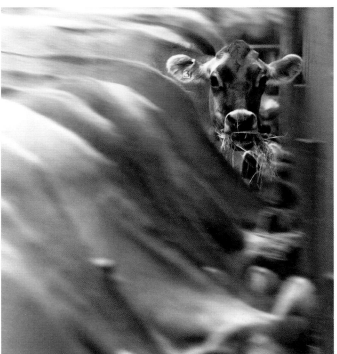

The *Motion Blur* filter, applied with 90-pixel length and at a slight angle away from horizontal, serves to highlight the cow without making it too obvious that a filter was applied.

» FOR STAIR-STEPPING SEE PAGE 64

precise extent of the blurring. Accept the filter, then hit Q again to change the quick-mask back to a selection – this time with the exact level of feathering you require.

Reducing masks without erasing

To fade or graduate a mask, a common mistake is to attempt to erase it – which works, but badly. Remember that white is, to a mask, a reduction of the masking. So draw a black-to-white gradient over the mask: this makes the mask now run from full to zero opacity. You can achieve the same effect in *Quick Mask* mode in Photoshop: draw your gradient in *Quick Mask*.

Using masking applications

In response to inadequate methods for selecting tricky objects, such as hair and glass, in earlier versions of Photoshop, software engineers developed their own methods. The best-known are Extensis Mask Pro and Corel KnockOut. In reply, Photoshop introduced the *Extract Image* command. But they all work on the same principle.

First you must define a transitional zone: from pixels that must be saved, to pixels that must be discarded, and, in between, those with blended values. Then you tell the software which areas are to be preserved, and which to be deleted – you are defining the foreground to keep and background to lose. When you apply these, the software delivers or applies a mask.

The secret of success with using any of this software is to be very careful over the definition of the transition zone: the narrower it is, the more accurate the mask will be. It is also helpful to increase image contrast temporarily, e.g. by adding an Adjustment Layer, as this exaggerates image boundaries. After creating the selection, discard the Adjustment Layer. As in all masking/ selection operations, it is helpful to work at generously higher resolutions than you actually need for output.

Working with selections

Selections are easier to grasp intuitively than masks. However, as selections become complicated, it becomes more difficult to tell what is enclosed, and what is outside. All professional-quality software allows you to add and subtract from your selection

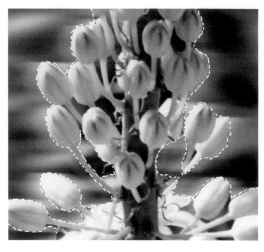

This glorious spike of flowers was seen on a roadside in Greece. The inevitable high light levels and my use of ISO 400/21° film meant that it was not possible to set an exposure that sufficiently blurred the background so the spike did not stand out from the background (*above left*). I used the *Magnetic Lasso* tool to select around the flowers (*above right*), inverted the selection and applied different blur effects. I finally chose the "Zoom" blur for being extremely eye-catching, if unsubtle. But the flower is revealed in all its glory.

without having to start all over again. In Photoshop you hold the *Shift* key down to add, the *Option* (*Alt*) key to subtract. Always remember to save the selection if it is at all complicated – it is much easier to discard selections than to redraw them. Saved selections can be loaded, i.e. used not only on the original, but also any other image.

Lasso and Color Range

The basic selection tool is the *Lasso*, which is available in all image manipulation software. It is best for selecting disparate areas with different colours and exposure. But you will find that for many separate, small areas it becomes very tedious to work with; if so, consider other selection methods such as *Color Range,* which is more flexible and often more versatile than using the popular *Magic Wand* tool. You can change fuzziness (a tolerance setting) at will, and it works faster than the *Magic Wand* where you need to select across the entire image.

Software such as Photoshop offers other flavours of *Lasso*. Where you have clearly defined objects that are distinguished by colour and exposure from the background, the *Magnetic Lasso,* or equivalent, is a good choice. In theory, if your hand wavers from the proper selection, the *Magnetic Lasso* keeps to the object. Its Sensitivity and Tolerance settings can be altered to match your image to give accurately drawn selections. If you need to select irregular areas with straight-line borders, the *Polygonal Lasso* is the obvious tool.

Growing and shrinking selections

In professional-grade software you can expand or reduce the size of the selection after you have made it. This can be useful. But beware that you have no control over the direction of the alteration, so you may radically alter the shape of the selection. In particular, growing and selection will round off or smooth sharp corners, while shrinking may leave "islands" of isolated pixels.

Changing feathering

In most software, you change the feather radius after you have made a selection. If you increase feathering, beware that the outline of "marching ants" will round off, so there will be no sharp corners. Reducing the feathering does not make the shape more precise.

Coins thrown in a fountain have been arranged by water currents into patterns. It is easy to select a large number of separate elements of similar colours, yet be able to distinguish small colour differences. The red coins represent the copper coins among the silver ones – the difference is not great in the original shot, but *Replace Color* (*left*) is able to distinguish between them. The screenshot shows how the colour of the coins was made more red, and the saturation increased to maximum and lightened.

Alpha channels

An additional channel to the three RGB or four CMYK channels of an image can carry masks or colours. These extra channels are often referred to as alpha channels. "Alpha" refers to a variable in the mathematical description of the way one channel interacts with another. It is a useful term, for it distinguishes these extra channels from the basic colour separation channels.

» FOR CHANNEL MIXING SEE PAGE 69, AND DEFRINGING SEE PAGE 85

MASKS AND SELECTIONS WORKSHOP
With the powerful tools available you can handle images with very fine detail

This shot of a sheltered pond in the gardens of Inverewe, Scotland, is rich with repeating forms, and rhythmic sweeps of colour. As an experiment, let's see what it looks like if the sky reflected in the pond is not the usual Scottish murkiness, but a Mediterranean depth of blue.

A shot from an airplane provides the evenness of blue that we need. So, our task is now to pull out the elements of sky from the image so that they may be replaced with the new sky. At the same time we want to retain some sense of reality or acceptability.

We make use of two sides of the same selection method: *Magic Wand*, and *Color Range*. With *Magic Wand* you click directly on the image to select pixels that are similar to those sampled, within limits or tolerance that you set, and you can choose to include only pixels that touch each other (are contiguous), or not.

With the *Color Range* command, from the *Select* menu, click on a preview to select all related pixels – the selection is, by default and necessity, non-contiguous. What is little known is that you can add to the selection and subtract in *Color Range* by the usual way: holding down *Shift* or *Option*, as appropriate.

One major feature of *Color Range* is that you can select wavelength-bands of colour – useful if you need to tone down skin tones, for example. And you can select out-of-gamut colours – useful for toning these down to within gamut.

1 The image, originally shot on a digital camera, is improved tonally and its defects cleaned. In particular, we need to reduce JPEG noise as much as possible. Next, the image is sharpened through USM. Normally, we would leave sharpening to last, but as there are complicated outlines to select, a little sharpening helps speed up and clarify selection.

2 With a higher Fuzziness setting, more of the reflection is selected. By holding down the *Shift* key, we can click on another, unselected area, to add to the selection. Hit *OK* and the pixels chosen will be enclosed by marching ants. Now, remember that in order to work with layers, your image cannot be on the background, so change that into a *Layer* in the *Layers* palette, if that has not happened already automatically. We can erase the selected pixels to transparency ready to drop the sky image behind.

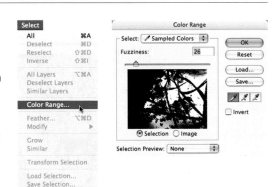

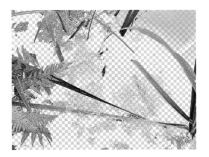
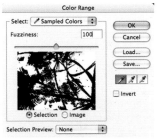

3 As the area we wish to remove – the reflection of the sky – is very even in colour, the best selection tools are *Color Range* or *Magic Wand*. The advantage of *Color Range* is that it is easy to vary the tolerance or fuzziness setting to capture more or fewer pixels, according to how different they are from the one you first sampled. With a low tolerance setting, only a small area of the image (shown white in the preview window of the screenshot) is selected.

WORKSHOP: 2

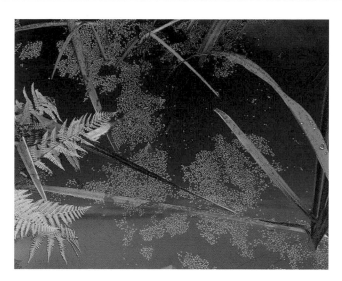

4 First ensure that the image to be pasted in is the right size – it saves fiddling later. The easiest way in Photoshop is to select the *Crop* tool, and with the receiving image on top, click on *Front Image* in the *Option* bar. Then open the sky image and crop a suitable area: it will be the right size. Now, select all and copy it, then move over to the pond image.

By default, pasted-in images always land on top of the receiving layer. So you need to reverse positions and immediately you see the sky behind the pond weeds. But this makes it apparent that we have selected too much. There is an unnatural lack of dark reflections, particularly on the left side.

5 We now turn to the *Magic Wand*, which selects pixels similar to those sampled. First check that Contiguous is ticked. If not, as here, click on the box. This will limit the selection to the immediate neighbourhood of the sample.

Hold down the *Shift* key as you sample, and you can add separate areas as seen in the fronds of the shadow of the fern. If you make a mistake, hold down the *Option* key and sample at the same spot, then return to the *Shift* key.

 Tolerance: 15 ☐ Anti-alias ☐ Contiguous ☐ Sample All Layers

6 By removing some of the dark reflections on the left of the image but leaving others, the compositing looks more natural. If you need to alter the tonal balance between the two layers, it is obviously easier to do so before flattening the layers onto the background. The close-up view shows how intricate the selection has been. Without *Color Range* to do the work, it would have been an utterly tedious task to select around every little leaf.

Working with type

Mixtures of type with very different letter-forms are usually unattractive. The first line of cursive (Edwardian Script) has fine lines, which may cause difficulties in printing. It is also not amenable to many text effects apart from distortion. The middle line, Copperplate, features small serifs, which are easily lost. But the even weight of stroke makes words easy to read. The most versatile type style for text effects are the grotesque faces – the bottom line – such as Arial Black.

The best way to add text to images is not to use image manipulation software at all, but to turn to desktop publishing software such as Quark XPress, Adobe Pagemaker, or Adobe InDesign, or even graphics packages such as Adobe Illustrator, or Corel Draw. However, for special effects with text, you can work within image manipulation software such as Photoshop, or Corel Photo-Paint.

Although the majority of image-manipulation software will handle fonts, not all do so in the most convenient way. Ideally, the fonts should remain fully editable – be in a form which allows letters to be added or removed, and changes in size, spacing and the like to be made.

Fonts and images

Fonts differ from digital images in that the shape of a letter-form is defined by commands such as rotating, extending, changing direction of a line. These commands make no reference to resolution, so with some methods of output or rendering, the full resolution of the output device can be used – this is the property of resolution-independence. Technically, fonts are said to be vector-based, whereas digital images are bit-mapped, i.e. inextricably tied to resolution. It follows from this that, for a font to be

You do not need powerful layer effects to have a lot of fun working with type on images. Simply changing colours and type size can give you a good deal of scope for effects to meet needs from greetings cards to poems, and business cards. The secret, as always, is to avoid overdoing the number of effects as shown above. A smaller range of colours, even varieties of grey, would be more effective.

Creating custom fonts

If you want to adjust a font for your own use, you do not have to do so in a graphics program. Add the letters you want to manipulate into a new document (in greyscale or colour) using the *Type* tool. Convert the type to a path or shape under the *Layer* > *Type* > *Convert to Shape* menu. Choose the *Arrow* tool (shortcut: A) also known as the *Direct Select* tool, and pull the shape to your heart's desire. Now you have the shape, you can use the *Pen* tools to add and subtract points for more changes.

output, you have a choice. It can be turned into a bitmapped image, or it can retain its vector information.

Bitmapped fonts

The vector outline for characters can be translated onto the bitmap raster. Typically, there are problems with slanted or non-orthogonal lines – which is to say, nearly all of them. The process of translating the vector slant into bitmapped form creates stair-stepping artefacts (jaggies). These can be reduced with aliasing – shading adjacent pixels to smooth out the jaggies. At small sizes, however, this has the effect of blurring the font outline. But an advantage of using bitmapped fonts is that there is no need for the output device to have access to the font description.

In practice, you should work at the highest available resolution when using type. Ensure the type can be read at the size you output the image to, and in combination with the image you use. Characters are far less legible against a busy background compared to a solid colour. Type designs that tolerate bitmapping better than others include those with strokes of equal weight, sans serif faces (ones that lack serif faces' "tail" ornaments), and ones with angular letter forms. Conversely, type that is unsuitable for bitmapping include decorative fonts, and those with long cursive or calligraphic flourishes, those whose weight of stroke varies greatly, and those reliant on fine serifs.

Vector fonts

These can be scaled up or down at will to any size your device can handle. Yet each character will be printed at the full resolution of the device, so they are said to be resolution-independent. This is possible because the fonts only describe the shape – the rest is up to the software and printer.

The advantage of using vector fonts is that the characters are very sharply drawn irrespective of output size. However, it is necessary for the output device or driver to have access to the font description itself, separately from the image. Some file formats, i.e. PDF, allow you to embed fonts so the font description is part of the document. But fonts using false bold or italic styles and warped text cannot usually be embedded.

Vector fonts are also inaccurately called "outline" fonts, after the old process of photo-typesetting in which a master outline was projected at different magnifications to create different type sizes. However,

These close-ups of the text show the effect of different aliasing regimes. Without any aliasing, curved and sloping portions of the type are jagged, but orthogonal (right-angle) lines are very clean (*top left*). With smooth aliasing the curves and sloping lines are improved, but right-angle lines are softened (*top right*). Sharp aliasing improves the right-angle lines over smooth aliasing and is overall the best – but only for the face being reviewed (*above left*). Other faces and magnifications may benefit from smooth aliasing. But sometimes it is best to apply none at all.

» FOR MORE ON STAIR-STEPPING SEE PAGE 64

there are limits to how far type can be resized this way: the proportions of serifs to stroke width vary with font size. In order to respond to the need to change these proportions as font sizes vary, vector fonts incorporate special data called "hints". These ensure, for example, that at small font sizes the difference between a thin stroke and a thick one is visible but relatively small. As font sizes increase their strokes can be a fraction of the width of a thick stroke.

Simple text effects are usually the most effective, allowing the text to have its say, and not be overpowered by gaudy effects.

Beware of black type

Black type should appear really black. If you place black type onto an image – photographic or otherwise – beware that you may need heavy black inking to make the type satisfactory, which could impact adversely on the reproduction of your image. Run a test or consult your print shop. Related to this, bear in mind the following: if you need small type in black, or fine black lines (such as key-lines for boxes), then set maximum grey-component removal (GCR) to prevent other colours being used to print the fine details, which will soften due to misregistration.

The *Layers* palette (*above*) displays all the effects applied to the image (*right*). Note that each one can be changed quite independently of the other.

There is no reason why you should not have fun playing with the thousands of effects available. But it is another matter to use them all on one image. The one on the left shows an example of overuse, and also the further limits of how many effects can be applied without one masking another. This image uses drop and inner shadows, outer and inner glows, a bevel as well as emboss, then a gradient overlay (giving the rainbow colours) as well as stroke to add extra colours. The complicated dialogue for the commands (*above left*) encourages endless experimentation.

Layer effects

Modern software offers thousands of ways – from subtle to extravagant – to manipulate type and effects. It is important to refrain from using too many effects in your image (such as the six effects in the example on the opposite page). And some would say two effects is one too many. In fact, it is not the number of effects, but the strength at which they are applied which is most important.

Bear in mind that when printed, the crisp outlines of type make them very distinct from the image. Too high a contrast between the type and image is very distracting and destructive of the visual effect. Also, bear in mind that any large areas of even tone provide a strong visual presence, so it is best to avoid using vibrant, deep colours when type is used large.

Clipping paths

In some circumstances, you do not have to erase or remove unwanted portions of your image, such as the background. You can use clipping paths. These act exactly like a mask, but only as far as the printer is concerned. Although the background remains on the image, the printer will recognize only that part of the image within the clipping path. The path has the effect of creating a transparency.

Clipping paths are easy to use in software that offers the option. You draw a path, or lasso, around the area you want to preserve, then turn the path or selection into a clipping path.

Two major points you need to watch out for: as paths are vector-based, they cannot have soft or feathered edges – the edges are as sharp as the highest resolution used in the output will allow. This means that clipping paths are ideal when used for text, but they need to be used with care. Second, ensure that your printer will recognize clipping paths: PostScript-driven printers will recognize clipping paths where they are saved as Photoshop EPS, DCS, or PDF files. If you do not have a PostScript printer, you may have to export the image and path to software that recognizes the path, and then print the document from there. Beware too that clipping paths, particularly those with complicated curves, are notorious for being a source of output problems.

One of the most graphically powerful and versatile devices is the type mask, in which type appears to be stroked or written with an image on top of another. There are many different methods of achieving the effect – from specific type mask tools, to creating type as clipping paths in illustration software and importing them to create masks. Each method has its advantages, but the key is to choose your component images with care for contrasts in colour or tone. In the above image, type was entered, then a clipping group created with an adjustment layer.

Bitmaps and vectors

There are two fundamentally different ways to describe any two-dimensional image. The pixel-based image is a bitmap – it is built up, pixel by pixel, across a raster or array. Bitmaps are ideal for photographic images with lots of detail. The resolution of the output depends on the size of the bitmap file. In contrast, vector-based images are built up from the application of standard strokes and operations such as rotate, translate (move), or fill. It is possible to describe a photographic image in vector form, but vectors are better for simple graphic elements like letters and logos. Output resolution is limited by the output device.

» FOR MORE ON SELECTIONS SEE PAGES 76–77

Advanced compositing

Composites may be made from any size, shape or quality of components appropriate to the image you have in mind to create.

It then takes the careful creation and manipulation of masks to blend them in a visually convincing way. Masks,

adjusted by painting in black or white, determine exactly where images show or overlap.

With a history almost as long as that of photography itself, photomontage or image compositing has been incalculably boosted by digital image manipulation. Composited images are the best-known face of image manipulation, yet in fact they form only a minority of image work. In digital image manipulation, compositing or photomontage techniques are advanced by the use of layer modes and interactions, as well as by the exploitation of gradient effects. First, let's consider the techniques for isolating a subject.

Erasing the background

To isolate an object in an image, you usually need to remove the background. The first step – as in any layer-based manipulation – is to change the background to a layer. Thereafter, the obvious erasure method is to call up the *Magic Wand* to select the background pixels, then hit *Backspace*. This is quick and easy, but it may leave untidy edges where the *Magic Wand* could not distinguish between background and object.

Another method is to use the *Background Eraser* combined with a path. First, select the *Background Eraser*. Set an ample brush and lower the tolerance to between 15–30%. Next, draw a path using the *Pen* tool just outside the object – the path can have free ends; it does not have to enclose any area. Then choose *Stroke Path* from the *Paths* palette. When you are asked which tool to use, choose *Background Eraser*. This cleanly removes the background close to the object, but leaves the object largely untouched. Adjust the tolerance setting on the *Background Eraser* if need be. You can now use the *Magic*

Composite layer copying

You may want to copy several layers at once, but not all of them. First select as much of the top layer as you wish, with all the layers you want copied visible. Now, to copy in Photoshop, hold down Shift in addition to the usual Command (Control) + C. This copies all visible layers within the selection area. Note, however, that when you paste, they are dropped together as one layer. If you want composite layers, you need to select, copy, and paste each layer separately.

Wand or another eraser tool to eliminate the rest of the background.

Your object must remain on a layer: if you try to flatten it, the transparency will become solid white (or take on the background colour if you have pasted it into a new document that has one).

Defringing

When you have removed an image from its background, you may find that a fringe of unwanted pixels clings to your object. This happens because the pixels were sufficiently similar to the edge of the object not to be selected, but are now sufficiently different from the object to be apparent. One way of dealing with this is to average out the colours at the edge, to reduce the differences. This is the job of the *Defringe* command, found under *Layers > Matting*.

Turn Background to Layer

A common error when working with layers is to leave the *Background* layer – which is set by default when you create an image – as a background. This limits your options, as you cannot change its opacity. But once you have created layers, you can decide to change their order in the stack.

Ultimately, though, you need a background with no layers at all, because that is the best state in which

Panorama applications, such as PhotoStitch (*left*) offer some interesting compositing effects. You can create large ensemble images by forcing the merge of disparate elements (*above*). Some components are distorted in the attempt to match image features to effect a seamless blend. At times, the software delivers wild distortions that you would not have the nerve to create yourself.

» FOR MORE ON DEFRINGING SEE PAGE 75

The simplest designs — such as images on a plain white background — can be effective while appearing clean and modern. In this test image for a picture agency, three students waiting in a hallway were isolated (*right*) and a motion blur applied (*below left*). One was copied, transformed to reduce her size, and moved, iteratively. The same regime was applied to another student. Finally hue and exposure were adjusted.

to output the file. The reason for this is that different programs code the layers in different ways, so you cannot be sure that the layer interactions have been correctly defined — as is sometimes the case when the image is saved with layers (floaters, or other items above the background) intact.

Matchmaking

In a skilfully composited image, elements should not only be seamless, but also match. After all, there is no point striving for a perfect seam between elements if they do not match in other ways. To get the perfect match you should observe the following factors.

Gamma

The tonal qualities of the elements should be appropriate to their position, distance and relation to the lighting in the image. For instance, a very distant object should be at a lower contrast than one that is nearer. An object in the shadows should not only be darker, its gamma should be lower.

Density

The maximum and minimum densities of the elements should also be appropriate to their position, distance, and relation to the lighting. Nearer objects

are more likely to be fully dark, and less likely to be very bright, except in their specular highlights.

Colour balance

The colour balance of composited elements should match, and also be appropriate. This does not mean that the balance should be neutral; rather, it should work with the background. Given a sunset scene, all the elements should be warmly balanced, to an extent appropriate to their relation to the lighting, etc.

Film and pixel grain

Whether your elements are sourced from film scans or a digital camera (or both), you need to ensure that their resolutions match. If the match is poor, e.g. if one element is from medium-format film, and the other is APS format, you usually have to add noise to the finer resolution image.

Sharpness

Related to the need to match contrast as well as resolution is the need to match image sharpness. An object that is behind the point of focus should not appear sharp, while objects near the main focal point should not be too blurred. In other words, the sharpness of each element should be appropriate to its apparent position in the view.

Direction of lighting

Ensure that shadows on all the elements fall to the same side, to suggest that they share common lighting. You will find it easier to make composites with flatly lit objects. However, this can diminish the sense of reality.

Layer modes

Layer modes determine the relation between the upper (also called the blend, source, or active) layer and the underlying (base, lower or destination) layer. While the variety of layer modes contributes a large part of the power of image manipulation, the sheer number of them can overwhelm. Indeed, the most recent version of Photoshop increases the choice further.

One could describe what each mode does, but the actual appearance of the composite often depends a great deal on the images themselves. It is best, therefore, if you just put two different images on top of each other and try them out, varying opacities at the same time. The following is a list of layer modes with a note of what I have found them useful for.

Complicated-looking images, such as the above composite, comprising elements photographed in Budapest, are easy to create with elementary control of layer modes and opacity. Satisfying results can be obtained quickly: the second layer was in *Difference* mode, and the top layer was set to an opacity of 54%. However, such images now appear a little dated, so their appeal is limited.

Learn from brushes

One effective way to learn about layer modes is not to use layer modes at all, but to paint with strong colours (or black or white) with different modes selected. You can then monitor changes while you paint; it's easier to learn how they work this way.

» FOR MORE ON FILM GRAIN SEE PAGE 46



Cycling layer modes

When you want to try out the look of different layer modes in Photoshop, use this shortcut: hold down the Shift key and press the + key to progress down the menu, or press – to pass up the menu. To change opacity press "1" for 10% opacity, "2" for 20% etc.



Normal, 50% transparency/opacity

To illustrate layer blends, take two different images, such as those above, and combine them in different ways. The basic way is *Normal* mode at less than 100% opacity. The other modes open the door to advanced manipulation.

The omissions – chief among them being the *Dissolve* mode – are because I have never found a use for them. The shortcut key for each is noted too: hold down Alt (*Option*) + *Shift* while pressing the letter (*below, in brackets*). Ensure that you do not have any kind of painting tool selected, or you will simply change the brush's working mode.

Normal (L)
Must be used with reduced opacity in the top layer. Changing the contrast of a layer varies the balance.

Multiply (M)
Imitates the overlaying of two transparencies or negatives. It makes the image darker, so try increasing exposure in *Levels*.

Screen (S)
Imitates shining two transparencies on top of each other, so the result is always brighter than either image. It can be used for dodging.

Soft Light (F)
A useful starting point for blending two images. Try changing the contrast of one of the images to make one dominate over the other. *Overlay* mode (O) is very similar to *Soft Light*.

Hard Light (H)
and Pin Light (Z)
Hard Light gives contrasted, punchy combinations of images. It can be softened to effects similar to *Soft Light* by lowering top layer opacity. *Pin Light* replaces colours, depending on the blend colour and is useful, therefore, for creating layering effects with colours that are not easily predicted.

Color Dodge (D)
Paint with greys on a layer to dodge the underlying. In other words, it makes areas lighter with added

Multiply

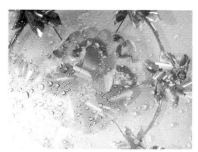

Screen

Soft Light

Hard Light

Pin Light

Color Dodge

Color Burn

Linear Dodge

Darken

Lighten

Difference

Color

contrast. Whites have the greatest effect, while black has none.

Color Burn (B)

Paint with black or greys on a layer to burn in the underlying. It makes areas darker with added contrast. Black has greatest effect; white has none.

Linear Burn (A)
and Dodge (W)

This darkens (*Burn*) or lightens (*Dodge*) the underlying pixel according to the colour of the top layer (so a burn with white or a dodge with black produces no effect). Both are softer than their *Color* counterparts, and do not increase contrast.

Darken (K)
or Lighten (G)

These modes are useful combined with gradients on a layer in order to burn in or dodge large areas of the image.

Difference (E)
and Exclusion (X)

Difference mode produces dramatic effects – which is handy for when you're desperate – but ensure your subject outlines are strong. Also for controlled reversal: white inverts, black has no effect, so try mid-tone grey. *Exclusion* is a milder version (you'd be forgiven for expecting the opposite).

Color (C)

This is one of the most useful modes, as it adds colour and saturation from the top layer to the underlying layer's luminance, making it excellent for colouring greyscale images. But it is also useful for changing the colours of a coloured image without distorting contrast or exposure. It has the opposite effect to *Luminosity* (Y).

» FOR DODGE AND BURN SEE PAGES 52–53

BLENDING OPTIONS WORKSHOP

Layers interact in many ways, but most important is the way one can be blended with another

There are entire books on the subject of layer interactions. But while layer modes produce a marvellous variety of results which can serve artistic needs (as well as mechanical corrections of tone and colour), one of the most powerful is the *Blending Options* control.

Blending Options brings virtually all layer options into one command centre. It therefore allows you to set the layer blend mode, and the layer opacity or transparency just as you can from the *Layers* palette itself.

Then there are the *Advanced Blending* controls. These controls are both complicated in their effect, and interdependent, so changing one can affect the others.

The vital controls are the sliders at the bottom: these can be regarded as a selective opacity or transparency control which allows the underlying layer to be seen according to the value of the pixel either above or below. Simply moving these sliders creates dramatic interactions between layers which no other method can match, but it can create unsightly sharp boundaries.

To prevent this, split the triangles by holding down the *Alt/Option* key while click-dragging on them with the mouse. This enables you to create up to four zones of transition in highlights and shadows between the layers so that you can imitate film-based multiple exposure techniques.

This workshop investigates the versatility and power of this control.

1 Some images really belong together. The ceiling of the Gur Emir in Samarkand (*right*) and the museum-city of Khiva (*below*) seem made for each other. For this project I wanted to see what a digitally created double-exposure of the two images might look like.

Once you become familiar with the *Blending Options* dialogue, the *Layers Palette* (*left*) will appear simplistic and crude.

2 With the silhouette image on top, a simple shift of the top layer shadow slider (*below*) reveals the underlying ceiling image, but with untidy results in the half-shadows.

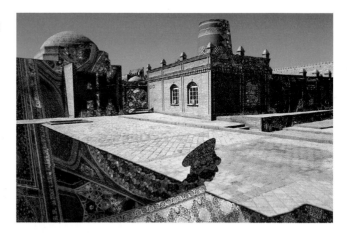

WORKSHOP: 3

3 This image shows just the top layer with the blend if the shadow slider set to 43. The checkerboard pattern reveals sharp transitions in the transparency as well as unwanted transparency in parts of the towers. You can reduce the effect of this by dodging these areas, thus raising them above the value at which they would be blended. However, this fails to solve the problem of the hard edges. The blend will not be acceptable.

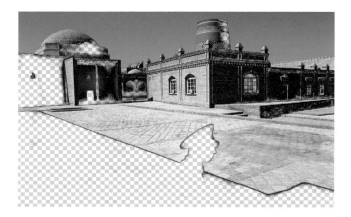

4 By splitting the shadow sliders, which distributes the blend over a range of values, we achieve a much smoother blend. This also means we can control more easily those areas that we wish to exclude from blending. That said, the result remains a little disappointing. Filling the strong silhouette with texture has made the image too busy.

5 We experiment here with a combination of blend mode and advanced blending. The mode is Linear Light. If the blend colour is lighter than mid-tone, the image is lightened, but if darker, it is darkened, so contrast is increased.

Lowering the Fill Opacity (*below*) would reduce its strength. Blend was set for the brighter parts of the top image, instead of the shadows as in the other images, emphasizing the silhouette.

Advanced painting

The enormous range of brush effects, shapes and automatically varied colour available today opens new worlds of two-dimensional work. The above image combines a "real" object (lying underneath all the strokes) with different blend modes (*Normal, Difference, Hard Light*, etc.) as well as global distortions of colour for a lively image.

Imitating art

If you slightly vary the size, pressure (loading) and colour of your brushes as you work – just as a real painter would – the effect you produce will look more lively. It is tempting in digital work to roar ahead at speed. Well, the speed of work might be impressive, but perhaps not the quality. Dab a little, return to the palette, dab some more and return to the palette, mix colours, load up and dab: that is the rhythm of painting. And it works just as well on the computer.

The brushes created by software designers are like the colours created by colourmen for painting sets. They are merely a starting point for creative work. The challenge, fun and artistry comes from creating exactly what suits your purposes. Modern software, such as Painter, Photoshop and Photo-Paint, offer a near-infinite potential for brush creation.

Taking command of brushes

The features that characterize brushes are largely the ones you will set when you choose them, or vary as you work. For the majority of the time, you can simply change a feature and see what effect it has, but the advanced control of brushes may not be as obvious as it seems.

Diameter

This sets the diameter of circle enclosing the direct effect size of the brush. If the brush edge is soft (*see below*) the diameter of the circle may actually be smaller than the area affected. This does not mean that all brushes are round: square-shaped brushes are measured by the circle that encloses them. In general, precise control of painting brush diameter is not necessary.

Shape

Your choice of digital brushes used to be round, or round. But now the range is, if anything, bewilderingly wide – anything from pencil-thin lines to butterfly shaped, scattered like grape-shot, or focused down to single pixels.

Softness

Also called "hardness", this sets the suddenness of transition between the brush effect and having no effect. It is worth paying a good deal of attention to this control, as it has a major impact on the realism of image work. On special effects brushes, such as those painting on flower petals or clouds, there is no sense in having a softness control.

Mode

There are two levels to a brush's effect. First, there is its loaded colour – usually taken from a

colour wheel or swatch palette. Second, the brush mode dictates the way in which colour affects an image. The normal mode for a brush is simply to replace pixels with a chosen colour. But with *Color Burn* you darken and increase colour; with *Difference*, the receiving pixels reverse both in colour and tone, and so on. Experiment with different modes to learn their effects.

Spacing

With normal brushes, spacing has a subtle effect as it controls how quickly colour is laid along the path following the brush's movement. Its operation is most obvious with special effects, such as painting leaf shapes. But it is important in cloning as well: too wide a spacing smudges image detail.

Airbrush

When you select this mode, you simply hold the mouse button down and the paint is airbrushed on. If you apply a real airbrush to an area continuously, it becomes more densely painted, and the painted area steadily grows. This can be imitated digitally.

Nozzles

One of the exciting developments in the artist's toolbox is the invention of paint "nozzles", which apply images rather than simply lay colour. You can control how the images are applied – whether scattered, or varying in angle, colour, or size, and so on. You can create your own nozzles too, an exercise which can amuse for hours on end.

Undoing mistakes

All that digital painting lacks in tactile feedback, it returns with its unparalleled ability to undo your errors. Software offers many levels of undo for each stroke – it may be as small as a dot, or a very long stroke covering the whole image. If it is continuous it is one stroke – there is nothing in between, although you can always erase a stroke even in software that offers only one level of undo.

Far more powerful, though, is the ability to paint backwards to a previous state; this is offered by Photoshop's *History Brush*. Suppose you draw a line but it is too long. You can try to erase it, but you could make things worse by damaging the image. Or you could undo the stroke completely and try again. Either solution is brusque and finite. But you can simply choose the previous state in the *History* palette, then

Imitating painters

A common mistake made by digital photographers or pixel processors is to paint onto a plain colour. A painter may spend as much time preparing the ground as in the painting itself – a well-prepared ground makes it easier to add paint. Before painting, create a textured surface with vague hints of colour, faint lines as if sketching out an outline. The rest of the painting will go much more easily.

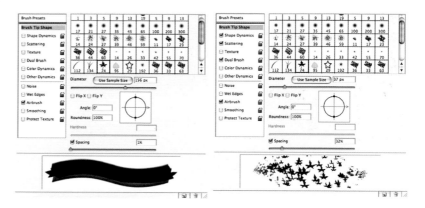

Modern digital brush controls are very complicated, but it is worth persevering, as a command of the controls gives you unprecedented flexibility and speed of creation. The top two images show the radical difference in effect by changing just the Spacing control. The secret to keeping control of brushes is to create a library of brush shapes that you use most often, and remove those you never use from the control. Next, ensure that you work from a colour swatch well suited to your image. For example, when using pastel colours the ANPA swatch (*left*) is much easier to use than the standard Mac swatch (*below left*).

» FOR MORE ON MODES SEE PAGES 88–89

select the *History Brush* tool (type Y) and paint back towards the original state. All that will change is what was painted, not a hair of the original image will be touched. Better still, try exploring the different modes with which the *History Brush* can be applied.

Memory overload

Beware, however, that there is a hefty price to pay for being able to undo your work so easily. The application stores full information about your strokes in temporary memory, so if you set out to undo too many levels, for example 40, or ask for as many as 40 *History* states to be saved, you will quickly clog up your available memory – both on scratch disks (temporary storage on the hard disk), and in RAM. The application will still work, but the computer will probably become very sluggish. And poor machine responsiveness mitigates against high creativity.

Preparing backgrounds

Few things are more intimidating than an expanse of plain white, especially to the unpractised artist. It is kinder to yourself – and can be in itself a source of inspiration – to prepare your backgrounds carefully, prior to starting to paint.

You could scan in papers and textured surfaces, or create them from scratch using filters such as those adding noise and texture. Keep a library of backgrounds. By overlaying and blending them you can create innumerable new backgrounds. Reduce the black point to tone them down in preparation for applying subtler, pastel shades.

Remember that if you paint in *Color* mode, you combine your colours with that of the background, rather than replacing the background. This provides another level of interaction between painting and background.

You can go even further. Try applying distortion filters to the patterns in the texture to give them shape and to hint at an underlying structure. You can also try lighting or texture filters, which could enhance the background further by adding a three-dimensional feel.

The secret of successful backgrounds is that they can seldom be too pale or blurred. You find more often than not that your background needs to be knocked back or blurred even more than you thought. An effective way to increase blur is to upsize a very small file.

These backgrounds (*right and below*) are based on a handmade paper. The paper was first scanned in a flat-bed scanner. The result was duplicated, turned 180°, and blended in Multiply mode. This made the image too dark, so the *Black* output levels control was used to reduce the blacks and lighten the image overall to obtain the final background image. The image below was obtained by digitally applying a spotlight from the top right, to bring out a texture.

An artist's sketchbook made of craft paper was scanned to obtain the basic image for the background shown below. The laid patterns of a handmade paper suggested the idea of mapping a shape onto the texture itself, obtained by applying a *Spherize* filter.

Use a graphics tablet

Anyone expecting to paint digitally should invest in a graphics tablet. This is a tablet equipped with an electrostatic-sensitive panel that senses the position, pressure, and angle of your "pen", which you use just like a real pen or brush. It is indispensable for control and flexibility – not to mention kind to your hand by causing less strain on the wrist.

Imitating art

The most effective way to imitate representational art effects is to clone an existing image so that your new image is created using strokes which imitate artists' techniques. This is the special province of software such as Painter and Photo-Paint. First create a clone of the entire image, then remove the original image: this ensures that the clone and target images correspond exactly and to the pixel. You then choose a technique – it may spatter drops around, or imitate a chalk texture – and clone back the image. The range of effects is limited only by your skill and the time you take. For best results, use a graphics tablet.

Using Painter's cloning technique, you can make any number of different versions of the same image (*above*). A brush delivering splatterings of small strokes was used to paint one (*above right*), a chalk-like stroke created another (*far right*), and a spray-on effect produced yet another (*right*).

» FOR SCANNING SEE PAGES 24–27

Increasing file size

The wonders of modern file compression and encoding achieve amazing results. The original file (*top*) was 14MB in size. It was reduced to 800K by resizing, then compressed in Genuine Fractals further to 640K. This was then enlarged back to a 14MB. The two enlargements show a slight softness in the compressed file (*above left*), but the losses are not so obvious and could easily be hidden in printed output.

The process of increasing file size is similar to enlargement in darkroom-based photography. But the differences are instructive. Digitally, increasing file size does not necessarily produce a larger or better image; it is only the quantity of data that increases. However, both darkroom and digital processes involve changes in the quantity of detail. Up to a certain size, darkroom enlargement may actually increase the amount of detail visible in the enlargement. This is because at small sizes, the resolution of the paper is insufficient to display all the information in the negative. Beyond a certain size, there is no real gain in visible detail. Digitally, increasing file size never in itself reveals any extra detail.

When to increase file size

Suppose you need to print a larger image than the file was originally designed to be output at. This does not automatically mean that you need to increase file size. Just a little experimentation will show that you can see no discernible quality difference between an image that is at full size and one that has been enlarged by 10%. But increase the output size further, and at a certain point degradation of image quality becomes apparent. This means you have passed the point of acceptable enlargement.

We could call this the "margin of enlargement", and it is in many ways analogous to the circle of confusion in depth-of-field calculations. We increase a pixel in size until we can see it as a square with discernible area, thus defining the beginning of an unacceptable level of enlargement, like an unacceptable level of unsharpness. The margin of enlargement appears to be greater with small, low-contrast, low-resolution images on matte papers and less with large, high-contrast, high-resolution images on glossy papers.

These factors working together determine how much you can enlarge output before you need to increase the file size to compensate.

File size

You can reduce resolution in step with the enlargement in output size. This keeps file size the same, so there is no resampling. This strategy is

Resizing and resampling

This is an important distinction. **Resizing changes the output size without altering the pixel count, i.e. the resolution changes – either dropping if the output size is increased, or increasing for smaller output. Resampling changes the pixel count – the output size may remain the same or change, therefore the resolution may also change or stay the same, depending on the changes you make. Resampling requires interpolation, whereas no interpolation is involved in resizing.**

available if your file was originally larger than it needed to be; you are simply exploiting the quality reserve. Incidentally, not only is resizing instantaneous, printing speed is also greater when resolution is reduced.

Nature of image

A scan of grainy black and white film will appear to hold less detail than a scan of a high-resolution colour transparency, or a digital camera image with a high pixel count – even where each of these files is the same size. The grainy image will tolerate more enlargement than the finer images because it offers an already noisy or degraded image.

Viewing distance

Larger prints tend to be viewed from further away, which lowers the need for quality. If you view a poster so that its apparent size is that of an A4 size print held in the hand, the file size needed for comparable apparent quality is similar for both an A4 and a poster-sized printer. (In truth, the relation between output size and viewing distance is not quite so linear; we need somewhat larger files.)

Viewing conditions

Higher-quality output is obviously needed in critical viewing conditions, such as an art gallery, compared to display in a dark place, like a subway or in a shop window. In viewing conditions where light level is lower than optimum, prints will benefit from being printed with sightly increased contrast and saturation.

Nature of substrate

A surface with a hard glossy finish will accept files of high resolution which would be wasted on a rough surface like that of watercolour or handmade Japanese papers. As a guide, you can halve the resolution of a file intended for a rough surface compared to that for a glossy print.

Printing method

Broadly speaking, methods that use photographic output – e.g. onto colour print film – will print good-quality results from lower-resolution files than the file sizes needed for inkjet prints of the same size and quality. This is because photographic processes depend on dye clouds for colour reproduction. These dye clouds are randomly distributed and vary in size, both factors help to smooth out the pixel raster and convey subtleties of tone.

Grain and sharpness

Grain or noise works against sharpness. Although a modern black and white film may actually be much sharper than a colour transparency, we usually consider the colour transparency sharper because the grain is far less visible. This is one reason to avoid sharpening film grain when applying unsharp masking.

Three methods of resizing an image: (*left*) from Photoshop (bicubic interpolation); (*top*) from Genuine Fractals (fractal decompression); and (*above*) S-Spline (spline-based interpolation). Quickest to use is Photoshop's, but the others offer quality advantages at a speed disadvantage.

» FOR MORE ON GRAIN SEE PAGE 46

The illustrations (*above*) are actual scans of inkjet output onto glossy photo-quality paper. They are a 10X enlargement from a high-quality 38MB scan of a top-quality medium-format transparency. This is equivalent to a print measuring over 120" (2.5m) wide. One is of a file at 500 ppi resolution, the other of 100 ppi resolution. It is not so immediately obvious which is the higher quality scan: there is a little more crispness in the fine branches of the top image.

Stair interpolation

The normal method of increasing file size is to call up the *Image Size* command and input the required numbers. For small percentage increases – up to around 30% – that method is fine. However, for larger percentages, you may find it beneficial to break down the increase into a series of smaller steps. It can be used with any interpolation method, but *Bicubic* is best as the exercise is about the preservation of image quality.

Say you wish to double the image size. Instead of increasing it by 100%, you first increase it by 10%, then another 10% and so on.

Any accountants among you will recognize that this is an example of compound interest. For the final step you can make the fine adjustment in the resize box to obtain the precise size you need. To automate the work in Photoshop or DeBabelizer, you can create an action or macro. Use the table (*opposite page*) as a guide. Note that the smaller the increase (and the more steps you'll need), the better the preservation of image quality.

Alternatively, create separate actions for specific enlargement ratios that you often use, for example, from your digital camera's file size to A3+ print. The SI Pro plug-in for Photoshop from Fred Miranda uses stair interpolation to resize images from a powerful but simple dialogue box.

S-Spline

Shortcut Software's S-Spline is a small application dedicated to one task: increasing file size while preserving subject outlines. You simply open a file or drag it into the work-space: S-Spline will work with most common formats, such as TIFF, JPEG, PNG, BMP, and PICT, but not with GIF files. Next, you simply set the

File resolution with Crop tool

This is a quick method of changing file size and resolution. With the *Crop* tool selected, input the resolution figure you want to the option box. Draw over the entire image and hit *Return*. Your image is instantly at the new resolution.

new size and the method of interpolation. "None" here means nearest neighbor interpolation. You can choose different methods and check in the preview window to see which is working best for your image.

In the majority of cases, S-Spline gives far better results than bicubic interpolation, particularly where you want strong contours to be preserved. But with some images, sharp lines become a little too sharp. Blessed are those with such a problem: you can always reduce it with a light *Gaussian Blur*. However, be aware that the rendering for S-Spline enlargement can take quite a long time. It creates a file in the same format as the original.

For many purposes either S-Spline, or the following utility, may reduce the necessity to scan to a higher resolution, or to use a higher-resolution digital camera when large image files are needed.

Genuine Fractals

A powerful and widely used plug-in to Photoshop, is Genuine Fractals from onOne Software. The latest versions work directly on the image from Photoshop's Automate menu. It is claimed that a "sweet spot" of good results obtains at enlargement factors of 500–600%. Up to 800% can be obtained by using Genuine Fractals to enlarge to 400%, then Photoshop's Image Size control is applied for the last 200%. These very large increases in scale are not an indication of any miraculous ability to enlarge without loss of detail, rather they can be considered only on the basis that the distance at which a print is viewed tends to increase as the size increases.

Files can be saved in Genuine Fractals' .stn format with a lossless compression of about 2:1 (similar to LZW compression in TIFF), or if visually lossless compression is acceptable, the compression ratio rises to about 5:1.

While a compressed file does save space on your hard-disk drive, remember that it takes longer to open a compressed file than an uncompressed one. This applies to other compressed files too, such as TIFF: an uncompressed TIFF file of 25MB takes 0.2 sec to open, but the compressed version of the same file needs three times longer to open. Another drawback to saving Genuine Fractals format is that Genuine Fractals must be installed in order for Photoshop to recognize the file type.

What is fractal compression?

All compression methods depend on redundancy: there is more in the code than in the data itself. Fractal compression exploits the "self-similar" nature of data, so that when you look at a close-up of some detail it has features similar to another view, either more or less close-up. This gives us the redundancy we need for compression.

These two images show the difference between a one-step enlargement of a 9MB to a 90MB file, and one in which a 2% increase was applied numerous times to achieve the same enlargement. The image (*left*) is soft and lacking in detail. The image (*below left*) is evidently superior, offering not only improved definition and retention of detail, but also far better colours and tonal rendering.

STAIR INTERPOLATION SETTINGS			
Desired increase	% setting	number of steps	result
50%	10	4	46%
70%	10	5	61%
80%	10	6	77%
100%	10	7	95%

» FOR MORE ON FILE COMPRESSION SEE PAGE 19

Advanced black and white

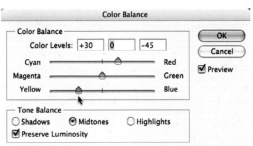

Even if you start with a greyscale image, such as the above scan of a mangrove swamp at low-tide, simply placing the image into RGB colour space opens up a world of tone and colour control. A few simple trials with the slider controls in the *Color Balance* dialogue (*left*) hots up the image tone.

So much for the greatly exaggerated rumours of the death of black and white photography. In fact, the digital project has breathed great new vigour into it. The superb quality of inkjet printers has taught us that what we once did in the darkroom should really have been called "grey and white photography". With inkjets, black can truly be black. Arguably, it is only now that we can claim the medium has come of age.

The latest technologies acknowledge the importance of monochrome and its subtleties by offering not only black but grey inks – in order to ensure smooth tonal gradations. With specialist narrow-gamut inks and archival pigments also available, the choice available to the discerning worker is multiplying rapidly.

Black and white in colour

Conversions between colour image and greyscale representation are not straightforward. Nor is the output of a greyscale image using coloured inks a simple matter. While we view the world and the monitor image in RGB space – in which full amounts of all colours produce white, and no light produces black – we must output in CMYK space. Here, the key fact to bear in mind is that full amounts of C, M, and Y combined do not produce black, but rather a muddy dark brown. On the other hand, black ink used alone only produces a dark grey. A small amount of black on heavy CMY inks produces a good black, and a small amount of CMY on a heavy K (for "key plate", which carries the black) inking also produces a good black. Clearly, the key component is K, the black separation.

Starting from colour

If your original is in black and white, you know already that the distribution of tones – in particular, the range of mid-tones – is adequate for use. But when you start from colour, what appear to be strong contrasts – such as between greens and reds, or purple and cyans – may disappear in the conversion to greyscale. It is important to assess the image carefully after conversion. A standard greyscale conversion usually gives only passable results: try extracting the G channel from the image in RGB or the L channel from the image in Lab mode.

The original shot, of sunlight through slats glinting off a stereo system, was made on black and white film. A wholly neutral image tone seemed inappropriate, so it was gently warmed using Color Balance.

For extensive work with black and white photography in colour, the best space to work in is CMYK. You will find that not only do tonal manipulations in the K channel have a powerful effect throughout the image, but the same channel is often the best place to sharpen the image or reduce noise. Note that some printers produce better results if you return the image to RGB space for printing instead of outputting the CMYK file.

Channel mixing

You might think that when a greyscale image is turned into an RGB image, all channels will look identical, so changes to their balance should only shift the overall tone. But experimenting for a moment with the *Channel Mixer* control will show otherwise.

You can use this control for strong toning effects that colourize the entire image, with the strength varying with the grey. But extreme manipulations can separate out the tones and split them so, for example, you have blues in shadows and magenta in the high values. The colours are strong, so you might want to desaturate them before finally outputting them to print.

A strongly blue tone was created through the *Color Balance* control. The beauty of digital blue toning is not only that it is dry and free of chemicals (and the results are predictable), but you also do not have to make a print in anticipation of the contrast changes caused by toning.

When the original greyscale image is turned into an RGB file and *Channel Mixer* is applied, you can create surprising separations of colour – here high- to mid-tones are cyan, lower mid-tones are blue, and darkest shadows are green – a result hard to obtain in any other way.

Hue/Saturation

Another technique for converting colour to black and white exploits the *Color* layer blending mode: for the effect we require we will allow the upper layer's luminance to vary according to the lower layer's colours. First open the image and duplicate the image into a new layer. While still in the new layer, desaturate the image, i.e. turn it grey but stay in RGB mode, then change the layer mode of this layer to *Color*. Now you select the bottom *Background* layer and call up *Hue/Saturation* control. Ensuring the "Preview" box is ticked, work the *Hue* slider.

You will see dramatic changes to the distribution of luminance in the image. For more control, work on individual channels or even more precise restriction of the hue bands, limiting effects just to dark blues. When satisfied, remember to flatten the image and save for use.

Duotones

The advanced digital photographer can choose between two ways of approaching the creation of duotones. For quick and direct manipulations, you can use the *Colour Balance* control. On some software, the balance is adjusted over the entire tonal range, whereas in others, such as Photoshop, you can limit the adjustments to broad bands of shadow, mid-tones, and highlights. By concentrating your attention on shadows and highlights, you can create attractive split-tone effects, in which the hint of colour in the lighter tones is different to that in darker tones.

For the most complete control of tone and colour, nothing matches the power of working in the *Duotone* (*Tritone and Quadtone*) mode. Strictly, these are all multitones, in that each colour plate is based on the same greyscale data. But in digital photography, we do not create duotones as such, but merely simulate them in colour space.

In Photoshop, the mode works rather like adjustment layers or colourizing channels acting on the greyscale image – precisely what a multitone does. You can add one duotone "channel" to make a duotone, two to make a tritone, and so on. In each channel you can change colours and you can change the curve or transfer function which controls how much colour is applied across the tone range.

The original image (*top*) is a long scan of two and a half of 135 format frames. You can apply duotones in reverse (*above*). In the dialogue, simply draw the curves so that they slope downwards (*right*).

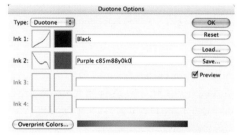

Tritone effects add a dimension of richness and subtlety to images. Beware, though, of overinking shadows. It is an advantage of converting to CMYK that maximum ink levels are controlled.

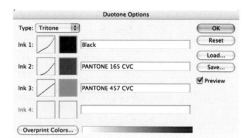

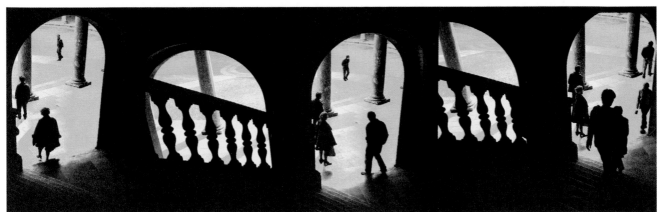

The best way to approach the construction of duotone curves is to learn from the masters. Start by loading the preset curves (found in the *Duotones* folder in the *Presets* folder of Photoshop). When you find one you like, you can adapt it to suit your image. When you find a curve and colour combination that suits your photography, you are likely to use it on other images. It's always best to save your own curves and colours into a separate folder for future use.

To output to desktop printers or for publication on CMYK presses, remember that you may need to turn the image into RGB or CMYK space.

Changing the Overprint colour

One little-known control is the *Overprint Colors* button. This leads you to a dialogue showing the various combinations of colours delivered by different full-strength combinations of ink. In a tritone, for example, you are shown the effect of combining the first ink with the second and third; the second with the third; and, finally, all three together. Clearly, a quadtone allows for a total of eleven combinations.

Now, if one of the inks is black, the overprint colour is going to be black, irrespective of the companion inks. Other colour combinations are what you would expect, e.g. orange with blue gives brown. But you are not stuck with these colours. This control actually allows you to define the overprint combination as any other colour available to the system – a marvellous power. You simply click on the colour patch to redefine it and, when you select a new colour, it is instantly applied to the image.

A quadtone setting (*right*) allows for eleven different overprinting combinations, each of which can be changed to any colour. This gives tremendous power to digital photography. However, even the basic quadtone (*above*) – with its orange, cyan and yellow inks – produces an infinite range of effects.

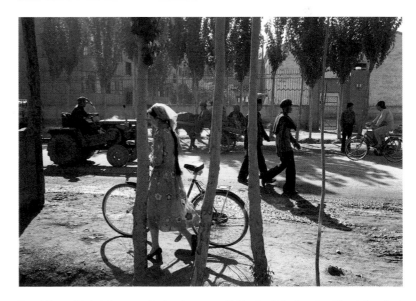

It would be a mistake to tone every black and white image. This street scene in Kashgar, China, is a simple documentary shot of daily life with lots of activity: there is nothing to be gained from toning it or applying complicated colouring effects.

» **FOR BLACK AND WHITE PRINTING SEE PAGES 130–31**

COLOURIZING BLACK AND WHITE PRINTS

If you start from black and white you can add colour, and if you start from colour, you can turn into black and white

The beauty of digital photography is that the only resource you expend is your time (and a little electricity). You need waste neither paint nor a single print, however much you experiment.

The basic idea for this workshop is to explore how in colourizing we are adding colour without distorting the underlying tones or tonal distribution.

This means that we cannot add colour to areas that are completely black, or wholly white. If we want colour in the highlights, for example, we either need to tone them separately, reduce the white point using the Levels control, or introduce noise so that there is something for the colour to get its teeth into.

The most straightforward method is simply to paint directly to the image. Choose a brush size, select a colour from a colour swatch, then set the mode of the brush to *Color*. This way is fun and almost dangerous: if you make a mistake you have to retrace your steps, and there is no method of making global changes.

A much safer method is to first create a new layer and set it to *Color* mode before painting onto it. This allows you to make global changes, such as reducing the opacity of the layer to soften the effect, and to experiment with layer modes such as *Soft Light*. Using multiple layers enables you to apply different brush styles, as well as exploiting layer modes to vary contrast and colour intensity. By working with *Layer Styles* you can even alter brush-stroke appearance.

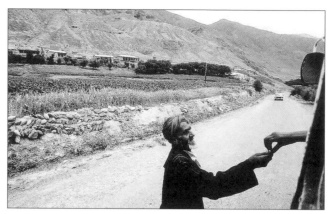

1 In this snapshot of a traveller in Tajikistan paying the bus-driver outside the bus (because inside it was too crowded to reach the driver), the black and white renders the shapes and tones clearly. But it seems to be crying out for some colour. The original image was a little dark, so Levels was applied to increase the exposure.

2 We choose the *Brush tool*, then *Color* mode from the large dropdown menu (*right*). Linear Dodge or Linear Burn (Photoshop v.7) used at very low opacity can alter local contrast. Constant, small variations in brush sizes and behaviors as you paint give your strokes liveliness and variety. Pressing a number on the keyboard sets opacity, e.g. "5" sets 50%. Flow thins out the colour, while the Airbrush icon makes the brush behave like an airbrush: the longer you hold the brush still, the more colour is added.

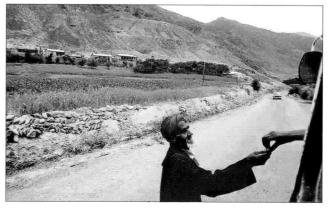

3 A quick application of colours is enough to show that it is worth working on this image. Unfortunately, very bright areas like the sky do not have enough grain to accept colour – addition of noise into the area gives the colourizing something to "bite" on. With the colours at full strength, the image looks rather amateurish – although this rough treatment has its uses.

WORKSHOP: 4

4 A new layer above the image is created, set to *Color* mode and selected. Although the opacity is 100%, the applied colours are pale because they do not replace the underlying pixels; that is the effect of the *Normal* layer mode. I use dabs of slightly different colour to build up an area – applying the same colour over too wide an area always looks unnatural. In later versions of Photoshop, the range of brushes is very large, and you can create your own. It is best to make a set of regular favourites. Try using one of the numerous brush shapes that are available; irregularly shaped, rough brushes will dab colour on in a less mechanical way than a circular brush.

5 A large amount of *Gaussian Blur* is applied to smudge out the brush-strokes: the screenshot shows the strokes before they were blurred. To soften further the source layer, the blending mode is changed to *Soft Light*, with a reduction in opacity to 70%. The result of changing the layer mode and blurring the brush-strokes is a pale, washed-out look. However, the end-result may seem *too* pale.

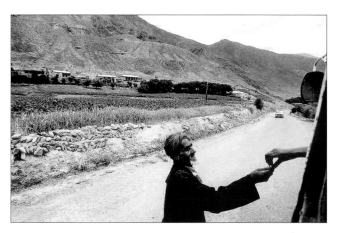

6 To intensify colours a little, the layer opacity is returned to 100%, then the *Hue/Saturation* control is called in to deepen colours in the top layer. As this shows up some untidiness in the brush-strokes, they are tidied up with the *Eraser* tool. Finally, prior to printing, the composite is flattened, i.e., so that the layers are combined and dropped down to create the background.

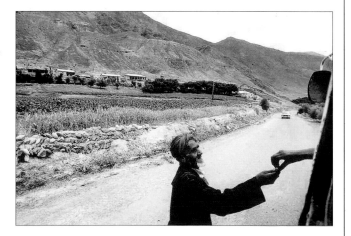

Advanced digital darkroom

After a long wait with camera at the ready, a priest opens the side-door to a church in Bethlehem. The symmetric composition, simple shapes and narrow range of colours make this a good candidate for Sabattier effects.

Working in colour, a peak-shaped curve heightens some colours and reverses others. Note how the extremely steep slope has brought out details in the shadows that were hidden before.

There are broadly two approaches to the concept of the digital darkroom. The first cleaves to traditional darkroom effects, thus limiting the range, repertoire, and flexibility of digital operations to simulate results achievable in a real darkroom with physico-chemical phenomena. This approach has the advantage of ensuring that effects are kept within reasonable bounds – a policy that helps avoid your image slipping into visual vulgarity. Naturally, the other approach is to announce open season on effects – in other words, to use darkroom phenomena as a launch-pad, leaving their conservatism behind in a welter of visual invention.

The best policy is undoubtedly to adopt a bit of both: true darkroom effects offer subtleties of mid-tone elision – smooth tonal transitions lacking gaps – that no digital printout can match. On the other hand, digital effects used with close regard to visual subtlety always serve to extend the range of graphic vocabulary.

Sabattier effects

The striking appearance of the Sabattier effect is better known than it is widely practised. In the darkroom it is the result of a second overall exposure to a print while it is still developing: developed areas mask some parts, while others are overexposed to the extent of reversal. This last effect, solarization, gives the process its other name, although it is really a misnomer. But if you try the *Solarization* filter in Photoshop (under *Filter* > *Stylize* > *Solarize*) you will be disappointed – the results are usually dark and uninspiring.

As you might guess, this darkroom technique is very hard to control – which is one reason why it is not widely practised. On the other hand, obtaining true Sabattier effects digitally can be the result of simply applying arch-shaped curves – a procedure that, once mastered, is highly repeatable. A curve that starts climbing, then turns to drop means that half the tones to the mid-tones are reproduced more or less accurately, but the other half of the tonal range is reversed. The crucial point, then, is where you place the point of reversal. Small shifts in the position of

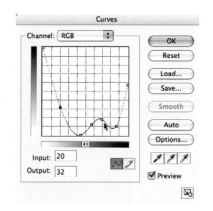

A few small changes to the curve compared to the previous one (*opposite bottom*) produces marked changes.

You can work with numerous curve shapes to come up with different results, but invariably the best are those that respect the image content. This complicated curve (*left*) produces an image which exaggerates some features of the image, but is not over the top.

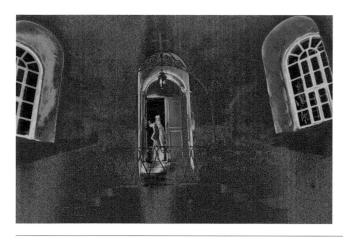

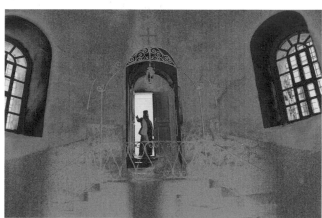

this – as well as very small tweaks to the shape of the curve – all have a substantial effect on the image. The real key to success, therefore – as is so often the case in digital photography – is to start from strongly shaped monochrome images while working in colour space.

If you start with a colour image, the half-reversal of the curve can create intriguing results, as some colours are flipped to their complementary ones, as well as reversing in tone. Beware, though, that these extreme shapes to curves will bring out every deficiency in image data, including any previous retouching. Clone areas, in particular, will be revealed. Caution is advisable.

Cross-processing

Consistent with the idea that it is good to use digital processes where the chemical equivalent is tricky to control, the next natural candidate is cross-processing. In this, you are exposing one type of colour film then developing it in a process for a

Starting with a greyscale image but working in colour can create atmospheric results where the hints of colour "tonify" the neutral, achromatic tones.

» FOR CLONING SEE PAGES 54–55

The reliable way to cross-process is to apply separate *Curves* to the master and to each of the individual colour channels. You can start with a cross-processed image that you like, then draw a set of curves which produces the combination of contrast, colour imbalance and saturation you are attracted to. Or you can start from the set shown (*below right*) which, when applied to the image (*right*) give the result shown below.

What is solarization?

Solarization is the partial reversal of tones resulting from extremely high exposure. When silver halide is normally exposed, it creates a tiny quantity of silver, releasing equally tiny quantity of halide ions. These diffuse into the surrounding gelatin. With extreme exposure, so much halide is released that it exceeds what can be held in the gelatin. This recombines with the silver to form silver halide which is transparent, thus reversing the density build-up.

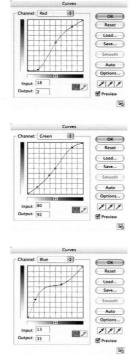

These curves set the axes to run left to right from dark to light as that is how the majority of users set up their Curves. The pre-press standard reverses the scale: darkest to far right.

different one. On the whole, the most usable results come from starting with transparency film: its higher inherent gamma as well as greater colour saturation gives vibrant effects. But the price is tricky exposure control – effective film-speed is changed – while high-gamma materials are always harder to expose correctly. In addition, the non-standard processing results in wayward colour balancing (and high saturation makes it difficult to know what a proper balance should be).

So, if you want predictable results, you need to apply curves to any colour image. This means you can start with any RGB image, whether captured, or scanned from slide or colour negative. A standard set of curves, created to mimic actual results, can be applied again and again to any image. These curves can be tweaked and manipulated to suit particular needs. You may also wish to apply desaturation if the colours become too bright for your liking, or correct the colour balance if the image leans too far towards blue.

Split-toning

Another popular technique, also notoriously difficult to control, is split-toning. If toning is the replacement of silver in a print by other metals or compounds, split-toning transforms silver in proportion to its size or density. This results, for example, in more tone being complexed into the shadows than in the high-lights, giving rise to extremely soft shifts in colour with image density.

Digitally, there are several ways to mimic this effect. One way is to correct colour balance differentially by tone band. For example, you can shift the shadows towards blue and move the highlights towards orange by using a colour balance control. Or you can adjust curves. Alternatively, you can select tone-bands using a tool such as *Magic Wand,* or *Replace Color*. The selection methods are limited to introducing only very small shifts in colour: large and obvious changes will create unsightly borders.

Smooth transitions can be obtained by using *Layer Style* in Photoshop to blend layers. The sliders in the *Blend If* control enable you to decide how much the bottom layer shows through the top layer according to ranges of bright and dark that you set. In this way, you could set it so that only the blue shadows from the bottom layer show up, leaving a warm-coloured top layer with attractive, warm-looking highlights.

While strictly not a darkroom process as it takes place in full light, a popular manipulation of Polaroid film is to distort the image while it is developing by pushing the emulsion around with a blunt object. The result looks exactly like it has been through a morphing manipulation. Here the *Liquify* filter from Photoshop has been applied. The difference is that you cannot see what you are doing with the Polaroid, but now you can.

A well-marked street in Falmouth, Cornwall (*right*), responds to the split-tone treatment (*left*). The background layer was duplicated and given a very warm balance. The lower layer was then given a blue balance. Finally, the two were combined using *Layer Style* so the blue comes out in the lighter tones, while warm tones fill the mid to lower tones of the image.

» SEE ALSO LAYER EFFECTS PAGE 83

DIGITAL LITH PRINTING

A popular and visually versatile technique is tricky in the darkroom but easy in the computer

Lith printing is noted for the warm allure of its results, but equally notorious for the unpredictability of the results it produces. In fact, the name is something of a misnomer: one does use lith developer, but only one that is very weak, nearly exhausted, or inhibited in some way. And the results are not lith-like – i.e. extremely high-contrast – more continuous tone than half-tone.

In the digital darkroom we can avoid all the horrors of chemical-based working entirely. The aim is to create images with strong maximum density, and with a compressed tonal range in which highlights are reduced along with mid-tones, yet with strong mid-tone contrast.

The reduction in highlights means that it carries density, and in lith printing that density is typically fogged to a warm tone. This indicates that the image should start greyscale, but all the work needs to take place in a colour space. It is this warmth of rendering that makes lith printing a technique applicable to many images.

This workshop is designed to begin telling you what the steps are – all are straightforward and technically available in any standard image-manipulation software package. And once you have a sequence producing images to your liking, you may be able to record a macro or action – create a digital developer – in which you can submerge any image and watch it come out, fully lith developed.

1 The fabulous sculptures of the Parthenon in Athens are high and out of reach – this shot needed a 400mm lens to fill the frame. The first step is to desaturate colours *(right)*. As the range is very narrow we can simply level out colour values. With any image offering numerous colours, it is best to lose colour through channel mixing.

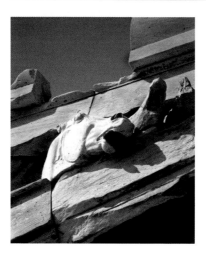

2 The desaturated image is checked to ensure that no important details are lost through destruction of colour contrasts. As the image is in RGB mode, we can directly change its overall colour using *Color Balance (above)*. Avoid setting too strong a colour as the subsequent steps will intensify it.

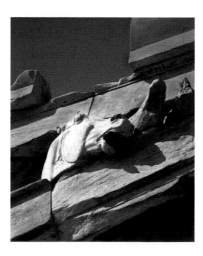

3 The result of applying a warm red to the mid-tones and highlights, with more yellow in the shadows is shown *(left)*. This is beginning to look promising, but the next step will seem anything but. The application of a curve that tones down the highlights – reducing the area under it – is to produce a very dark image.

WORKSHOP: 5

4 Application of a severe underexposing, contrast-reducing curve produces a very dark image. But under the gloom you can begin to see the qualities we need for a lith print effect: solid blacks, of course, and toned highlights. We correct the underexposure in *Levels*, by pulling the right-hand highlight slider a long way to the right, as well as pulling the gamma/midtone slider to the right.

5 The result of applying the *Levels* correction in the previous stage is this gaudy image. Clearly, we made a mistake in introducing so much red into the mid-tones in the early stages of this manipulation. But that is easy to correct: apply the Hue/Saturation control. First, tune the overall colour towards yellow in the *Hue* slider. Next, desaturate the colours a little, to make them closer to true darkroom products.

6 Applying the *Hue/Saturation* corrections leads us to the image shown on the left. Now it is a matter of taste: the image is perhaps still too strongly pink. The easiest way to correct this is to retrace your steps – only half a dozen, after all – and start with a different setting for Color Balance. The result of doing so, with a more yellow balance is shown (*right*). You can take your pick, or simply print both.

Advanced digital filters

This scene from the English countryside (*above*) is not the most promising, but its simple shape is likely to survive considerable manipulation. Before we start, we duplicate the background

layer. The first effect, a *Sumi-e* brushstroke, (*above right*) is not promising. The following images – fragmentation, clouds and so on – add effects into the empty sky.

Finally, the manipulated image is blended with the original image, still lying beneath. A number of different layer modes were tried out, before *Linear Light* was selected as it brings out colours, keeps overall shape, and opens up ideas for visual treatments.

One of the marks of an advanced digital photographer is his or her moderate, if not reluctant, use of filter effects that radically change the image. Nonetheless, filters do repay experimentation, as you may find that a combination of effects with a certain layer mode will solve a problem you have struggled with. Here are some strategies for approaching filters.

Work on small files

As filters require extremely complicated processing, even for seemingly simple effects, they work slowly on large files. The solution to speedy work is to experiment with small image files. Beware, however, that the effect of some filters – such as the *Pixelate*, *Sketch*, *Style*, and *Render* – vary widely with the file size.

Filter duplicate layers

A rich seam of experimentation is offered by working with filters on duplicate layers. Applying a filter to duplicate layers allows you to manipulate not only opacity, but also layer mode interactions to give you a broad choice of effects – equivalent to applying the *Fade Filter* command, which is one of Photoshop's most powerful features. The use of multiple layers also enables you to clone portions from one filter effect onto another, offering you yet another range of manipulation opportunities to choose from.

But do bear in mind that many filters are still relatively primitive in their abilities to preserve overall exposure. It follows that some are more effective if you prepare the image for the filter. If not, then at least you should ensure that you do not assess a filter's success until you have normalized the tonality.

The most effective method of achieving this level of control is to use *Adjustment Layers*. In fact, you can simply create a few adjustment layers and move them around the *Layers* palette to observe their varying effects on each filter treatment.

Filter composite layers

It is asking too much of image-manipulation applications to be able to filter across separate layers. But applying a filter to the top layer just does not do the trick. The solution is to make a temporary

composite layer of the visible layers and apply the filter to that. First, show the layers that you wish to work on as one, and select the whole of the top layer. Create a composite layer by first making a composite copy: *Command* (*Control*) + *Shift* + *C*, then pasting it. This creates a new layer composed of the visible layers. Now you can apply your chosen filter.

Filters accumulate

In my years of watching students and beginners tackle filters, I have never seen anyone apply one filter after another to an image in their experimentation process. Everyone seems to apply a filter to the image, undo the effect if they do not like it, then apply a different effect, and so on. But the fun really starts when you apply one filter after another – the possibilities multiply exponentially – and, of course, the effects are cumulative, so they interact in some surprising ways.

You need to remember a few points, however. Some filters – such as *Sketch > Chalk & Charcoal* – remove a great deal of colour data which cannot be later recalled by another filter. Other filters greatly simplify data which also cannot be recovered. These form good reasons for working on a duplicate layer.

Work in selections

Global filter effects produce overly broad brush-strokes which are seldom immediately effective. Even filters that merely enhance detail, such as *Unsharp Mask*, produce their best work when used selectively. With special effects filters, selective working produces a richness and a variety of texture and effect with which even traditional print-making methods would find hard to keep up.

In addition, you can work with hard-edged selections as well as soft-edged, feathered selections. As we are working in the realms of ersatz art – substitute art – the usual precautions directed at maintaining photographic realism by disguising handicraft may be justifiably abandoned.

A handy selection tool to use is *Magic Wand*. Or, for greater flexibility and control, use the *Color Range* command, since this allows you to choose broad bands of colour. These tools tend to respect image boundaries, while freehand selections with the *Lasso* or *Magnetic Lasso* enable you to blur or distort shapes in the image.

Using *Magic Wand*, different art textures were applied to different regions. Then colour balance was altered towards warmth, and colours were strengthened in key areas.

» **FOR MASKING AND SELECTION SEE PAGES 74–77**

Advanced sharpness control

The original of this image, taken in Kyrgyzstan, was slightly soft. *USM* could help save it from oblivion.

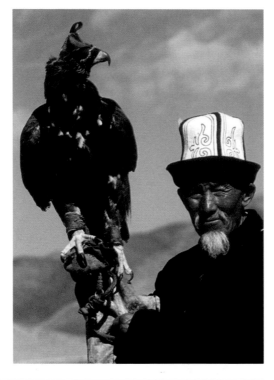

All digital images benefit from being sharpened at some stage in their lives. That is because all captured images – digital or analogue – suffer from blurring or softening of detail at some point.

Blurring occurs when the representation of an object is at a lower contrast or retains less detail than is present in the original. Sharpening compensates for this loss by improving the visibility of the information in the image. It works by applying a convolution kernel over the image: this is a matrix of numbers which is applied to an array of pixels, with the matrix centred over one pixel at a time. Sharpening cannot add genuine information, although it can add artefacts – image data which do not represent the object. Indeed it is these artefacts which improve the appearance or impression of sharpness.

USM to Luminance

The key to effective image sharpening is to work selectively. The most basic selection is to apply *USM* (*see below*) to the channel which gives the greatest effect without introducing artefacts and without emphasizing unwanted detail, such as grain or noise. We know that luminance data in an RGB file is found mostly in the green channel. However, it is not advisable simply to apply USM to the green channel.

Too generous a sharpening in Lab mode causes artefacts, such as a bright halo along image boundaries.

A modest *Amount* setting applied over a large *Radius* produces a visually much more acceptable sharpening effect, but notice how contrast is slightly raised.

What does USM mean?

USM (UnSharp Masking) is a little-known and even less practised darkroom technique for improving the sharpness of prints. One variant has a very pale, out-of-focus copy of the negative made. When placed in register with the original negative, the blurred mask spreads out the light at boundaries between light and dark: it adds density overall, but with extra on the dark side of boundaries, but less on the light side. In this way it increases the apparent difference between light and dark sides of the boundary – precisely what is achieved by digital USM.

The *Custom Filter* option in software such as Photoshop enables you to create your own filters – and at the same time demonstrates how they work. The set of numbers is called a kernel. It is "placed" so the central number applies to the pixel in question, and the other numbers alter the neighboring pixels.

A positive number increases brightness, while a negative one darkens. The kernel with five adjacent numbers (*below left*) is a basic sharpening set of small radius. A kernel with more numbers (*upper left*) will sharpen over a wider radius, evident by its greater effect on the image.

A sharpening is about the manipulation of local contrast, even the smallest change restricted to a colour channel will cause a colour shift. You need a pure luminance channel – one without any colour information – to manipulate, so that your work does not affect (or "cross-talk" with) any other channel.

The answer is to apply *USM* to the *L*, or lightness, channel in Lab colour mode. (Note that working in HSV or HSB colour space, available in some software, is not the answer as the luminance is not fully separated from saturation data.)

To sharpen in *USM*, you first move your image into Lab space (*Image > Mode > Lab*). Select the *L* channel – the image should turn into black and white – apply *USM*, then return to RGB space.

USM settings

Unsharp masking is provided in a wide range of software – from scanner drivers and management utilities, to image-manipulation programs themselves – all presenting slightly different controls. The best known tool is that in Photoshop, which shares its basic features with other software. Note that each variable interacts with the other so it is possible to obtain nearly identical effects with very different settings.

Amount

A measure of the strength of sharpening, roughly as a percentage of the increase in edge contrast. You will mostly work within the 50–200% range.

With an *Amount* setting of 55% and a *Radius* of 30, the image was improved not only by sharpening, but also gained in macro-contrast – in the medium-sized details. However, some parts of the image, such as the face, are too contrasty, which suggests that a smaller *Radius* setting would have given better results.

» **FOR LUMINANCE AND CHROMINANCE SEE PAGE 21**

Radius

This measures the number of pixels over which the mask strongly operates – more pixels may actually be included in the calculations, but to lesser effect. A radius of three may in fact cover seven or more pixels. As this is a mathematical measure, in some software *Radius* can take fractional values. Photoshop is unusual in permitting an extremely large radius setting to be input. It needs to be set with care as it has the greatest effect. In practice, low figures give crisp edges; larger figures produce broader edges, and increase overall contrast.

Threshold

This measures the minimum difference between two boundaries which the mask will operate on. Zero threshold tells the mask to operate over the entire image. As higher and higher thresholds are set, the mask ignores more and more boundaries.

Other settings

Scanner driver software and others may use different terms. In general, *Smoothness* describes the effect of changing threshold: higher smoothness is equivalent to high threshold. *Strength* is obviously the equivalent of *Amount*.

General USM guidelines

The first point to note is that, in general, you should leave *USM* until last – until after you have made all the adjustments and manipulations you need, and just before you save your work. For critical work you should check the image after *USM*. First, if the image is a scanned image, check for any dust specks made obvious by the *USM*; second ensure that sharpening did not create any bright, bare patches.

Start your *USM* operations with these settings as a guide. Adjust by eye to obtain the best effect, but ensure that you observe the image at multiples of 100%, i.e. 200 %, 400%, and so on. This is because at other magnifications the screen aliasing required to create the image can distort image sharpness.

Image consists mostly of fine details

Set a strong amount of sharpening, with very small radius and a low threshold, e.g. *Amount*: 200, *Radius*: 1–2, *Threshold* 1–2. This improves all boundaries in the image over a small distance. While these settings will also increase grain or noise, they will be hidden by the detail.

A hastily snatched picture at a wedding with on-camera flash is not well focused and the skin tones on the hand are poor. This warns that an overall sharpening of the image will produce unattractive results in the skin tones.

Clearly we need to isolate the flowers and apply our sharpening tricks. First, we duplicate the layer, then create a selection of the flowers in order to apply the Find Edges filter (*above left*). If we blend this to the destination layer with *Multiply*, to intensify colours we obtain the result seen (*above right*). Instead, we use the selection to create a mask (*top left*) before applying the blend. The result improves the roses without affecting the skin tones.

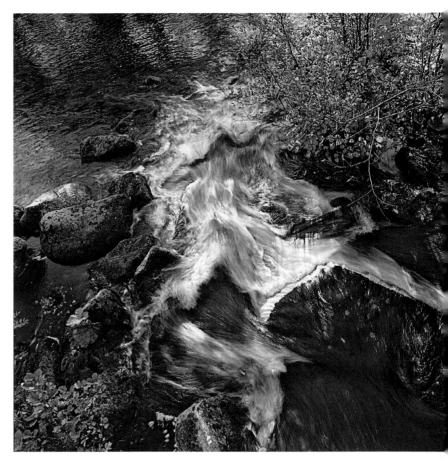

Beware changes in micro contrast

USM works by creating localized changes in contrast at boundaries. If these boundaries are close together they can join up and create bald highlights. This should be avoided on critical parts of subjects such as faces and metallic objects. Reduce *Highlight* output in *Levels* to compensate. On the other hand, this is a cue for you to exploit the very same artefacts to your image's advantage.

Image has large areas of even tone

Set a modest amount of sharpening, and a large radius with a relatively high threshold, e.g. *Amount*: 50, *Radius*: 20, *Threshold*: 10. The high threshold ignores noise while the high radius compensates for the moderate amount. Now, it is clear that if your image consists of a mixture of fine detail as well as areas of even tone, you will need to adapt different settings to the image character. This uses more advanced selection techniques.

Adaptive sharpening

Aficionados know it as smart sharpening, but such implied elitism is not helpful. In fact, there is a family of sharpening which is adaptive – that is, which more or less modulates the amount of sharpening in response to image character. In essence, we use increasingly sophisticated methods of selection – from broad areas to specific edges. Remember: we are trying to enhance fine pictorial detail, while ignoring details such as film grain or digital camera noise which carry no pictorial content.

Selective sharpening

With large areas of sky or water, simply apply a gradient, or use the *Magic Wand* to select a large swathe of image. Then invert the selection so that the unsharp mask applies to all but the sky and sea, and apply *USM*. This technique is handy for sharpening eyes in portraits: working in *Quick Mask* mode, use a soft brush to paint round the eyes, exit *Quick Mask* and invert so the selection is on the eyes, then apply *USM*.

The next level of sophistication is to find the best channel, then use that as a basis for loading a

A 48MB file from a high-quality scan of a medium-format transparency of a mill stream in Bamford, Yorkshire, England should need little in the way of unsharp masking. Indeed, overenthusiastic sharpening easily mars the image. However, we might like to put a bit of sparkle in the sunlight reflecting on the waters. By setting a modest *Amount*, but a large *Radius* with *Threshold* left at minimum, the filter pushes up contrast in the details. The image is shown unsharpened above, and the filter applied below.

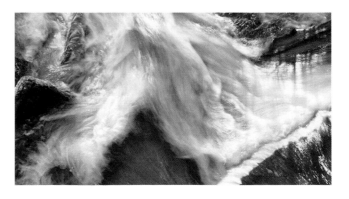

» FOR MASKING AND SELECTION SEE PAGES 74–79

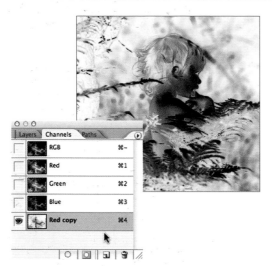

There is a lot of soft detail in this shot, but we do not want to sharpen the child. So we limit sharpening to the ferns and other details. The "Red" channel holds skin details, so we use it to exclude the child – loading the "Red copy" channel as a selection prior to inverting the selection, then applying sharpening.

selection. One method is to select the channel, then duplicate it. Make your changes – for example, increase the contrast, invert it, and blur – in preparation for loading it as a selection. In Photoshop, use the menu item *Select > Load Selection* and pick the copy of the channel as the source. Alternatively, you can use the *Magic Wand* to make a selection. Now you can apply *USM* to just the areas that you wish to be affected.

Find Edges sharpening

Further up in our fine discrimination is a method based on the *Find Edges* filter. This ensures *USM* hits only the major subject boundaries while leaving untouched areas of more or less even tone.

First, duplicate the background layer then apply the *Find Edges* filter – either to the whole image or, for even more control, to a channel. Next, soften the *Find Edges* effect using *Gaussian Blur*. Now invert this so that white defines the areas to be sharpened. Using *Levels*, make a high-contrast, clean-cut mask – in other words, where black is black, and white is white.

Next, turn to the Channels palette and load the selection (left-most button): this creates a selection based on the areas that you want sharpened. The white areas define the edges plus a little of their neighborhood, feathered by the tonal gradient. Now, apply sharpening: it will be limited to the selected areas, ignoring even areas of grain or those which are tonally gradual.

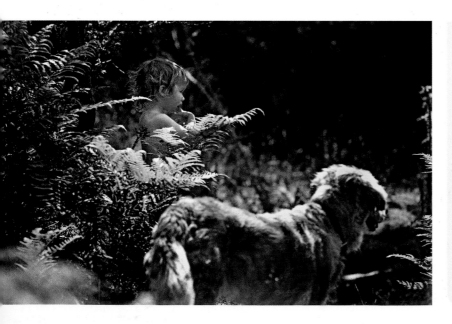

USM in CMYK

If you are working in CMYK space, it is not necessary to convert to Lab space in order to sharpen luminance. You could try sharpening in the K channel only, but that will have little effect. Instead, apply USM to the composite channels as usual (i.e. all of them at once). Then invoke the Fade command (*Edit > Fade Unsharp Mask*) or *Command* (*Control*) + *Shift* + F. There, change the mode to *Luminosity*. The sharpening is then applied only to the image's luminance data.

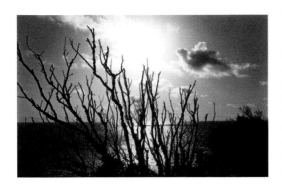

As an exhibition print, this landscape (*left*) is fine, but for reproduction we want more sharpness and higher local contrast. Duplicating the image, apply *Find Edges* (*below*) and invert it (*below right*). Searching through the channels, Blue has the best contrast. Copy that and use it as a source for a selection (*below left*). When *USM* is applied, it lifts the edges of the branches, as well as sharpening the sea detail.

Sharpening faces

Where images are rich in flesh tones, or delicate highlights, e.g. in flowers, the usual artefacts of injudicious sharpening can easily harm their appearance. Try working in CMYK, in order to sharpen only the cyan channel. This is likely to carry much of the luminance data, as skin is very deficient in cyan. Also adjust highlight output in *Levels* after sharpening, not before.

» FOR MORE ON CMYK SEE PAGES 31 AND 71

High-pass sharpening

A different approach to selective sharpening is to use a filter that removes large or blurred features. The High Pass filter (*Filter > Other > High Pass*) does exactly what it says on the label: it passes high-frequency detail. It is the opposite of a low-pass filter. (A softening filter on a lens is a low-pass filter, as you can see only broad image outlines; it works just like the digital Gaussian Blur.) With the High Pass filter, low frequency features such as areas of even tone or areas of gradual transition are hidden behind a grey mask.

The procedure is straightforward. First, duplicate your image layer, select the duplicate layer, and set it to *Overlay* mode. Ensure that you observe the image at 100%. Then call up the *High Pass* filter. Your image instantly appears sharper, if only because it is more contrasty overall. Adjust the *Radius* slider to sharpen the edge details without straying too far into even tone (where grain will be accentuated).

Thanks to the flexibility of being able to fine tune the radius of the filter's effect, the method is useful for improving JPEG images damaged by the artefacts caused by compression. You can sharpen just short of the JPEG blocks. Two passes of this filter at a small radius can make better improvements than a single pass at a larger radius.

The technique is open to refinements and options. You could work with different layer modes: *Soft Light* or *Pin Light* blending gives subtle results with good control of contrast. For more visible effect, i.e. for book or poster printing, you can try the Hard Light blending mode. If the effect is too strong you can reduce it by lowering opacity of the source layer. Alternatively, you can apply *USM* to the *High Pass* layer itself. And you can always make finer adjustments to the filter with the *Fade Filter* command that we discussed earlier. If the overall contrast is raised too high by the sharpening, you can correct that after you apply the filter.

Finally, you could try to press other filters into the service of improving sharpness. The *Emboss* filter can be used like the *High Pass* – working on a duplicate layer and blending in *Soft Light* or *Overlay* mode with the original – to improve very soft images significantly, often with remarkable results for the smaller-size image.

This handheld shot (*top*) in a cold dawn in the Namib Desert was not sharp, but we do not want the grain in the sky to be sharpened. The *High Pass* filter on a duplicate layer in *Normal* mode appears grey (*above left*) but efficiently finds the subject outlines such as the crucial figure in the background (*above right*). When applied to the background image, in *Overlay* mode, the contrast in macro detail – such as in the sand – is also improved (*below*).

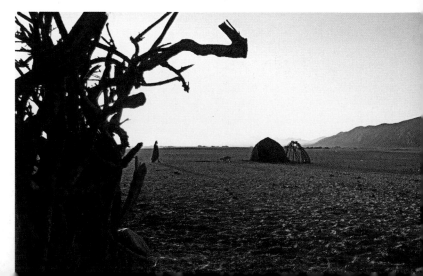

PART TWO

MASTERING IMAGE MANIPULATION

MASTERING YOUR MATERIALS

Organizing your images

The main window of FotoStation (*above*) shows some of the 1300 images stored in a folder. It takes only a few seconds to display all the images (which can be shown at a different size), yet all house-keeping such as changing file-names and moving or copy them can all be done in the one place.

You will, in no time at all, accumulate hundreds of image files – some from digital cameras, some from scanning, some downloaded from the Internet, and others from cover-mounted CDs given away with computer magazines. How on earth do you keep track of them all? And how do you find the image you need without having to rummage through dozens of CDs or folders?

Managing your assets

Broadly speaking, it is easier to manage files – move them around from one folder to another, change their names, and so on – in Mac OS than in Windows. Features such as the Automator in Mac OS also make it easy to rename hundreds of files at once. Note that if you work in a mixed OS or network environment, file transfer may not be straightforward: if you try to copy the entire contents of a Mac OS folder onto a network disc you may find the operation is aborted because Mac OS creates invisible files that are not accepted by the Windows OS.

Start now

The most important decision is to get organized now: before you get into a mess, and before you lose your precious data in a computer crash. It might seem like a waste of time to plan a file-management system while you have only a few dozen images, but it is easy while the task is small, and you will learn about how to adapt systems to your needs. If you start when you really need to – with a collection of hundreds or thousands of images – you will face an uphill struggle.

Save to folders

Before you save an image, think about where you will keep it. Then create a folder and save the file there. Don't save files into the first place offered by the software – it is almost always the wrong place. It is better to have too many folders than to have hundreds of unsorted images on your hard drive.

Not too many items per folder

Avoid storing too many items in the same level of a folder. Just like the real-world equivalent, too many items in one place makes it a chore to find anything. Any set with more than a few hundred images is likely to consist of subsets of images – so keep these in a lower-level folder.

Sensible file names

It is remarkable how unhelpful some file names can be. With modern operating systems, there is no excuse for using cryptic file names that will mean nothing in years to come. Plan ahead: you know today what you mean when you call a file "Alice beach", but years later, you might just find "Blonde girl – Capetown beach" far more helpful.

Link scans to film filing

Photographers do not need to be told to file their transparencies and negatives in numerical/date order, sequentially numbered. When you make scans from the same source, it makes a lot of sense to append the film reference to the scan, along with a simple, standardized description.

Give your folder a face

You can replace the icon for your folder from the boring standard view with a thumbnail view of an image. It is easy to do in both Mac OS and Windows, but the procedure varies with different versions – look up the Help files.

Keeping file dates consistent

Files downloaded from a digital camera or memory card may have their creation dates changed to that of the day you made the download, rather than the day you took the photograph. To change the date it may be easiest to use a utility such as GraphicConverter, and apply a set date from the content command to an open file.

List them by date modified

If you arrange files by date modified, the first file offered will be the one most recently worked on. This is much easier than rifling through files that are listed alphabetically.

Add caption information

The majority of image-manipulation software and certainly all digital-asset-management software are able to add metadata – textual and other data in addition to the main data – to the image. A standard structure has been adopted by the IPTC (International Press Telecommunications Council) and is widely adopted. The full name of the standard is the IPTC Core Schema for XMP, where XMP refers to the extensible metadata platform. With the acceptance of the Core Schema by software, you can enter information in Photoshop and will find it appear in the right place in PhotoMechanic or Portfolio. More important, when you submit your pictures to an agency or commissioner, they too can easily locate

Many image-manipulation applications incorporate their own file browsers, such as that in Photoshop (*left*). But most operate slowly and are cumbersome compared to dedicated image databases. They also lack house-keeping facilities, such as moving groups of files around the system.

File integrity

Once in a few hundred saves, an error will be introduced by the hardware, or a portion of the disk might be damaged. But this might not be apparent until you try to open the file. To avoid problems use archiving software that verify copies as they save, or set disk-burning software to verify the data that is written. Naturally this takes longer than a simple copy or write operation, but could well save you from problems later. Note that even if you do check a CD or DVD by successfully opening a few files that offers no guarantee that every file on the disk will open.

The IPTC panel in Quantum Mechanic's Photomechanics shows there is ample space for adding a good variety of different information about an image. In this application, convenience features, such as being able to copy all the contents of one panel, then paste it into the IPTC panel of another image and being able to load presaved entries are handy time savers.

» FOR FILE FORMATS SEE PAGES 17–19

the copyright, caption and keyword information that you have provided.

As with all aspects of asset management, the sooner you add the IPTC data, the better. Remember that you can record not just the obvious caption information or keyword descriptors. You can make notes about the manipulation steps or settings of filters or controls used, the names of colours used to create duotone images, and so on.

Image databases

An essential application for digital photographers, image databases enable you to link textual information with images. Essentially, the image – in the form of a thumbnail – is handled as if it were a data field, like the date, the file type, or other information. Like all databases, its usefulness is in proportion to how much work you put in at the outset. If you save this data when you first create an image, file management becomes much easier as you go along. You are saving yourself work in the long run. If your collection runs to several hundred images or more, you will undoubtedly benefit from an image database. Your work can only grow.

At the time of writing there are over 50 different image-database applications. These range from the competent and free – such as iPhoto for Mac and Picasa for Windows – to fully-fledged professional media management systems that handle not only pictures but any kind of files, work over networks, and can maintain websites. For the majority of

Adding file extensions
For Mac users. If, like me, you turn off the automatic addition of file extensions in *Preferences* you may sometimes need to add them for Windows users. For one-off occasions, simply hold down the *Option* key as you choose the file format in the *Save* dialogue box, and the appropriate three-letter extension will be added to your file name.

photographers, the best solutions are in the middle ground. Applications such as Portfolio, ACDsee, iView Media, Fotostation, and Cumulus offer large capacities – tens of thousands of images – and features that range, variously, from being able to run slide shows, grade pictures, add metadata, burn disks, update websites, and archive collections. Picture management is also built into image-manipulation applications, for example, Bridge, which can grade images and batch process raw files – is part of Adobe's Creative Suite.

However, as software applications are more powerful they tend to work more slowly. An application popular with photojournalists and sports photographers as well as picture editors, because it uses little RAM and works quickly, is Photomechanic. It offers tools for quickly grading and comparing pairs of pictures, as well as adding IPTC information, altering profiles, sending by FTP, and so on.

Image display and contact sheets
Another advantage of image-database applications is their ability to display sets of images conveniently. You simply make a selection and instruct the software to "project" them: the images fill the screen, with each picture succeeding another at regular intervals, or at the click of a button. This is much faster than, say, opening each image in image-manipulation software, as the projected image is based on the thumbnail, not the full-resolution file.

A related ability, much valued by every photographer, is being able to print several images out on a sheet of paper. Ideally, this includes the file name. The size of each printed image varies with the number being printed per page, of course. Fotostation, for example, can print up to 63 different

The digital equivalent of the photographic contact sheet is the index print, produced by image-management software such as FotoStation, Portfolio, and so on. What it lacks in flexibility is amply compensated for by its ease of use.

images onto one sheet. This is a very useful feature and the results are such a delight to the eyes: you have to stop yourself from producing these index sheets for every folder you have.

Data back-up and archiving

In the past there were many disadvantages to complete data back-ups: storage was very costly, and transfer rates were low. But now there is no excuse at all. You can save to inexpensive, fast external hard disks through FireWire (IEEE 1394) cables. Hard disks of around 300GB capacity generally offer the best value measured at cost per GB, while keeping the cost to under 20% of a typical computer. And archiving on CDs is truly inexpensive when each CD costs less than an average mobile phone call, and most modern computers come equipped with a CD burner.

Avoid CD-RW (rewritable) discs as thay are not only more expensive and cumbersome to re-use, but their compatibility is suspect (a lot of machines fail to read them). In addition, I would avoid writing to hybrid formats unless you have to: native formats appear to be more reliable on the home operating system.

Dedicated software such as Retrospect or Personal Backup can save you a great deal of time as you will want to update only those files that have been modified, and not old files that are unchanged. Back-up software can also be set to operate overnight, or at specific times of the day.

It is prudent to store archives in a different place from computers. What might destroy your computer – fire or flood – is also likely to wipe out your archive if you keep it at the same location.

File rescue

The worst way of losing your files is doing so by your own hand – deleting a folder full of images, for example. The key to full recovery of your files is that nothing is written over files that you want to rescue. In both Windows and Mac OS, deleted files are kept in a temporary Trash or Wastebasket folder, and simply need to be dragged out to be usable again. And even if the Trash is emptied, recovery utilities such as Norton Tools (or Utilities) can reconstruct the files. That said, rescuing files from media such as CompactFlash, Memory Stick, or SmartMedia cards might require the services of specialist utilities, such as ImageRecall from Peak Development.

One of the great dangers with digital photography is the premature deletion of images. *Above:* A shopping centre display was marred by camera movement. But it turns out to be a popular Christmas image.

Stripping EXIF data

The majority of better digital cameras append image data such as focal length, shutter and aperture setting, equivalent ISO "speed", date, and so on in a standard format called EXIF. Some append the colour space that is used. Some cameras work in Adobe (1998), producing files in that space, yet they append the ICC profile for sRGB space. Photographers should avoid using sRGB space as it significantly limits colour gamut. If your camera insists on attaching sRGB profiles to your images, you should remove them – Adobe provides a plug-in, or you can create an *Action* in Photoshop to replace sRGB with Adobe (1998).

» FOR PUBLISHING PICTURES ON THE WEB SEE PAGES 132–136

Output your images

Night scenes place the heaviest demands on printing paper as they hold a great deal of ink – such as this scene in Kuching, Sarawak. Large black areas cause the paper to buckle with ink. Reduce output blacks in the *Levels* control as much as possible (*below*). Remember that if the image looks dark grey on screen it may still print perfectly well.

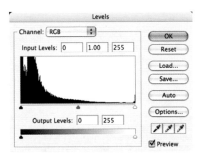

By dragging down the black output (bottom slider) by 5–15 levels you will reduce the heaviness of the maximum black. This is best for mass-printing, and will also save you ink with desktop printers.

Noise to improve prints

A trick for reducing ink overload problems in heavily dark or black areas is to introduce noise into the shadows. Select the dark tones and add monochromatic noise: it will be barely visible on the print, but it reduces ink pooling.

Up to this point, your work has centred on the screen, but always with the ultimate aim that your image be printed onto paper to create a glowing, dynamic and satisfying print. But it is important to remember the primacy of the monitor image; do not, for example, make the mistake of altering the screen image in order to make it match a print. You will then have no idea how the next print will turn out.

Technicians call the monitor image the "soft proof" – a virtual test as opposed to a hard proof (print). More prosaically, then, regard the monitor as your paper economizer. Maintain the monitor, maintain colour profiles, use standard inks and papers that you are familiar with and there will be no reason why you should not output top-class prints that compete with photographic prints in quality, reliability, and repeatability.

Soft-proofing

You can easily run around in circles attempting to control colour reproduction. As there are so many variables, such as the ink, paper, viewing conditions, and so on – you might be tempted to call them "traps" – you need to base all your operations on something fairly reliable. This has to be the calibrated monitor: one that is set up to meet a standard as closely as possible, and with its deviation from the standard characterized by a colour profile. Needless to say, the monitor should be the best you can afford: in the long run, it will save you countless trial prints and time.

To recap on earlier advice, have your monitor turned on for at least 30 minutes before using it for colour assessment. Set it to maximum brightness, and its contrast to a gamma of 1.8. For printing out on high-white glossy paper, a white point of 6500 K (or D65) is best; for mass printing, the preferred white point is 5000 K (or D50).

If possible, set up your monitor using a hardware calibrator. These, and associated software, are far less costly than they were before – about the price of Photoshop 7 – and ideal for those with several computers. Hardware calibrators are not foolproof, but they are still better than the screen-based

Seriously wrong?

**If you have a serious problem with the colour from your printer, you are almost certain to find the culprit in or around the printer itself. Always check the printer first. Confirm high levels of ink in the cartridges. Check that the manufacturer of the cartridge is the same as the one you have used before. Clean and check the nozzles: run them through the cleaning procedure, then print out a test pattern to look for gaps – even one blocked nozzle can disturb colour balance. Confirm that you are using paper you know, love, and have tested. Do not be tempted to make changes
to the screen image.**

calibration, which is the subjective "squint-as-you-adjust" alternative.

Preflight printing

The experienced digital photographer will always "preflight" an image file with care before hitting the "Print" button. Some of these checks may seem rather obvious but, like failing to load film in the camera, we all make these mistake at least once.

Check the image
Check that black output is clipped by five to fifteen levels, and that white is clipped by five to ten levels. Take one last quick look at the image for specks and defects. Flatten the file if it has many layers – a simple file prints more quickly.

Have you saved?
Check that you have saved the file and backed it up if necessary. Printing large or complicated files can crash a system.

Check output size and resolution
Is the output size correct, and will it fit on the paper you are using? And is the file's resolution sufficient for the results you wish for? Use the *Print Preview*. Avoid setting magnification to anything but 100%, as enlargement or reduction eats up processor time.

Printer settings
Is the printer set to print in colour, or black and white? (It's obvious, but …) Are settings for quality, paper,

Paradoxically, perhaps, images with the least going on are the hardest to print. The very lack of detail denies the printer places to shelter – every dot counts in producing clean, grain-free skies, such as this digital image from a very noise-free camera.

The most elementary preflight check is to ensure that the output size is appropriate for the size of printing paper. In the print with preview dialogue, you can check the size, position, and orientation of the image on paper, as well as setting the colour-management controls.

This shot of a beach in New Zealand is ideal for inkjet printing – any modern printer would produce a very passable print. The water and sand provide texture in otherwise open tones; the range of colours is limited; and the overall density is light. I lightened the shadows in the sea with the *Dodge* tool as a heavy black would disturb the tonal flow in this otherwise finely balanced image.

A carefully constructed colour chart is the essential starting point for creating printer profiles. This is from Binuscan PhotoRetouch Pro and provides thousands of patches. When printed out, this target is scanned and a carefully standardized printed version is also scanned using the same scanner. The software analyzes the difference between the two targets to determine the printer's characteristics, corrected for the scanner's own characteristics.

dithering, and so on correct? Are the colour management settings what you usually set?

Make notes

Have you noted all the settings – especially any which are different from usual? Note which type of paper you use, along with special features of the image, and so on.

Output levels

It might seem strange that an adjustment much used by the advanced worker should produce no visible effect – at least, nearly none. The output level controls

Roughing out the smooth

Extremely smooth tonal gradients such as those produced by highest-quality scanning or graphics illustrations are prone to banding when output on any device. It is extremely difficult for a print to disguise its printing pattern against very subtle changes. You can help by adding some noise to the region. It need not reduce quality, and even if it does add some roughness, that is preferable to either printer banding or linear gaps.

the appearance of pure black and pure white. A small decrease of output black by 5 to 15 levels (change the default of zero to between 5 and 15) will make a hardly visible change in the printed image, but it can reduce problems with heavily inked areas. This will save you ink. With night scenes, you might try reducing black levels by as much as 20 levels.

A dip in the highlight levels of five to ten puts a shade of density into the purest whites. It is highly recommended for mass printing, but it can also be a benefit in desktop printing too.

Advanced colour control

For the highest level of control, you need colour profiles for your printer so that it is linked into the whole management chain. There are two approaches to this. You can print out standard target images and have them analyzed by the many services that are now available. Soon after the profiling service receives your print, it will email back an ICC profile for your paper/printer combination. If you change your paper or printer, then simply send off another sample for a new profile. Unfortunately, this can work out to be costly as well as cumbersome and time-consuming.

Alternatively, you can do the profiling yourself using a scanner and suitable software. First, print out a standard colour file with the printer's default settings. Then you scan the result, with the scanner also set to its defaults, and with the colour-management facility turned off. The resulting file is then analysed by the profiling software against a scan of a standard target – the differences provide the basis for the printer profile. An excellent application

JPEG compression levels

For output to print, use quality settings of between seven and nine. You will be very hard pressed to see any difference between the nine and ten settings, but the difference in file size can be significant. At the medium settings, quality can be acceptable – provided the original file possessed ample resolution for the output size required. For Web output, quality settings of three to five will be fine; even less if the image has simple outlines and offers few gradient transitions.

It is important to determine whether your printer uses colour data in CMYK or RGB space. The actual colour of the inks used is immaterial as the issue is the mode of processing data. With ColourSync enabled (*left*), the printer will offer either a CMYK or RGB *Printer Neutral* profile – giving you the answer.

With highly manipulated fantasy images or content with no obvious visual references, colour reproduction can be wildly inaccurate yet acceptable. This image (*above*) is a multiple exposure of a waterfall against an Islamic monument, combining natural light with tungsten-lighting. From the beginning, then, there can be no wholly accurate, colour-balanced output solution.

» **FOR MORE ON PRINTING SEE PAGES 28–32**

One of the most surprising developments in digital photography is the maturing of black and white output. Desktop printing can now provide a depth of black and dark tones which extend, rather than compete with, gelatin-silver prints. Even straightforward shots like this image, above, can take on a richness never seen in a darkroom product.

for this purpose is Binuscan's PhotoRetouch Pro, which not only creates ICC profiles, it is an excellent image-retouching application in itself. Pantone offers a specialist application for profiling using a flatbed scanner.

Output to film

For professional photography – or to be more precise, to provide images to still-conservative publication clients – the best output for a digital image is to transparency film. Not only is the physical presence of the film an assurance, the transparency is its own colour-matching, quality-assurance standard.

For the best quality output, note that even the large gamut defined by Adobe RGB (1998) is unable to enclose the range of colours reproduced in the best modern colour transparency films, such as Kodak Elite SW and Fuji Velvia. To give image files tagged with Adobe RGB (1998) to a film writer would create similar disadvantages to giving a CMYK-tagged file to an RGB printer: colour gamut is unnecessarily clipped. To deal with this, Kodak have made available the ProPhoto profile: the gamut is so large that one corner – the yellow – extends beyond CIE xyz space. ProPhoto is a good profile to consider for people supplying top-quality drum-scans in 48-bit space, who wish to keep as much quality as possible in their files.

The disadvantage of this route – using a film-writer – is its very high cost. Film-writer technology is

rather old and costly to engineer: a turret of three narrow-cut (high-precision) red, green and blue filters rotates each filter in front of a small, very high-grade television screen. Focused on the screen is a normal camera: any format can be used following attachment of the appropriate lens and film magazines. Each line of the raster is drawn for each separation colour: the exposure must be extremely precisely controlled. Output capacities of 3,000 to 6,000 lines are available. This means that, for example, a 3,000-line output delivers 3,000 lines per inch on 35mm film, and 3,000 lines over 2¼ inch = 1,333 lines per inch.

Production rates are low, and the film subsequently needs to be processed – all of which add to costs. But in return, you can deliver a transparency which appears to be an original, and which can be used directly for quality control. And whenever you write to film, you can print with it: by the end of the process, the end result may completely conceal its digital origins.

Far better – as concerns grow regarding the long-term reliability of digital images – to know that film-writing offers a superb way to preserve precious digital images. In fact the best archive for images from your digital camera and image manipulation turns out to be none other than film.

Black and white printing

A great but largely untrumpeted benefit of digital photography is that photography can, at last, enjoy true blacks in a black and white image. Place an inkjet print next to a gelatin-silver print and see for yourself: the silver print is lovely to hold, but it cannot carry the weight of a true black.

Forever image

If you want your prints to last forever, the best way is to keep them in the dark – cold (chilled, but above freezing point), and humidity controlled (low humidity, but not completely dry) conditions. Use acid-free papers (the best are made from cotton rag) and store within buffered, archival-grade binders with limited (not zero) clear air circulation.

Dye and pigment inks

Dyes are colours which create their effect by staining or being absorbed into a substrate. Pigments are coloured substances which lie on the surface or collect within the fibres of a paper substrate. Pigments are commonly regarded as having greater longevity, but because they alter the surface of the paper, their apparent colour may change with the angle of illumination or quality of light.

For black and white inkjet printing, you have a choice of a composite or single black output. A composite (or polychrome) black uses some or all of the different inks available. To enable this, you must first turn your greyscale image into RGB or CMYK mode prior to printing, then set the print driver to print in colour. This uses your inks evenly, can give great richness of tones and, of course, allows you to change the tone of the black through the colour balance control. Note, however, that the result may be metameric, i.e. the tone colour varies slightly according to the colour of the illuminating light, particularly if pigment inks are used. This is because part of the pigment load lies on the surface of the paper, which alters the reflective qualities of the paper.

A variant of composite black is to print using different black ink tanks, which replace the usual tanks of coloured ink. This can give superlative results with extremely good archival qualities. Note that some printers print with two different black inks – a deep black and a dark grey – while other printers may use as many as six different black inks. Using multiple black inks, it is possible to mimic traditional black and white prints very closely.

Printing single black or monochrome is, of course, to set the printer driver to print in black. This can give good results, but you should print at the very highest resolution available. While this extends print times, tonal range will be extended and tonal smoothness will be improved compared to lower resolutions.

For low-key images with deep, rich tones and intense colours there is still no better method of output than the photographic print, particularly R-type (reversal) prints made from colour transparency. The digital file needs first to be output to film.

» **FOR COLOUR PROFILES SEE PAGES 69–70**

Output to web

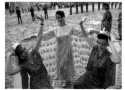

Images such as the above picture – of national celebrations in Uzbekistan – are simply not for the Web. It is full of detail, small areas of skin tone and fine textures. As a result, there is so much going on that at any rate the image cannot be used successfully at small sizes. Second, images like it will compress poorly – it is hard to find any data that can safely be lost. Further, any JPEG compression on an image with a small number of pixels will greatly and immediately damage detail, texture and micro-contrast.

Small profiles

ICC colour profiles are text files and generally can be kept very small indeed – a few hundred bytes – so you need not worry about a profile greatly increasing an image file size. Profiles can be highly detailed, producing correspondingly larger files, but these are used for characterizing printers or scanners.

The fundamentals of producing output for the Web are very simple. The digital photographer will save images of the requisite size in JPEG format. However, the reality is more complicated. To the majority of surfers on the Internet, so long as a colour that is meant to be red looks more or less red (and the same goes for other hues), then their requirements for colour accuracy are met. Even colours that they are familiar with, such as Kodak yellow or Coca-Cola red have to be wildly incorrect before the average Web surfer notices.

The advanced digital photographer is not, however, anything like so tolerant. We are sensitive to colour balance, hue and exposure (brightness). And the greatest of these is exposure.

Mac and PC monitors

It is sad but true that two standards in colour monitors are still battling it out. This conflict of standards alone guarantees that consistent colour reproduction between two individual monitors – let alone all monitors in the world – is simply impossible.

Essentially, Mac monitors look brighter and less
contrasty (set at a nominal gamma of 1.8 but often
closer to 1.6) than PC monitors (which are set to a
nominal gamma of 2.2). Therefore, an image that is
perfectly balanced for one standard will look wrong –
too dark or too light – on a monitor set to the other
standard.

Furthermore, the majority of users leave their
monitors at the typical default white balance of
9300 K. This produces a markedly blue balance when
compared to that adopted by digital photographers of
either D65 (6500 K), or prepress-oriented workers
who work at D50 (5000 K). Images that are colour-
balanced on the warmer standards of D50 will look
too blue on monitors balanced for 9300 K.

The first practical strategy to adopt, given that the
vast majority of Web surfers work on 9300-balanced
screens, is for you to work on a screen set to the
demotic standard.

Next, you should move your images into the Web-
centred colour space of sRGB. This allows you to
check whether your image appears satisfactory in this
relatively narrow, lowest-common-denominator space.

Two other strategies presume perhaps too much of
a perfect world, but are worth considering
nonetheless. You can prepare two sets of images,
optimized for gamma 1.8 and gamma 2.2 monitors
respectively. Then you set up the website so that
visitors can choose between the Mac- or Windows-
optimized sets. In addition, you can embed the profile
for the image so that as it loads the image, the Web
browser makes the necessary corrections. However,
this assumes firstly that the surfer has properly
profiled their monitor. And if so, one hopes they are

Can you spot the difference?
Both images are 100% close-
ups of a 9MB scan of a 35mm
transparency at 1600 ppi. One
is the full-size file (*above left*),
the other is a JPEG compressed
at zero quality setting to a
mere 167K in size – over 50
times smaller. The fur on the
cows of the compressed image
is defined somewhat less
clearly and details such as
the distant fencing paling is
a little softer (*above right*).

» FOR WHITE POINT SELECTION SEE PAGE 23, AND FOR FILE SIZES SEE PAGES 96–99

Why 72 dpi?

It is conventional advice to output Web-targeted images at 72 dpi for viewing on users' monitor screens. Given a monitor whose resolution is in fact 72 dpi, a line that is 72 pixels long at 72 dpi output resolution will display as 1 inch (25mm) long. But at other resolutions, the line cannot be 1" long. In fact most modern monitors work at higher resolutions – around 80–110 dpi. Given the range of monitor sizes in use – from 12" to 24" and the resolutions possible – from 720 to 1920 pixels – it is not possible to set an output resolution that guarantees a target size for a displayed image. For modern users, an output resolution of 80 or even 90 dpi is better than 72 dpi; or else the image will appear too small – if, indeed, a resolution setting is needed at all.

The size of an image on a monitor screen depends on its pixel dimensions. Even if the small image (*above left*) is sized to 250mm wide (it is) it will appear on screen only a quarter the size of the image (*above right*) which is sized to 70mm, because it, the smaller image, possesses only a quarter the number of pixels.

not only running a browser that supports profiles, but have turned on ColourSync management in the browser preferences.

Optimizing Web images

Web image optimization is almost an art in itself. The overriding concern is to speed up file downloads while not compromising on image quality. While no file can load quickly enough, fortunately the quality demands of Web-based image consumption are none too rigorous. This has come about partly as a result of education – most viewers' expectations are not high – partly, of course, due to the chaotically different monitor standards. Nonetheless, quality standards are steadily rising. It is now commonplace for even starter outfits to display millions of colours at resolutions exceeding a thousand lines.

Do not save previews

The simplest way to save on file size is to not save image previews (thumbnails or icons). In Photoshop, previews are not saved when images are saved as GIF or JPEG in the *Save for Web* menu.

Decrease picture size

An even easier way to save on file size is to make do with a smaller image – either by cropping it or through an overall shrinking. Small changes make a big difference as the file size varies geometrically: for example, a modest 25% reduction in size produces a 50% drop in file size.

Compression setting

A common mistake made by digital photographers in setting JPEG compression is to be too conservative about compression. Prima donnas of quality need not apply for Web publishing. In the vast majority of Web pages, image degradation from JPEG compression is the least of your worries. The images which suffer most from compression defects are those that feature large areas of solid, bright colour and graphic lines – the very images which should be saved in GIF.

Slicing for quality

Image slices are essentially separate images which are seamlessly joined to make a single image. They are used to create rollovers and other effects. To the advanced digital photographer, however, they offer a method to match compression rates to areas of the image that have different levels of detail. In other words, they provide crude adaptive compression (one that responds to changes in complexity of data). For example, an image with important detail in the centre, such as a portrait, but which has a plain background can be sliced to enclose the portrait. The remaining areas will be automatically sliced. Each is then separately saved – with its own file-name – with minimum compression applied to the face and maximum to the other slices.

Security from Internet thieves

The key precaution for preventing your images from being stolen is to make them as small in displayed

size as possible, appropriate to the design. And you should also compress them to the greatest extent without compromising quality. These measures render your image unusable at anything but a very small output size. Here are some other ways:

• Add your copyright notice as text directly onto the image. The drawback is obvious. The © sign interferes with the impact of your work – even if discreetly placed or, like a watermark, made semi-transparent. Also one "Copyright © John Doe" notice after another makes you look rather precious about your work.

• Slice the images into two or more sections. On webpages, slices are essentially separate images that are sewn together by the browser software interpreting the HTML codes. Image slicing helps prevent theft by making it awkward to download an entire image – only the slice that is clicked on will be downloaded to the viewer.

• Overlay your image with a transparent – i.e.invisible – image of exactly the same size. When someone tries to download your image, they get what they deserve – nothing visible. There are various ways of achieving this. One is to create a table the same size as the image with the image set as its background colour, then create a transparent GIF image of the same size and make it the table contents. Another method is to make image slices from layers, the top one of which is transparent. A close relative of this method is to use mouse rollovers with a transparent image – so the transparent image comes on as the mouse rolls over the image.

Naturally, these methods will increase download times, and some are tricky to implement. Also, nothing will stop the determined. The best course of action is to keep file sizes very small. And feel flattered if anyone burgles your website … should you ever find out about it.

Watermarking images

A different approach to the protection of your assets is the digital watermark. This is an invisible encryption stored in the image which can be read by special software to prove that you are the owner. This is best for those who market high-resolution images through the Internet: the watermark can be removed only with a key code. However, watermarking can reduce

You can add a visible "watermark" to your image. This not only identifies you as the photographer, it discourages others from stealing the image. As seen above, a little work – such as the creation of glowing text and a drop-shadow – discourages theft because of the work needed to remove it.

Web-safe colours are meant to offer some security in screen-based picture-viewing but in reality they now unnecessarily restrict colour gamut. Also, only the oldest monitors are restricted to 8-bit colour.

Web-safe colours: they're extinct

GIF files are based on the so-called "Web-safe" colours, a set of 216 colours which could be more or less guaranteed to be reproduced on colour monitors in the early days of the Internet (they are all the colours where the R, G, or B values are either 0 or a multiple of 51). Nowadays, virtually all monitors are capable of displaying millions of colours. There is very little point in any photographers limiting themselves to Web-safe colours.

» FOR MORE ON DIGITAL COLOUR SEE PAGES 20–23

A webpage designed in FotoStation (*right*) is very basic, but it needed all of 30 seconds to generate. It does the job safely, simply, and quickly. The background can be improved by specifying a colour or an existing image.

Webpages (*right and below right*) designed in Photoshop 7 are stylish and can look purpose-built (except that hundreds of other websites may look the same). You can create static shows that the viewer must scroll through, or a slideshow, which projects one image after another at defined intervals.

sharpness slightly and can increase file sizes considerably. And obviously, watermarking is of no use unless you can obtain a copy of your files used by the offending party.

Web publishing

With nearly everyone connected to the Web having the space to publish their own webpages, it is commonplace now to show your pictures on the Web. Image-manipulation applications and picture management make it easy to create webpages. These are not the most elegant, but the process is almost entirely automatic. All that you have to do is point the application to a folder and decide on a style of layout and a few other settings. Moments later, the webpages are created and all you have to do is to upload the files onto a server.

The usual structure is that thumbnail views are shown, and clicking on them will return a larger view. Simple navigation aids allow the user to backtrack, or return to the main display.

As the preconstructed formats or templates for the webpages are quite rigid, you should ensure that you have the correct number of pictures for the layout you choose. For example, you are offered a "Table View", which comprises four rows of three images. If you offer up 25 images, you will be left with a single image on the last page.

The templates employed by the software can be customized using standard Web page creation software, such as Dreamweaver, GoLive, or Freeway. Modern techniques allow for pages to be set up so that they can be linked to folders and as you add new pictures the pages are automatically updated.

However, you do not have to set up your own webpages. You can join one of the numerous online picture databases or online picture albums, such as Snapfish, Kodak EasyShare, or Smugmug. Some allow you unlimited numbers of pictures, representing free or highly cost-effective ways to show your pictures to people all round the world. Some sites allow you to offer prints of your pictures for sale, which provides revenue for running these sites.

REFERENCE

Glossary

24-bit
Measure of the resolution of data: sufficient to code 17 million different colors.

5000
White balance used in prepress and printing industry: a very warm white.

6500
White balance compromise between prepress and Web standard: appears warm compared to 9300, cool compared to 5000.

8-bit
Measure of the resolution of data sufficient to code 256 levels or differences.

9300
White balance similar to daylight on a clear day: used for Web; appears cold compared to 6500.

achromatic color
Varies in lightness but not of hue or color, e.g., black or greys.

addressable
Point in space referenced by e.g., printer or scanner.

alias
Representation for the original continuously varying signal produced by sampling and measuring the signal to convert it into a digital form.

alpha channel
Part of a file: changing the alpha channel changes, e.g., opacity or transparency of the rest of the file.

analogue
Effect, representation or record that is proportionate to some other physical property or change.

anti-aliasing
Smoothing away the jaggies or stair-stepping in an image or type.

archival
Describing process or arrangements designed to ensure long-term preservation of image, files, etc.

array
Arrangement of image sensors: either two-dimensional, grid or wide array or one-dimensional or linear.

artifacts
Imperfections or artificial elements in an image created during image acquisition, image manipulation or processing.

attachment
File sent with an email e.g., an image or other email.

background
Base layer of an image, lying under any other added layers. Generally cannot take on certain properties unless changed into a layer.

bicubic interpolation
Resampling of data in which the new pixel is calculated from the values of its eight new neighbors. It gives better results than bilinear or nearest neighbor interpolation.

bilinear interpolation
Resampling in which the new pixel is calculated from the values of four new neighbors at the cardinal points. It gives poorer results than bicubic, but needs less computing.

bit depth
Measure of amount of information that can be coded. One bit registers two states: 0 or 1, e.g., either white or black; 8 bit can register 256 states.

bit-mapped
Image defined by values given to individual picture elements of an array whose extent is equal to that of the image.

blend
Method by which an image on one layer interacts with the image below it.

blur
To soften or make indistinct image edges or outlines.

brightness
Visual perception varying with amount or intensity of light.

brush
Image-editing tool used to apply color, blurring, burn, dodge, etc. Limited to areas the brush is applied to.

buffer
Memory in device such as printer, CD writer, digital camera which temporarily stores data for supply to other components.

burning-in
Digital image manipulation technique that darkens the image.

byte
Unit of digital information: one byte equals 8 bits.

cache
RAM temporarily storing recently read off data.

canvas
Virtual area in which an image is located. Usually the same size as the image, it can be larger but cannot be smaller unless the image is cropped.

CCD
Charge-Coupled Device: semiconductor device used to measure amount of light, hence used as image detector.

CD-R
Compact Disk – wRite: storage device for digital files.

channel
Set of information grouped in some way, e.g., by lying within a band of frequencies or wavelengths.

CIE xyz
A color model enclosing all visible colors used as basis for CIE chromaticity diagrams, etc.

clipboard
Area of memory reserved for temporarily holding items during editing.

CLUT
Color Look-Up Table: the collection of hues used to define a set of colors: e.g., for GIF, 216 colors are chosen from 256 possible colors.

CMYK
Cyan Magenta Yellow Key: the three primary colors of subtractive mixing plus the black or key ink.

ColorSync
Color management software system invented by Apple.

colorize
To add color to a greyscale image while maintaining original lightness.

color
Visual perception characterized by hue, saturation, and lightness.

color cast
Colored tint evenly covering an image.

color gamut
Range and extent of colors a device can produce.

color management
Controlling devices in a production chain to ensure that color reproduction in outputs are reliable.

color picker
Means by which user can select a color for use, e.g., in painting.

color temperature
Temperature of a standard heated source when color of its light matches that of light being measured.

complementaries
Pairs of colors which produce white when added together as lights.

compositing
Combination of one or more images with a basic image.

compression
Process of digitally reducing size of files.

constrain
To keep one factor while changing another, e.g., keeping proportions while resizing image.

continuous tone image
Record in which relatively smooth transitions from low densities to high densities are represented by varying amounts of marker, e.g., ink, silver.

contrast
Measure or assessment of difference between brightest and darkest, or rate of variation of density with light.

crop
To use or scan a portion of an image.

Curves
Graphical representation of the way original pixel values are changed to output values.

cyan
Blue-green: primary color of subtractive mixing; secondary color of additive mixing.

D50
Also D5000. *See 5000.*

D65
Also D6500. *See 6500.*

daylight
Adjective describing film whose color balance is correct for light-sources whose color temperature is ~5600 K.

delete
Removing a file from computer records.

density
Measure of image in terms of its ability to stop light, i.e., its opacity. The number of dots per unit area delivered by a printer.

desaturate
To reduce the depth or richness of color in an image.

device resolution
Measure of the number of points per unit length that device can read or print to.

dialogue box
Software feature for giving settings to the application.

digitization
Process of translating values for brightness or color into digital code.

dithering
Simulating many colors or shades by using what is in fact a smaller number of colors or shades.

d-max
Measure of greatest or maximum density of silver or dye image attained by film or print in given sample.

dodging
Reducing density to "hold back" or preserve shadow detail.

down-sampling
Reduction in file-size when a bit-mapped image is reduced in size.

dpi
dots per inch: measure of device resolution of printer as the number of dots which can be addressed by the device.

driver
Software used by computer to control a device such as scanner, printer.

drop shadow
Graphic effect in which object throws a fuzzy shadow off-set and below it.

duotone
Mode of working simulating printing of image with two inks.

dye cloud
Microscopic dispersion of colored dye in photographic emulsion: the basic element of color photograph.

dynamic range
Measure of the range of highest to lowest energy levels that can be captured by e.g., digital camera.

effects filters
Image-manipulation filters offering effects similar to their camera counterparts.

enhancement
Alteration of qualities of an image in order to improve the visual appearance without altering its content.

EPS
Encapsulated PostScript: File format that stores an image in PostScript.

erase
To remove part of an image.

exposure
Process of allowing light to reach photo-sensitive material to create image.

f/number
Setting of lens aperture of amount of light transmitted by lens.

fade
Gradual loss of image.

feathering
Reducing the sharpness or suddenness of the change by blurring or spreading out a selection or margin.

file format
Structure by which a software program stores data.

fill
Covering a selected area with a color or pattern.

filter
Software producing effects simulating effects of photographic filters.

fingerprint
Invisibly marking an image file in order to prove ownership.

FireWire
Rapid serial bus technology for interconnecting devices: the same as IEE 1394 and iLink.

flare
Non-image-forming light in optical system.

flat
Low-contrast result or tending to produce low-contrast results.

flatten
Combining all layers, masks and alpha channels of an image into the background, rendering all effects at the same time.

font
Set of letters, numerals, symbols designed to look similar and work together.

format
Shape and dimensions of image or paper, hence also of publication size. The orientation of an image, whether landscape or portrait. Also preparation of digital media for recording.

fractal
Curve or other object whose smaller parts are similar to the whole.

gamma
In digital photography, the steepness of the middle portion of curve or transfer function. In monitors, the correction to the color signal prior to its projection.

Gaussian blur
Blurring effects filter in which extent of blur can be controlled.

GIF
Graphic Interchange Format: a compressed file format designed for use over the Internet. Comprises a set of 216 colors chosen from 256 supported by the format.

gradient
Smooth transition in density of color or mask.

grain
The individual silver (or other metal) particles that make up the image of a fully developed film. Also the surface texture of a sheet of paper.

greyscale
Measure of number of distinct steps between black and white that can be recorded or reproduced by a system.

half-tone cell
Used by printing or reproduction system to simulate continuous tone reproduction.

hardcopy
File printed onto a support such as paper and film.

hardness
Measure of the sharpness of edge of a brush.

histogram
Graphical representation of the distribution of values.

History
Method in Photoshop for displaying different states of undo for reversing changes to image.

hue
Name given to visual perception of color.

indexed color
Method of creating color files or defining a color space.

ink-jet
Printing technology based on the controlled squirting of extremely tiny drops of ink onto a receiving substrate.

input resolution
Measure of fineness of detail captured by a scanner or the number of effective pixels of a digital camera image.

intensity
Measure of light radiated by a source.

interpolation
Insertion of pixels into an existing digital image in order to increase file size, rotate image, etc.

inverse
To reverse a selection, i.e., select all the pixels that were originally not selected.

invert
To reverse the colors and/or tones of an image.

jaggies
Appearance of stair-stepping artefacts.

JPEG
Joint Photographic Expert Group: data compression technique. JPEG 2000 is another standard, using different compression technology.

K
Key color or black: the fourth color separation in the CMYK four-color reproduction process. Also Kelvin: unit of temperature relative to absolute zero.

KiloByte
1024 bits or 210 bytes of data; abbreviated to KB.

key tone
The black in an image. The principal or most important tone in an image.

Lab
Color mode based on CIE space.

lasso
Method of selection by drawing a shape enclosing a group of pixels.

layer
Component of an image which "floats" virtually above the background image.

layer mode
Image-manipulation feature determining the way a layer in an image interacts with the layer below.

lens resolution
Measure of ability of optical system to separate fine detail.

line art
Artwork of black lines and areas, with no intermediate grey tones.

lpi
lines per inch: measure of resolution or fineness of photo-mechanical reproduction.

LZW compression
Lempel-Ziv Welch: a compression method for lossless file compression.

Mac
Apple Macintosh computer.

magic wand
Tool in Photoshop used to select group or groups of pixels which are alike in value.

marquee
Selection tool which covers a rectangular area.

mask
To obscure selectively or hold back parts of an image while allowing other parts to show.

master
To make the first incarnation of a photograph or recording.

matte
Finish on paper that reflects light in a diffused

way. Also mask that blanks out an area of image to allow another image to be superimposed.

maximum density
See d-max.

megapixel
Million pixels (does not refer to actual size of pixels).

mode
Method, state or way of operating.

moiré
Pattern of alternating light and dark bands or colors caused by interference between two or more slightly differing superimposed patterns.

multi-scanning
Scanning an image more than once in order to combine data.

native
File format belonging to an application programme.

nearest neighbor
Interpolation whereby the value of the new pixel is an average of the contiguous neighboring pixels. Best method for line-art images.

noise
Unwanted signals that tend to reduce the amount of useful information.

opacity
Degree of denseness of layer or lack of transparency.

out-of-gamut
Color or colors that are visible or reproducible in one color space but which cannot be seen or reproduced in another.

output resolution
Measure of effective resolution of a device: always less than device resolution due to need to construct half-tone cells, etc.

Pantone
Proprietary name for system of color coding and classification.

paste
To place data copied or cut from one position into another.

photomontage
Image made from the combination of several other images etc.

PICT
Graphic file format native to Mac OS.

pixel
Picture element: smallest unit of a digital image.

pixellation
Appearance of a digital image whose individual pixels are visible.

plug-in
Application software that works in conjunction with a host program as if a part of the program itself.

posterization
Representation of an image using a relatively very small number of different tones or colors.

PostScript
Language designed to specify elements that are printed on a page or other medium that is device and resolution-independent.

ppi
Points per inch: measure of input resolution of scanning device.

prescan
In image acquisition: a quick "snap" of the object to be scanned, taken at a low resolution for adjustment of cropping, etc.

process colors
Those which can be reproduced with cyan, magenta, yellow and black.

proofing
Confirming the quality of a digital image before final output.

prosumer
Professional quality product for the consumer market.

quadtones
Type of multitone image, using four different colored inks.

quality factor
Defining how much larger a file should be to be sufficient for output: file resolution should be 1.5 to 2 times the screen frequency.

RAM
Random Access Memory: component of the computer in which information can be stored or accessed directly.

raster
The regular arrangement of addressable points of any output device such as printer, film writer, etc. Means much the same as "grid."

RAW
Image file in its basic form, as output by photo-sensor, before processing.

RGB
Red Green Blue: color model that defines colors in terms of relative amounts of red, green, and blue components.

rubber stamp
Photoshop name for the clone tool – replicating one part of an image onto another.

scaling
Changing the size of an image relative to its input.

sensor resolution
Measure of the number of effective pixels output, without interpolation, from a digital camera.

separation
Converting tones and colors into three or more channels of information.

sharpening
Increasing the contrast of image boundaries.

shutter-lag
Time elapsed between pressing the shutter button and the camera making the exposure.

snap
Property of grid or guidelines whereby an object placed nearby is pulled or snapped to the line.

soft proofing
Use of monitor screen to proof or confirm the quality of an image.

sponge
Photoshop name for the brush that applies changes in saturation.

stair interpolation
Increasing file size in several small steps, instead of one large one.

stair-stepping
Jagged reproduction of a straight line.

thumbnail
Representation of image as small, low-resolution version.

TIFF
Tag Image File Format: a universal image format.

tint
Overall coloring that affects areas with density but not clear areas (in contrast to a color cast).

tolerance
In Photoshop, defines range of variation within which a selection is made.

transparency
Degree to which background color can be seen in the foreground layer.

tritones
Type of multitone which prints with three differently colored inks.

TWAIN
Toolkit Without An Important Name: driver standard used by computers to control scanners.

undo
Reverse an editing action within an application.

upload
Transfer of data between computers or from network to computer.

USB
Universal Serial Bus: standard for connecting peripheral devices.

USM
UnSharp Mask: image processing for improving apparent sharpness of image.

warm colors
Hues such as reds through oranges to yellows.

watermark
Feature or data – which may be visible or invisible – in a digital image file used to identify the copyright holder.

white point
Nominal balance of red, green and blue at their additive maximum: varies according to standard from slightly yellow to slightly blue.

width
The side-to-side dimension of an image; runs at right angles to the depth or height axis with which it defines the size of an image.

write
To record data onto storage device e.g., CD or hard-disk.

zoom
To change magnification of the image on the monitor screen.

Further reading; Web resources

Realworld Photoshop CS2
Blatner, David & Fraser, David; Peachpit Press; ISBN 0 321 33411 6
Excellent, authoritative and clear – there's something worth remembering on every page. Particularly strong on prepress preparation. It does not set out to be a comprehensive guide to all of Photoshop's features.

Photoshop 7 Trade Secrets
Aronoff, Janee and others; friends of ED; ISBN 1 903450 91 8
Easy-to-follow book with numerous handy tips, with some usefully advanced techniques, some rather limited ones. Assumes a fair knowledge of Photoshop.

Photoshop Studio Secrets
McClelland, Deke & Eismann, Katrin; Hungry Minds; ISBN 0 7645 3576 5
Written by two of the best veterans in the business, this is an attractively full collection of practical techniques used by professionals with an unusually broad range of work. Some high-power ideas are aired. Highly recommended for the advanced worker.

Dictionary of Photography and Digital Imaging
Ang, Tom; Argentum; ISBN 0 8174 3789 4
Comprehensive listing of terms covering much of modern imaging with easy-to-understand definitions catering for beginners and more experienced workers.

Photoshop Color Correction
Kieran, Michael; Peachpit; ISBN 0 321 12401 4
A thoroughly solid, informative, well-illustrated and insightful treatment of the entire subject of digital color. Essential reading for anyone who wants to be serious in digital photography.

Professional Photoshop
Margulis, Dan; Wiley; ISBN 07645 3695 8
Filled with practical advice which is well presented but the slap-on-the-back style of writing can be wearisome. Its authority has been supplanted in part by Photoshop Color Correction. Highly recommended nonetheless.

Photoshop Channel Chops
Biedny, David and others; New Riders; ISBN 1 56205 723 5
A comprehensive and even entertaining treatment of the tricky subject of channels and layers in Photoshop 5. Look out for an updated version to cover new layer modes in Photoshop 7.

The Reproduction of Color
Hunt, RWG; Fountain; ISBN 0 85241 356 X
The definitive text on color reproduction in all its aspects, including film and TV. Highly technical and a taxing read, but there is none more authoritative and complete.

The Reconfigured Eye
Mitchell, William; MIT; ISBN 0 262 13286 9
An excellent introduction to a critical approach to digital image manipulation that is easy to read and very well illustrated.

Digital Imaging
Graham, Ron; Whittles; ISBN 1 870325 12 5
The first half is a good and generally accessible technical introduction to the fundamentals of digital photography. Much of the second half is now dated.

Linotype Color Book
Legrand, Dominique; Trait d'union graphique; ISBN 2 950346 2 7
Excellent visual guide to color theory and color printing with color charts and accessories for measuring prints.

Web resources
CreativePro
www.creativepro.com Wide-ranging site covering graphics, design, fonts as well as photography. Many useful articles, links and reviews.

DP Review
www.dpreview.com Without doubt the best site for up-to-date news on digital cameras, with some tutorials and links. A must-book-mark site.

Imaging Resource
www.imaging-resource.com Rich resource for photo-technique tutorials, equipment reviews, and for many subjects, as well as links and subscribing to RSS feeds.

Fotosearch
www.fotosearch.com
Useful starting point for search of royalty-free images, including many freebies offered to tempt you to register with a site.

Image Recovery
www.imagerecall.com
ImageRecall software from Peak Development recovers files from removable media; also file recovery service.

Legion Paper
www.legionpaper.com
High-quality ink-jet paper in acid-free, archival sheets and rolls.

Piezography
www.con-editions.com
Range of black inks for exhibition-grade black and white ink-jet prints, with claimed archival qualities using replenishable inkwells and special printer drivers, developed mainly for Epson printers.

Imaging Insider
www.imaginginsider.com
Highly informative, busy site offering reviews, advanced techniques and fora for discussions.

Poynton
www.inforamp.net/~poynton
Charles Poynton's color technology pages are informative and authoritative, even if some take issue with his views. Useful links to color technology pages.

PC Tech Guide
www.pctechnguide.com
A nerd's nirvana: full of glossaries and details of how things work. Clearly and largely accurate accounts of how scanners, digital cameras and printers work.

Wilhelm Research
www.wilhelm-research.com
The key resource on ink-jet printing, with authoritative tests on ink-fading.

Wet Pixel
www.wetpixel.com
Dedicated to underwater digital photography, with equipment data, hints, diving information.

Photodo
www.photodo.com
Fund of technical information and detailed, some very detailed, equipment reviews including unique lens tests.

Rob Galbraith
www.robgalbraith.com
The guru of digital photojournalism's site is full of advanced techniques and hard-won practical information. A must-book-mark site.

Computer Darkroom
www.computer-darkroom.co.uk
Photoshop tutorials, reviews of the less-reviewed items, e.g., profiling software plus useful links.

Extreme Tech
www.extremetech.com
As its name suggests, not a source for the technophobic: extensive and some very in-depth background, with numerous links and regularly updated.

ndex

Page numbers in *italic* refer to illustrations

adjustment layers 48–9, 53, 57, 69
Adobe RGB (1998) *20*, *23*, 31, 32
aliasing 63–5, *64*, 81
alpha channels 77
archiving images 125
art, painting effects 92–5
artefacts 62–5

battery life 34–5
bicubic interpolation 98
bit-depth 27, *27*, 48
bitmapped fonts 81, 83
black and white photography 100–5
 printing 130–1, *130*
 scanning negatives 45, *46*
black point compensation 32
blur filters 56–7
BMP format 18
bokeh 40
brushes 53, 55, 92–3, *93*
burning-in 52–3, *52*
burst capacity 34

calibration:
 monitors 21–3, 126–7, 133
 white point 36–7
cameras, using 34–41, *35*
canvas size, increasing 58–9
captions, adding to images 123–4
CCD sensors 12, *12*, *13*, 15
Channel Mixer 68, *69*, 101, *101*
channels 20, 21, *46*, 114–15
 alpha 77
 chrominance 21
CIS sensors 25
clipping paths 83
cloning 54–5, 57, *57*, 95, *95*
CMOS sensors 12–13, *13*
CMYK mode 20, *27*, 71, 118
 and black and white photography 100, 101
 printing in 31, *31*
colorimeters 22, 23
Color Range tool 77, 78, *78*
color 20–3
 calibration 21–3
 channels 46, *46*
 color aliasing 63–4

color filter array interpolation 13–15, *14*
color gamuts 21, 30–3, *31*, *32*
color management 20–3, *20*, *23*, 32
converting to black and white 100–5
correcting *22*, *29*, 36–7, 66–73
printing in 28–32, *128*, 129–30
profiles *20*, 30–1, 35–7, 69–71
replacing 68, 77
saturation control 72–3
Web-safe 135, *135*
composite images 84–91
compression 18–19, 24, 99, 134
 see also JPEG compression
contact sheets 124–5, *124*
copyright 135
cropping *58*, 59–61, *61*, 98
cross-processing 107–8
Curves control 50–1, 70, 106–7, 108
Custom Filter tool *115*

darkroom effects 106–11
databases 17, 124–5
defringing 75, 85
demosaicking 13–15, *14*, 63, *64*
digital vs film 8, *9*, 11, *11*, 28
distortion:
 correction 39, *40*, 58–61
 creating *60*
dithering *29*, 30
dodging 52–3, *52*
Dropper tools 49–50, 66, *66*, *67*
drum scanners 26
duotones 102–3, *102*
dust removal 27, 43, 56–7, *56*
DXO Optics 60

enlarging images 96–9
EPS format 18
EXIF data 15, 125
exposure problems 41

feathering 75, 77
field of view 38, *39*
files:
 compression 18, 19, *19*

corruption 12, 41
enlarging 96–9
file rescue 125
formats 17–19
management of 122–5
 size 10–11, *16*, 112, 129
film 65, 130, *131*
 versus digital 8, *9*, 11, *11*, 28
filters 112–13
 blur 56–7, 75–6
 color filter array interpolation 13–15, *14*
 sharpening *115*, *116*, 118, *119*, 120
focal length 37–8, 40
 focal length multiplier *34*, *39*
fonts 80–3
fractal compression 99
fringing 10, 38, *64*

Genuine Fractals 99
GIF format 18, 135
gradients 53
grain 45, 46, 65, 97
graphics tablets 95
greyscale mode 100–1, *100*, *107*

half-tone cells 29–30, *29*
Healing Brush 55
high-pass sharpening 120, *120*
History Brush 93–4
Hue/Saturation control 72, 102

ICC color profiles 36, 132
image manipulation *17*
 color adjustment 100–5
 color correction 66–73
 composite images 84–91
 darkroom effects 106–11
 dodging and burning 52–3
 filters 112–13
 image correction 58–65
 masking and selection 74–9
 painting 92–5
 retouching 54–7
 sharpening 114–20
 tone control 48–51
images:
 capture of 11
 image slices 134–5
 organisation of 122–5
 outputting 126–36
 for Web use 132–6
inks, printing 131

Internet *see* Web
iPhoto 16
IPTC data 123–4, *123*

jaggies 64–5, *64*, *65*, 81
JPEG 18, 19
 compression *19*, 32, 129, *133*, 134
 compression problems *62*, 63, 120

L channel *68*, 115
Lab space *31*, 71
Lasso tools *76*, 77
layers:
 adjustment layers 48–9, 53, *53*, 57, 69
 effects with 83
 modes 87–9
 use in color manipulation 104
 use in composite images 84–6, 87, 90–1
lenses 37–40
Levels control *17*, 48, *48*, 49, *50*
LIDE sensors 25
Lightness channel *68*, 115
lith printing 110–11
luminance channel 21, 114–15
LZW compression 18

masks 74–9
memory cards 15
metadata 123
moiré 41, 43
monitors 132–4
 calibration 21–3, 126–7, 133
MOS sensors 13, 15

negatives, scanning 45, *46*
noise *9*, 46, 62–3, 65, 97

OpenType fonts 81
Overprint Colors 103

painting effects 92–5
PanoTools 61
patching *54*, 55–6
PDF format 18, 81
perspective distortion 59
photo-electric effect 9
Photo Mechanic *123*, 124
photomontage 84–91
PhotoRetouch Pro *128*, 130
photosensors *see* sensors

Photoshop:
 adjustment layers 48–9, 53, *53*
 Channel Mixer 68, *69*
 cloning 57
 color profiles in 36–7, 69–70
 Curves 50–1
 filters 112
 Genuine Fractals 99
 healing and patching 55, 57
 Hue/Saturation 72–3
 image browsers *123*
 masking and selection 76–7
 painting in 92–5
 Quick Mask 75–6, 117
 Shadow/Highlight 51, *51*
 UnSharp Mask 115–19
PICT format 18
pixels 10–11, 13, 44–5
PNG format 18
posterization *8*, *29*
PostScript fonts 81

printing 97, 126–31
 in black and white 130–1, *130*
 in color 28–32, *128*, 129–30
 lith printing 110–11
 preflight checks 127–8, *127*
 problems with *29*, 32

prints:
 scanning 45
 storage of 130
problems:
 artefacts 8, *19*, 62–5
 banding *8*
 blooming 10
 distortion 58–61
 dust 43–4, 56–7, *56*
 exposure 41
 file corruption 41
 fringing *10*, 38, *64*
 graininess 45, 46
 lens flare *38*
 moiré 41, 43
 noise *9*, 46, 62–3, 65
 posterization *8*, *29*
 printing 127, 128, 129
 saving images 123
 well overflow 10
profiles, color *20*, 30–1, 69–71
 in-camera 35–6
proofing images 126–7

quadtones 103, *103*
Quick Mask 75–6, 117

R-type prints *131*
raw format 18, 35, 41
Rayleigh scattering 46
rectilinear projection 59
rendering intent 31–2, *31*

resampling images 96
resizing images 96–7, *97*, *99*
resolution 10–11, 13, 44
 and file sizes 96–7, 98
 in scanning 25, 26, 27, 44–5
 for Web use 134, *134*
retouching 54–7, *55*, *56*
RGB mode 20, 46, *46*, 71, 100
 printing in 30–1, *31*

S-Spline 98–9
Sabattier effects 106–7, *106*
saturation, controlling 72–3
scanners 24–7, 62
scanning *24*, *25*, 26–7
 batch 27, 42
 black and white 45
 negatives *25*, 26
 problems with 43–4, 45
 resolution 25, 26, 27, 44–5
 techniques 42–6, *42*
sensors 12–15, 25, 37, 38, *39*
Shadow/Highlight control 51, *51*
sharpening 43, 97, 114–20
Smart Fill 56, *56*
software 16–19, 35, 125
solarization 106, 108
split-toning 108–9
stair interpolation 98, *99*
stair-stepping 64–5, *64*, 81

telecentric lenses 39
TIFF format 18
tools, painting 92–3
transparencies, outputting to 130, *131*
triple-well arrays 15
tritones 102, *102*, 103
TrueType fonts 81
type, use on images 80–3, *80*

unsharp images 40
UnSharp Masking (USM) 114, *114*, 115–19, *115*

vector fonts 81–2, 83

watermarks 135–6, *135*
Web, images for 132–6
 creating webpages 136, *136*
white point calibration 22–3, 36–7

Acknowledgments for original edition

More than everyone and everything else put together, my inspiration and strength for completing the demanding task that has been this book is my wife Wendy. Thank you so much.

Many thanks to Eddie Ephraums for alerting me to Rayleigh scattering in film-scanning. To the team at Mitchell Beazley – namely Michèle Byam, Vivienne Brar, Christie Cooper, Louise Dixon – my thanks particularly to Michèle for her sound stewardship. And I am most grateful to Jeremy Williams for his steady good taste, precision, and utterly reliable professionalism.

To software houses Adobe, Alien Skin, Binuscan, Camerabits, Corel, Fotoware, Quantum Mechanics, Shortcut go my gratitude for their technical assistance and for helping to keep me up to date. Also to the editors at *Total Digital Photography*, *MacUser*, *MacFormat*, and *Digital Camera* magazines: many thanks for commissioning features from me and for your continuing technical assistance.

With very few exceptions, usually made clear by a reference to scanning, all the images in the book were captured on digital cameras of which my mainstay is the Canon D30. Other digital cameras used were the Nikon D1X, Nikon 990, and Nikon 885, Sony F717, Canon G2, Canon EOS–1D, and Canon D60. A wide range of Canon lenses was used, ranging from the 17–35mm to the 100–400mm zoom including the 24mm TSE, 50mm macro, 28–135mm, and 28–70mm lenses. Film-based cameras used were the Canon EOS–1n, Leica M6, as well as the Rolleiflex 6008.

The scanners used were the Microtek Artixscan 4000, the ever-reliable Heidelberg Saphir Ultra II flatbed, and the excellent Minolta Scan Multi Pro.

Tom Ang
London 2003